THE COMPLETE BOOK OF
PHOTOGRAPHIC
— LENSES —

THE COMPLETE BOOK OF
PHOTOGRAPHIC
LENSES

AMPHOTO
An Imprint of Watson-Guptill Publications/New York

Joseph Meehan is a contributing editor at *Petersen's Photographic* and also writes for the *British Journal of Photography* and *Industrial Photography*. A former professor in the State University of New York system, Meehan has also taught courses in photography at the School of Art, Ealing College, London, and the National Taiwan Academy of Art, Republic of China. His photographs have appeared in many books and magazines in the United States, Europe, and Asia. He is the author of *Panoramic Photography* (Amphoto, 1990).

I would like to thank Ingeborg Bruckmann and Amphoto editor Liz Harvey for all their help in the preparation of the final manuscript. I would also like to thank my colleagues Robert Farber, Chris Faust, Art Gingert, and Peter Klose, and my former students Michael DeBonis, John Denver, Petra Liebetanz, Ivan Nosenchuck, and Stefano Ohaviani for the use of their photographs.

Editorial Concept by Robin Simmen
Edited by Liz Harvey
Graphic Production by Stanley Redfern

Copyright © 1991 by Joseph Meehan
First published 1991 in New York by AMPHOTO,
an imprint of Watson-Guptill Publications,
a division of BPI Communications, Inc.,
1515 Broadway, New York, NY 10036

Library of Congress Cataloging-in-Publication Data
Meehan, Joseph.
 The complete book of photographic lenses/by Joseph Meehan.
Includes index.
ISBN 0-8174-3697-9
1. Lenses, photographic. I. Title.
TR270.M44 1991 91-16236
771.3′52—dc20 CIP

Manufactured in Singapore

1 2 3 4 5 6 7 8 9/99 98 97 96 95 94 93 92 91

To my son, Joseph Robert,
and his love of family

Contents

Introduction 8

CHAPTER 1
How Photographic Lenses Work 12

CHAPTER 2
Composition and Lenses 38

CHAPTER 3
Standard and Moderate Lenses 62

CHAPTER 4
Longer Telephoto Lenses 82

CHAPTER 5
Medium-Wide and Ultrawide Lenses 98

CHAPTER 6
Special Lenses and Accessories 114

APPENDIX 1
View Camera Movements 138

APPENDIX 2
Lens Testing 140

Index 143

Introduction

When you listen to photographers talk about lenses and the way they're used, you get the impression that these tubes of metal, glass, and plastic are reliable, old friends. Some lenses even take on almost mystical qualities and powers. Indeed, some photographers purchase a particular lens hoping that it will impart greatness to their photography, while others tend to be more pragmatic and select lenses to solve specific photographic problems. The camera industry responds to both the hopeful and the hard-boiled with advertisements that are crammed with technical jargon, and specifications embellished with such photographic buzz phrases as "needle-sharp images" and "high-tech accuracy."

There is no doubt that today's automatic cameras and lenses are technological marvels and that recent advances have enabled more people to take better pictures more often. But the down side of this progress is the loss of understanding how each step in the shooting process affects the final image. I don't side with the "anti-automation, keep-photography-manual crowd," many of whom want to roll back the tide supposedly to preserve the "essence of pure photography." Automation is here to stay; the only uncertainty is the degree to which it will coexist with or completely supplant manual photography. For me, the more important question is how we can prevent ourselves from losing control over the final image when our cameras do everything for us, including focus and determine exposure. I think that we should be concerned with how we can make all of this new technology work for us and get the most from it. To achieve this, you have to know how your equipment works.

This brings me to the main objectives of this book. I'll explain how lenses work and how they affect the content and composition of a photograph. I also want to show how combining this knowledge with testing and experimentation will make it possible for you to create rather than merely record with your photography.

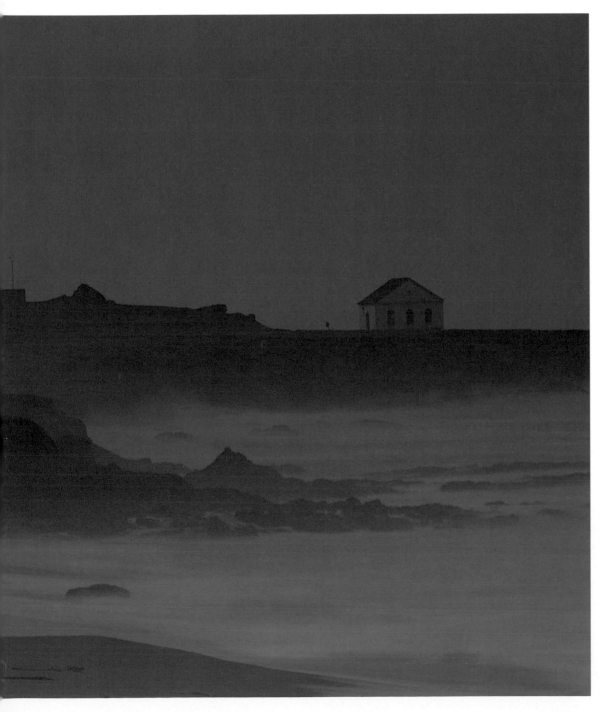

Shooting this lighthouse on a gloomy day with a 300mm lens and my 35mm camera, I underexposed tungsten film to produce a deep blue effect and to enhance the mood.

From the start, I make certain assumptions. First, lenses aren't magic wands; they are tools that strictly obey the laws of optics. Furthermore having a working knowledge of them is vital, but is of little use unless you apply it during the picture-taking process. Finally I believe that instead of preventing you from learning your craft, automation should help you take it even further. In other words, photography is a creative, and very democratic, medium. Putting aside our ability to afford the latest equipment, we're separated as photographers by both an uneven distribution of inherent talent and the level to which we're willing to work at our discipline. A how-to book like this one can't provide you with a skill simply by your reading it. You must use the information contained within these pages. Otherwise, you'll just build up a body of facts in your head and become another "non-practicing photographic expert." You can recognize these people because they talk endlessly about photographic equipment and methods yet they rarely show their pictures, and when they do the images never reflect the level of knowledge they possess.

Photography is a series of many steps, each of which has to be performed in a careful and exact manner. If any one step is weak, the final image will reveal this. Any knowledgeable photographer will tell you that mastering the procedure takes hard work over time, as well as a willingness to accept failures. Few of us get it all right the first time we shoot. For most of us, photography is a gradual, cumulative process. In fact, all respected and accomplished photographers have, in their own way, refined their craft. And although I've heard some of them brag about their disdain for the technical in favor of the artistic, more likely than not their work shows very good technique and a thorough understanding of how to use lenses. If this level of achievement isn't the result of formal training, then it came from trial and error, which is another (obviously less efficient) way to acquire knowledge through study and thoughtful experimentation. No matter how compelling the "free-spirit" arguments are, higher levels of photographic expression are ultimately dependent on a command of photographic tools, methods, and procedures. In a sense then, this is yet another variation of the long-standing question, "Is photography art or science?"

I had to struggle with this question early in my career, partly because I was trained in the sciences and partly because I was so fascinated by cameras and lenses. But the main reason why I picked up a camera almost 25 years ago was the pleasure I derived from making pictures—not from using the equipment. That pleasure continues to this day and is now a passion. I have come to realize that it is an essential form of self-expression. I didn't reach this point overnight, however. At first, I only recorded what I saw. It wasn't until much later that I developed a need to interpret what was before me and how I felt about it. The first part, recording the scene, was easy in the sense that it required very specific knowledge and the skill to apply it. The second phase, interpreting the scene, has turned out to be a lifelong quest because it requires a much deeper understanding of both the visual world and my reasons for wanting to capture it on film.

My father, who was a superb amateur photographer, introduced me to photography as a form of personal expression. His craft, developed through years of trial and error, was good. In later years, I was able to answer his technical questions. But he always brought our discussions back to the image and what he was trying to capture. This is a refinement of my second objective in writing this book: to prove that a thorough understanding of lenses is a means to an end. That end is a photograph that documents and records, conveys a message, evokes an emotional response that can vary from awe to revulsion, and if you wish, expresses something within you.

To make the enormous subject of photographic lenses accessible, I have divided the book into three parts. Chapter 1, the first section, provides essential information about how lenses work. I explain how these optical devices translate reflected light rays into specific images on film. The second part, Chapter 2, covers composition, discussing how lenses control the arrangement of visual elements and outlining the range of opportunities that lenses offer in terms translating reality onto film. The last four chapters comprise the third part, and each is devoted to a major lens grouping. Chapter 3 describes standard and moderate-angle lenses; Chapter 4, telephoto lenses; Chapter 5, wide-angle lenses; and Chapter 6, specialized lenses. In each of the chapters, lenses for all cameras, from 35mm to view cameras, are covered. I included this information for two reasons. There are major operational differences between these lenses, and these differences make apparent certain advantages and disadvantages that you should be aware of because they represent choices you should consider during the photographic process.

Throughout the book, you'll be struck by the need to weigh what often seem to be diametrically opposed but equally appealing options. For example, you'll see that

you sometimes have to choose between a small, light lens that is easy to carry and use and a larger one that is more of a bother to carry and set up but that allows greater control over composition. Choices, options, decisions—this is what a large part of photography is all about, especially in today's world of almost daily "technological breakthroughs." It might seem that the more you learn, the more options you have to deal with, and the more decisions you have to make. This can be frustrating at times.

Take heart: when you reach that point, you're now dealing with photography on a much deeper level where you can appreciate not only the complexities of the medium, but also its nuances. This is much different from just raising a camera to your eye and snapping a picture. I hope that this book will help you understand the myriad of lenses and their effects and help you choose the lenses most appropriate for your purposes. But don't be surprised—or disappointed—if I leave that last step up to you.

The standard lens is frequently used for small-product work, such as this 4 × 5-inch large-format shot. The blur effect was achieved by smearing petroleum jelly over a piece of glass held over the lens. Courtesy of Petra Liebetanz.

How Photographic

In theory, photography is a process by which light reflected off a subject is focused on film through an optical device called a *lens*, or an *optic*. Because subjects have various textures, reflective properties, and colors, light is reflected off them in different ways. This, in turn, produces different qualities of light. It is, therefore, the lens' job to gather light rays and accurately translate the image they form on film.

THE PINHOLE PRINCIPLE

In practice, demonstrating the creation of a focused, reflected-light image is even simpler. All you have to do is darken a room completely and make a very small hole in one wall to the outside. A dim, inverted picture of whatever is outside will form on the opposite wall. This happens because part of the reflected light passes through the opening and "focuses" on the wall. Usually, light is reflected in all directions off a subject. If you expose a sheet of film to this undifferentiated light at a correct exposure without a way to focus the light rays, the developed film won't show an image. Instead, you'll see an even exposure to light across its whole surface. Many rays of light from each point on the subject will reach the film but without any device to sort out one ray per point of reflection, all of the light rays will be superimposed on one another. This will result in the photograph of continuous white light.

If, however, the only way that light can strike a sheet of film is through a small hole, then the number of possible paths for the light rays will be reduced. Theoretically, then, only one light ray per point of reflection will reach the film, and no overlapping and blending will occur. Each point on the subject will be represented by a corresponding point on the film with a specific intensity and color to form a two-dimensional representation of the real world.

In this wide-angle shot taken in California's Death Valley, the site marker in the foreground describes mountains in the background that are 18 miles away. Using a small aperture, f/22, on a 20mm lens allowed everything from just a few inches in front of the lens to infinity to be in sharp focus.

Lenses Work

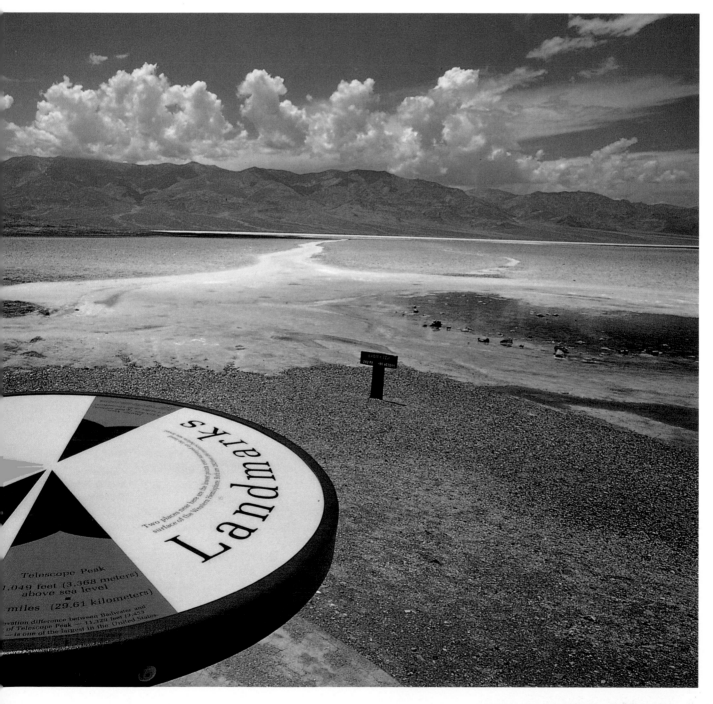

Telescope Peak
1,049 feet (3,368 meters)
above sea level

miles (29.61 kilometers)

Lenses bring light from subject points to focal points in the image plane (top). But pinholes don't bring light to a focus (bottom). Instead, the light spreads out as cones whose bases form circular spots in the image plane. A smaller pinhole reduces the spread of the cone and, as such, the size of the spot in the image plane, thereby producing a sharper image until the diffraction of light caused by the edges of the hole cancels out the gain in sharpness. Courtesy of Michelle Bogre, "Pinhole Revival," *Popular Photography,* May 1976.

LIGHT AND THE PINHOLE

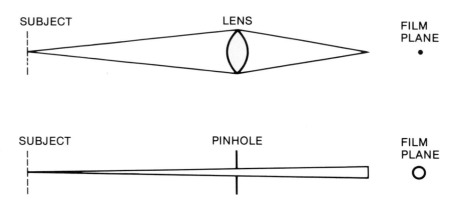

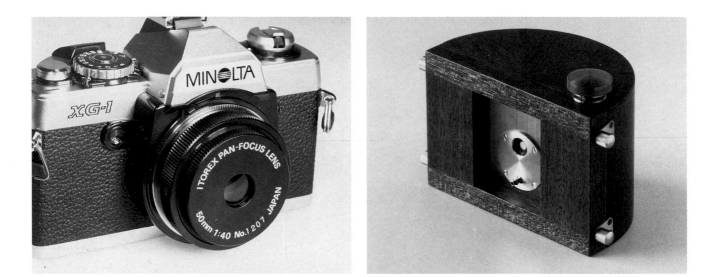

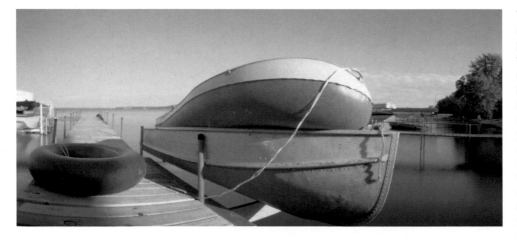

The pinhole principle continues to fascinate photographers because it enables them to easily control the sharpness of the final image, as this photograph of a boat and an inflatable raft at a dock shows (left). To achieve this, you can use a pinhole camera (above right). You can also mimic the extensive depth of field that pinhole cameras are capable of by using a lens with an extremely small aperture, such as this *f*/40 lens (above left). Courtesy of Chris Faust (left), Kurt Mottweiler Cameras (above right), and Porter's Camera Store (above left).

This is a simplified description of the *pinhole principle.* The image the pinhole forms in a darkened room can be controlled quite easily. To a certain extent the smaller the hole is, the sharper the image will be because you're limiting the chance that divergent light rays from the same point will slip into the hole and blur the image. And the farther apart the hole and the opposite wall are, the narrower the angle of view will be; in other words, you'll see less of the outside scene (see page 20). Conversely the closer the hole and the opposite wall are, the wider the angle of view is.

LENS DESIGN

In principle, a lens produces a focused image as does a pinhole, but it does so differently and its design enables you to control the final image even more. When light passes through a piece of glass in which both sides are roughly parallel, there is just the slightest change in its straight-line path. If, however, light passes through a curved piece of glass, the light rays slow down and *refract*, or bend, toward the same focus point. Once you begin to control the light path and the focus point, all kinds of possibilities and problems come into play.

A lens allows much more light to reach the film than a pinhole does. The number of single pieces of glass, called *lens elements*, combined into groups determines both whether a lens is a *wide-angle* or a *telephoto* and, accordingly, how much of the scene is recorded on film. When the lens elements shorten the light path, the lens is a wide-angle; when they lengthen the path, the lens is a telephoto. This parallels the effect of changing the distance between the pinhole and the wall on which the image is projected. The trick with lenses is to know how each bending of the light and the qualities of the glass itself will work together. This is no small task, but today's lens designers have a great deal of help.

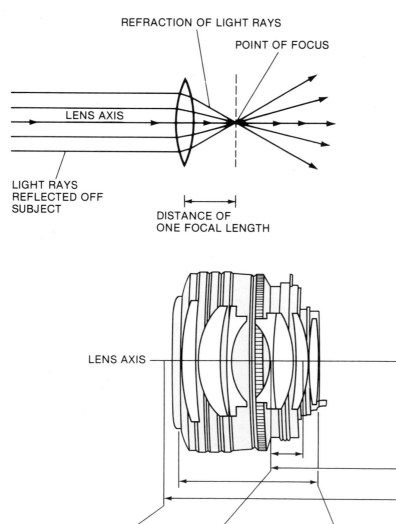

REFRACTION OF LIGHT RAYS

POINT OF FOCUS

LENS AXIS

LIGHT RAYS
REFLECTED OFF
SUBJECT

DISTANCE OF
ONE FOCAL LENGTH

A modern camera lens is a complex device made up of several elements in groups. As a result, light rays passing through the lens are shaped in many different ways to correct for aberrations and to obtain various focal lengths. Single-element-lens light rays bend, or refract, to a single point where the subject will appear focused (left). Areas in front of or behind this point will show a blurred or out-of-focus image. Courtesy of Michael Freeman, *Cameras and Lenses,* Amphoto, 1988.

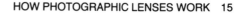

LENS AXIS

PRINCIPAL
FOCAL POINT

FRONT
NODAL POINT

REAR
NODAL POINT

PRINCIPAL
FOCAL POINT

First, many designs have performed very well over the years and are still being improved on. Such names as Tessar, Gauss, Goerz Dagor, Symmar-S, and Planar might sound familiar because they're used to identify specific lenses; however, they also represent lens configurations. Lens elements come in different shapes, including concave and convex. Early lens designs are basic in comparison to the modern, multi-element group designs. It used to be true that the more groups and elements in a lens, the better the image quality was. This statement is a bit too simplistic in today's world of computer-aided designs and special glasses and coatings. Nevertheless the more complex a lens configuration is, the more likely it is that the quality of the lens is high.

In addition to proven designs and the development of new lens configurations, designers also have better glass to work with now. Materials come closer to theoretical, or ideal, levels of light transmission. Such manufacturer notations as "Superachromat," "Apro-Ronar," "PS Series," "ED-IF," "LD," and "T*" refer to the use of certain glasses, lens coatings, and designs that reduce the number of *lens aberrations*, which are optical flaws, and increase the amount of light transmitted.

Lens Aberrations and Image Quality. In contrast to the theoretical and ideal optical principles, in the real world of photography certain factors stand in the way of a perfect lens. Some of these come from the way the lens is used. Examples include the straight lines of buildings converging near the top of a photograph when the camera is tilted upward and an object's size increasing when placed very close to a lens. These aren't lens aberrations. Instead, they're changes brought about by the way a particular lens is used. This is often referred to as *apparent distortion.*

Lens aberrations, on the other hand, are intrinsic to the design of and/or material used in a lens. Several aberrations affect the final image by either reducing its contrast or preventing an accurate geometric representation of the subject. Other aberrations alter the amount of light that passes through the lens, producing a picture that is darker at the corners; still others cause the appearance of *color fringes* in the highlights, or focus shifts with each wavelength of the color spectrum so that not all colors focus at the same point. (The best way to understand lens aberrations is within the context of lens testing. See pages 138–139.)

LENS ABERRATIONS

Aberration	Cause	Where common	Ways of improving	Effect
Spherical aberration	Spherical glass surfaces	Cheaper lenses, large-aperture lenses	Aspherical surfaces or floating elements; stop down	Unsharpness, especially in close focus; focus shifts when stopped down
Coma	Variation in magnification with aperture	Off-center highlights	Symmetrical design; stop down	Teardrop-shaped images of off-axis points of light
Astigmatism	Nonsymmetrical refraction	Cheaper lenses	Stop down	Vertical and horizontal subjects focus at different distances
Distortion	Oblique light rays bent by edges of lens	Nonsymmetrical lenses	Symmetrical design; de-emphasize through composition	Nonradial lines curve out (barrel) or in (pincushion)
Field curvature	Focal plane curved because lens surfaces curved	Wide-angle lenses, large apertures	Manufacturer overlaps different image shells to approximate flat plane; stop down (improves depth of focus)	Focus position varies from center to edge
Diffraction	Wave nature of light	Small apertures, common in closeup	Do not stop down fully	Loss of resolving power
Axial chromatic aberration	Dispersion of light	Long lenses	Achromatic or apochromatic design	Colored fringes to highlights; focus shifts with color
Lateral chromatic aberration	Dispersion of light	Long lenses	Very difficult: fluorite or similar (ED glass)—but these cause focus shift with temperature change; mirror lens	Colored fringes to highlights
Vignetting	Light travels farther to edge of film frame than to center	Wide-angle lenses	Stop down	Uneven illumination—darker toward corners

Courtesy of Michael Freeman, *Cameras and Lenses*, Amphoto, 1988.

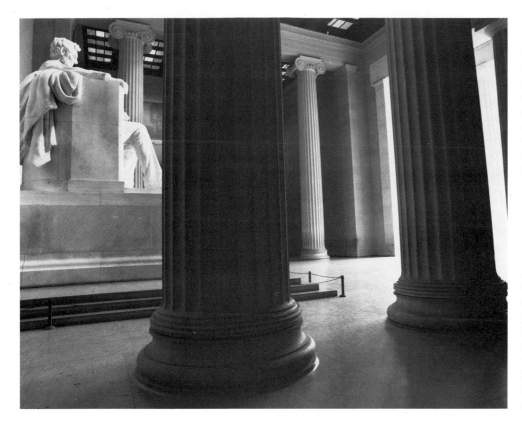

For this shot of the Lincoln Memorial, I used a medium-wide-angle lens on a nonshift 6 × 4.5cm camera; as a result, the columns on the far right are unparallel (left). By switching to a medium-wide-angle lens on a view camera, I was able to keep all the vertical lines perfectly straight (below left).

A lens' inherent optical qualities are greatly affected by the camera's position and its capability to move the lens in relation to the film and subject. Here the distortion caused by using a 35mm ultrawide-angle lens on a 6 × 4.5cm camera is hidden by the subject, the circular staircase.

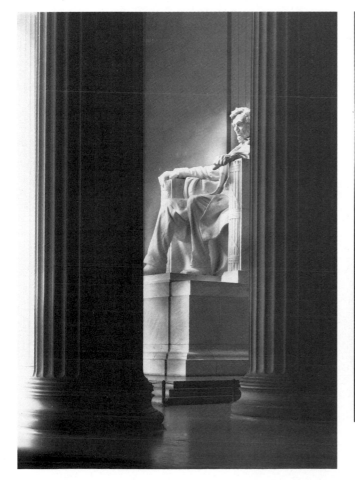

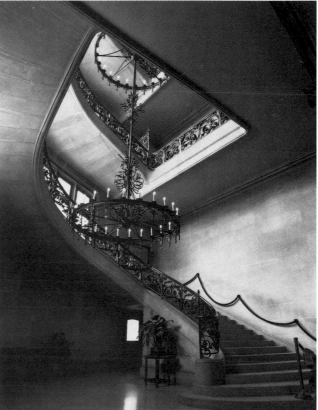

BASIC PROPERTIES OF LENSES

To fully understand how a lens can be used to its greatest technical potential, you should be aware of the fundamental lens properties. These are focal length, aperture range, shutter, angle of view, and covering power. The result will be a refinement of your picture-taking technique as well as a way to evaluate your need for other lenses. Furthermore, knowing how to better control the final image will lay the groundwork for trying new approaches to composition.

Focal Length. This is the single, most important lens property because it controls *magnification* of subject matter: how much of the scene is recorded and how the objects in the scene relate to each other. The *focal length* of a lens is the distance it takes for light rays to focus at the same point. If the light rays go beyond or fall just

short of this point, the image will be out of focus. A lens' focal length is usually given in millimeters.

More specifically, focal length is the distance between the focus point and the *second nodal point*, which is where the light rays leave the lens. The *first nodal point*, therefore, is where light enters the lens. Modern lenses are complex and have many elements, so the exact location of a nodal point depends on the design of the specific lens.

The focal length assigned to a lens is always based on a focus point of infinity. This is the spot where everything in a scene is in focus from that point to as far as the lens can "see." The larger the focal length, the more likely it is that the lens is a telephoto; the smaller the focal length, the better the chances are that the lens is a wide-angle. Between the *long-focal-length* telephoto lens and the *short-focal-length* wide-angle lens lies the so-called

The range of lenses available today is staggering, as is the difference in results when a simple lens switch takes place. I photographed this house with a 1000mm lens from a distance of 3 miles (right). If I had chosen a 50mm lens, the house would've been the size of one of the chimneys. To achieve the bulbous, curvilinear effect, I used a 180-degree fisheye lens and stood about 20 feet from the nearest column (below).

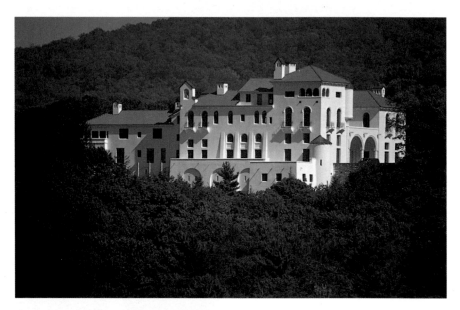

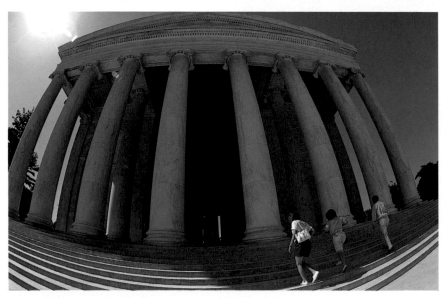

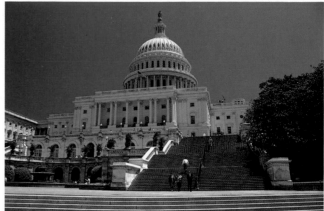

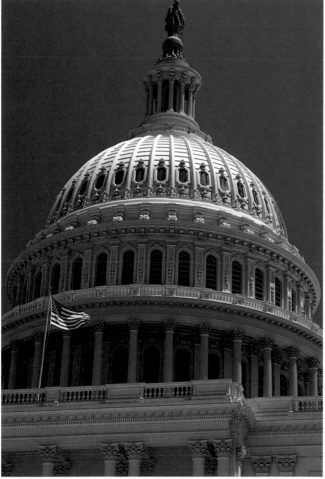

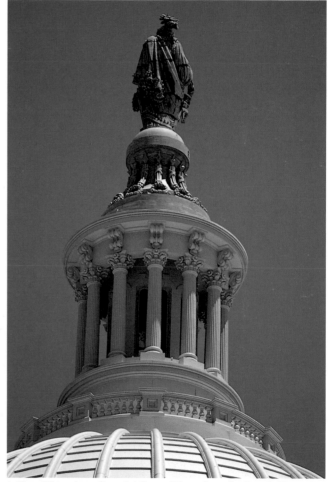

Lenses with different focal lengths produce very different inter-pretations of a subject. For these pictures of the Capitol in Washington, DC, I used a 35mm camera and a 15mm lens (top left); a 24mm lens (top right); an 85mm lens (bottom left); and a 300mm lens and a 1.4X tele-extender, which effectively was a 420mm lens (bottom right).

"normal" focal length of the *standard* lens. Lenses that have only one focal length are called *fixed-focal-length* lenses. Those that change via an adjusting ring are referred to as either *true-zoom* or *variable-zoom* lenses.

To operate true-zoom lenses, you move a single ring on the lens barrel back and forth to increase or decrease the focal length. At the same time, you can rotate this

ring to adjust the focus. *Variable-focus* models have two rotating rings: one ring changes the lens' focal length, and the other controls focus. All zoom lenses are labeled and categorized by their minimum-to-maximum focal lengths. For example, an 80-210mm lens has a minimum focal length of 80mm and a maximum focal length of 210mm. Zoom lenses might be in either the telephoto or the wide-

angle range, or they might combine a wide-angle minimum focal length with a telephoto maximum focal length; this combination zoom lens includes a normal setting as well.

Angle of View. Closely connected to a lens' focal length is its *angle of view*, which indicates how much of the scene the lens sees. The angle of view serves as the basis for labeling a lens as a telephoto, a standard, or a wide-angle. Keep in mind, though, that the size and *format*, or shape, of the film frame being used affect the angle of view. Take, for example, the 90mm focal length. In 35mm photography, this is a telephoto focal length. But in many cameras using medium-format film or 120mm rollfilm, a 90mm focal length is considered normal or just slightly

long, and on the 4 x 5-inch film used in large view cameras, it is regarded as a wide-angle.

A simple way for you to understand this concept is to visualize a 90mm photographic lens focused on a piece of 4 x 5-inch film. Next, draw the much smaller 35mm frame (which actually measures 24 x 36mm) in the center of the 4 x 5-inch film. It should be obvious to you, then, that the angle of view for the 90mm lens in relation to the 35mm film is much smaller than that of the 4 x 5-inch film. So a lens' angle of view is determined by the extent to which its focal length records a scene on a negative of a particular size and shape. This angle can be measured across the horizontal, vertical, or diagonal of the film frame. With zoom lenses, the angle of view changes with any alteration of focal length.

THE RELATIONSHIP BETWEEN FOCAL LENGTH, ANGLE OF VIEW, AND FILM FORMAT

35mm		6 × 6cm		6 × 7cm		6 × 9cm		4 × 5 in.	
Focal Length (mm)	Angle of View* (degrees)	Focal Length (mm)	Angle of View* (degrees)	Focal Length (mm)	Angle of View* (degrees)	Focal Length (mm)	Angle of View* (degrees)	Focal Length (mm)	Angle of View* (degrees)
20	84					50	81	65	86
24	74							75	78
28	65	40	69	50	69	65	66	90	68
								100	62
35	54	50	58	65	56	75	59	120	53
						90	51		
44	44	60	49	75	49	105	44	135	48
50	40	75	40	80	46			150	44
				90	42			165	40
55	36	80	39	105	36	120	39	180	37
58	34	100	31	120	32	135	35	210	31
		105	30	127	30	150	32		
85	24	120	26	140	27	180	27	240	28
105	19	135	23	150	26	250	19	300	23
		150	21	180	22			360	19
135	15	250	13	360	11	360	13	450	15
180	12							480	14
200	10								

* Horizontal format.
Courtesy of Calumet Photographics.

Many terms are used to describe the degree to which a lens is a wide-angle or a telephoto. Such labels as "superwide" and "extreme telephoto" are hard to quantify without using some specific form of measurement. Photographers should use angle-of-view figures in relation to film formats, but they don't. Instead, they use categories that have been more or less agreed upon. Here, I divide wide-angle lenses into three groups: "moderate-angle," "medium-wide-angle," and "ultrawide-angle"; the third category includes fisheye lenses. Similarly, I divide the telephoto lenses into three categories: "moderate," "medium-long," and "very long."

Covering Power. All camera lenses are designed to be used with certain types of film. The size of the circular image that lenses project is called the *image circle*; it is large enough to surround, or cover, the frame of the final image on the film. So if you take a lens intended for 35mm film and use it with a larger-sized film, its *covering power* won't be extensive enough. As a result, *vignetting*, which is the darkening of the image's corners, will occur. In a situation in which the covering power is extremely inadequate, a darkened circle appears around the image. Conversely, using a lens from a larger-format camera on a smaller camera works because there is more than enough coverage. (This is what happened when you visualized a 90mm lens covering both 4 x 5-inch and 35mm film.)

Photographers who use 35mm or medium-format lenses aren't very concerned with covering power because they almost always shoot with lenses designed

5 × 7 in.		8 × 10 in.	
Focal Length (mm)	Angle of View* (degrees)	Focal Length (mm)	Angle of View* (degrees)
75	97	120	92
90	87	135	85
100	81		
120	71	150	79
		165	74
135	64	180	69
		210	61
150	59	240	55
165	54		
180	51		
210	44	300	45
240	39	360	38
300	32	450	31
360	27	480	29
450	21		
480	20		

Although vignetting can occur for many reasons, two of the most common are using a lens hood that extends too far in front of the lens and stacking two or more filters on a wide-angle lens. This photograph of a moonrise was taken with a 35mm camera and a 24mm lens; the vignetting wasn't visible in the viewfinder.

specifically for their cameras, or at least the same camera format. As such, ample coverage is built-in. With cameras that call for larger sheet-film sizes, however, the situation is quite different. Because mounting large-format lenses on any large-format camera is relatively easy, the lenses might be required to cover 4 x 5-inch film with one camera and 8 x 10-inch film, which obviously is twice as big, with another. Consequently, photographers must know if a particular lens has enough covering power. Manufacturer specifications, which include a lens' *angle of coverage* (see below) and image circle and are based on the lens being set at *f*/22 and focused at infinity, indicate whether or not the lens has enough covering power to actually project an image over a specific film size.

Angle of Coverage. This is a measure of the entire image circle of the lens. Don't confuse this with the angle of view. The angle of coverage simply refers to the image-forming cone of a lens. This tends to be similar for a number of different focal lengths that are made from the same basic lens design. Take, for example, the Schneider

The larger the negative, the better the quality of the final image. A large-format view camera, a medium-wide-angle lens, a 5 × 7-inch negative, and palladium printing were used to make this exquisite photograph. Courtesy of Peter Klose.

Super Angulon series. Almost every lens in this group has an angle of coverage of either 100 or 105 degrees and focal lengths ranging from 65mm to 210mm. All of these lenses are considered wide-angles, and each focal length is designed for a specific format. The 65mm lens is intended for use with 4 x 5-inch film; the 210mm lens, with 8 x 10-inch film. These lens-and-film-format combinations provide wide angles of view of approximately 86 and 61 degrees, respectively.

As mentioned earlier, the image circle refers to the area that produces sharp images. Once again, the size of the image circle is determined by the specific lens design. Furthermore, each film format has its own minimum requirement for coverage. For example, 4 x 5-inch film needs 161mm, and fittingly enough 8 x 10-inch calls for twice as much, or 323mm. But these are just minimal figures, required when the lens axis is aligned with the center of the film, as with 35mm and medium-format cameras.

Large-format cameras, however, are designed to move their lenses and film in relation to one another; this feature enables photographers to correct for the various apparent distortions that are produced when they take photographs from certain angles or perspectives. As a result, when the lens is moved off-axis from the center of the film plane, a larger image circle is needed to cover the film. Consequently, a 150mm lens, which is considered a normal focal length for the 4 x 5-inch format, has an image circle approximately between 210mm and 225mm; this is much larger than the minimum of 161mm. *High-modulation*, or *extended-coverage*, lenses have even larger image circles, ranging from 150mm to 255mm for extreme camera movements.

Aperture. Don't confuse the uppercase "F" that signifies focal length with the lowercase "f" used to denote *f-stops*. Here, the "f" refers to the size of the *aperture*, or the lens opening. This is the bladed diaphragm inside the lens that opens and closes to control light, much like the iris of the eye. An *f*-stop, then, is a measurement of the size of the aperture opening. The higher the *f*-stop number is, the smaller the opening is. For example, *f*/2 lets more light enter the lens than *f*/8 does. This doesn't seem logical because 8 is bigger than 2, but all *f*-stops should be thought of as fractions. So think of *f*/2 as 1/2, which is larger than 1/8 (*f*/8).

Today, all lenses used for general photography follow a standard *f*-stop scale. While no lens has a complete set of stops from *f*/1.0 to *f*/64, all lenses set at the same *f*-stop theoretically transmit the same amount of light. More-

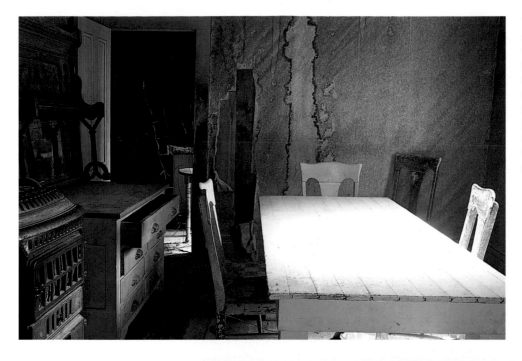

The effect of exposure on composition is a given in photography. Shooting with a 28mm wide-angle lens on a 35mm camera, I used aperture settings 2 full stops apart to record two rather different renderings of this strong light source coming through the window of a house in an old ghost town.

over, the change in the amount of light that any two full, adjacent *f*-stops transmit is the same. For example, switching from *f*/4.0 to *f*/5.6 is a difference of 1 stop less light, as is switching from *f*/22 to *f*/32. The aperture settings on 35mm and medium-format lenses are the *click-stop* type, some of which have provisions for half-stop increments. Large-format lenses favor a sliding scale from *f*-stop to *f*-stop.

The range of aperture settings a particular lens has varies with film format and camera design. Nevertheless, some generalizations can be made. The larger the film format is, the more likely it is that the lens' maximum

aperture is slow (see page 24) and minimum aperture is small. For example, a standard lens in 35mm photography typically has *f*-stops to *f*/16; a medium-format lens is slower, but can stop down to *f*/22 or *f*/32; and a large-format lens can go all the way to *f*/64. This is because larger-format lenses offer less apparent *depth of field* at each *f*-stop, so they need the additional aperture settings to produce images with a reasonable depth of field; this is the area in front of and behind the point of focus that appears sharp (see page 25).

The formula "Maximum aperture equals the focal length of the lens, divided by the lens' diameter" is used

to establish the *f*-stop that allows the greatest amount of light to reach the film. Depending on a lens' maximum aperture, photographers tend to classify it as fast or slow. So a 50mm lens with a maximum aperture of *f*/1.4 is considered fast compared to a zoom lens with a maximum aperture of *f*/3.5 set at 50mm. Some large lens openings, such as *f*/1.0, *f*/1.4, and even *f*/2.0, very often enable you to take pictures in low light or at fast shutter speeds in moderate light. They also make the image seen in the viewfinder of certain cameras very bright and easy to focus. When considering lenses, keep in mind, though, that lenses with fast apertures are bigger and heavier because they contain more light-gathering glass, and are much more expensive than other lenses.

All fixed-focal-length lenses have both their focal length and maximum aperture indicated on them. For example, a 105mm 1:2.5 lens has a focal length of 105mm and a max-

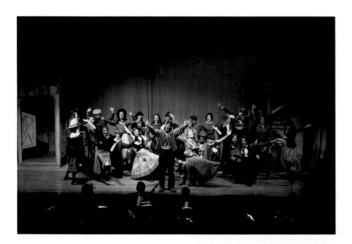

imum aperture of *f*/2.5. With zoom lenses, however, you might also see a double *f*-stop designation, such as 28-85mm *f*/2.8-3.5. The two apertures are indicated because the lens' maximum aperture changes along with its focal lengths. In this example, the lens openings begin at *f*/2.8 for the 28mm focal length and progressively change to *f*/3.5 by the time it reaches the 85mm focal length.

Controlling Exposure. Selecting apertures is one of two ways that you can control exposure in exact, measured amounts. (The other is choosing a shutter speed. See page 28.) Photographers use the terms *stopping down* and *opening up* to describe what happens when they change the amount of light reaching the film. They do this by turning the aperture ring located on the lens to a smaller *f*-stop number, which is stopping down, or to a larger number, thereby opening up. Aperture settings are quite accurate—when the lens blades are lubricated and are clean.

Automatic apertures are the norm for *single-lens-reflex (SLR)* cameras. The lenses on this type of camera remain wide open until the moment of the exposure. The aperture closes down to the selected *f*-stop as the mirror swings up, and the shutter opens and closes. If the mirror then resets to its original position, it is an *instant-return mirror*. (Lenses for rangefinder cameras and all large-format cameras, as well as the taking lens of *twin-lens-reflex*, or *TLR*, cameras, have *manual* apertures. See page 37.) Automatic apertures are great for focusing, but they can be deceptive when you compose a picture

Fast lenses are particularly useful when the available light is limited, such as during stage events. I made both of these shots with a 35mm camera and wide-open lenses. For the picture of the bodybuilders (right), I chose a special 70-200mm *f*/2.8 low-dispersion zoom lens adjusted to about 150mm. To capture the musical finale (above), I selected a conventional-design 135mm *f*/2.0 lens.

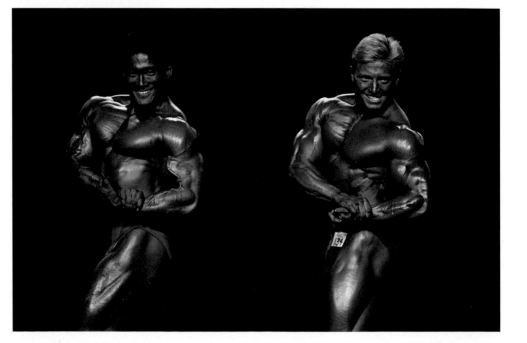

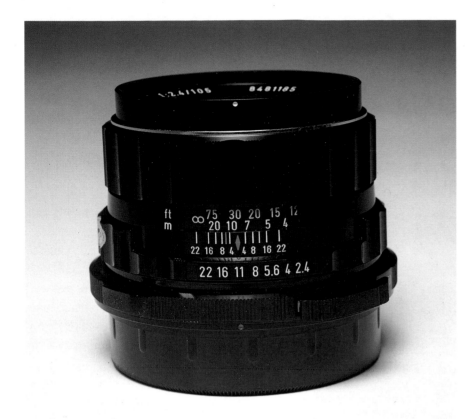

This closeup of a medium-format lens shows the aperture and distance scales. The diamond-shaped marker indicates that this lens is set at *f*/11 and 30 feet. To determine depth of field, you simply look for the hash marks on either side of the diamond that correspond to the *f*-stop. Here, the *f*-stop falls between the numbers 16 and 8. This *f*/11 marker indicates that the depth of field extends from about 18 to 70 feet. The single red hash mark is used in place of the diamond when you shoot infrared film. The lever on the ring closest to the bottom of the lens controls the stopping down or preview function.

because you're always looking at the scene through the lens' maximum aperture.

To compensate for this, you should check the depth of field, if it is critical to the composition, by one of two methods. Either stop down the lens by pressing the *preview button* on the camera or lens to actually see the effect in the viewfinder, or calculate the extent of the depth of field by checking the distance scales on the lens. The latter method is more accurate, and is the only practical way of gauging depth of field in rangefinder cameras since you're looking through a rangefinder lens; this type of lens doesn't change when you alter the *f*-stops. It might also be necessary for you to consult a set of depth-of-field tables; these provide the most accurate data and usually come with new lenses. The preview-button/viewfinder method is less accurate because it depends on your determining what is and isn't in focus on the viewing screen, which is becoming increasingly dimmer as you stop down. Nevertheless many photographers, especially those who work with view cameras, rely on this method and develop a keen sense of what is in and out of focus in an image. The difficulties associated with this method probably contributed to the recent trend to discontinue the preview feature on the new, all-electronic SLR cameras.

A *preset* aperture, which is found in certain special-purpose lenses and a few extreme telephoto lenses, has one ring that changes the aperture setting and a second ring that "marks the spot." To operate it, set the aperture using the first ring. This causes the aperture to close or open; you'll see the effect through the viewfinder. Next, dial the second, or *marker*, ring to the *f*-stop you've selected. The first ring is now adjusted to the widest aperture for focusing and composing until you're ready to take the picture. Finally, turn the first ring until it stops at the *f*-stop of the marker ring. This mechanically blocks the first ring from going any farther.

Controlling Depth of Field. The aperture setting determines not only exposure but also depth of field, which is one of the most important compositional controls you have over your subject. Depth of field is the part of the picture that is in focus. In practice, this means that when you pick up your camera and focus on a subject, a certain amount of area in front of and behind that point will be sharp. Aperture settings affect how large that area is. The bigger the *f*-stop is (the larger the lens opening), the smaller the area in focus and, therefore, the shallower the depth of field. If you stop down, the area of sharp focus increases with each *f*-stop. For example, using an

80mm lens set at *f*/2.8 and focused to 6 feet for 6 x 6cm photography produces 6.6 inches of sharply focused area. Closing down to *f*/11 increases the area to 26 inches.

Consider another example. Suppose you set your lens' focusing ring at infinity and aim your camera at a scene in which a person is 20 feet away from you. A look at the

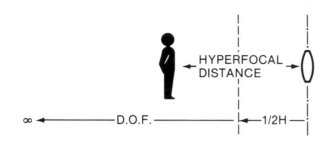

When a lens is focused at the hyperfocal distance for a particular aperture, the depth of field begins at half the hyperfocal distance and extends to infinity. The hyperfocal distance is different for each aperture setting of a given focal-length lens. Courtesy of *Kodak Encyclopedia of Practical Photography*.

lens' distance scale tells you that for the *f*-stop you've selected, everything from 10 feet to infinity is in focus. The point at which the depth of field begins and extends to infinity is called the *hyperfocal distance*. Here, the hyperfocal distance is 10 feet. Next, refocus your camera to the hyperfocal distance by turning the focusing ring to 10 feet; now the image will be in focus from infinity to half the distance between the camera and the hyperfocal distance. Here, the area in focus is now between 5 feet and infinity.

This principle applies to any lens on any format. It also enables you to quickly set up depth-of-field zones that come in handy when you have no time to focus. Using the hyperfocal distance as a benchmark is more accurate in terms of controlling depth of field than even shooting with an autofocus camera because in practice, autofocus lenses focus on the subject. In this example, the resulting depth of field would be less with an autofocus camera than with the hyperfocal approach.

By understanding this principle—and using it when you shoot—you can always maximize depth of field.

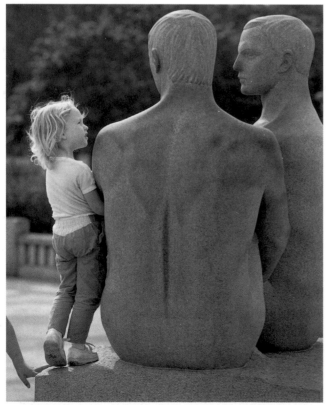

I manipulated the depth of field to isolate this curious little girl (above). I used a longer 150mm lens set at a wide-open aperture on a 6 × 4.5cm camera. For the shot of the guard (right), I chose a 300mm lens and set it at *f*/5.6. This brought him into sharp focus in the foreground and blurred the background.

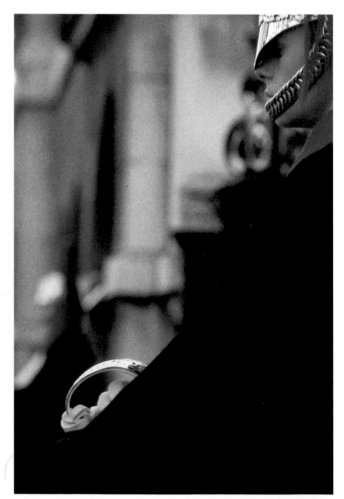

Unfortunately, many photographers just focus on an object and assume that they must accept the depth-of-field arrangement dictated by the particular *f*-stop. Moreover, many photographers follow the so-called "one-to-two rule," which states that when you focus on a subject, the ratio of the depth of field in front of the subject to that behind it is 1:2. This would be a very useful rule, but it doesn't always hold true.

The depth of field depends on the aperture, as already mentioned, the magnification of the focal length, and the distance between the subject and the lens. For example, a 90mm lens used on a 35mm camera set at 2 feet and *f*/22 yields a total depth of field of 2 inches; this is the difference between a near limit of sharpness of 23 inches and a far limit of sharpness of 25.1 inches. But a 135mm lens also set at *f*/22 and 2 feet yields a depth of field of only 0.8 inches; this is the difference between the near and far limits of 23.6 and 24.4 inches. So, then, wide-angle lenses provide more depth of field than standard lenses do, which in turn provide more depth of field than telephoto lenses do.

Another point to keep in mind is that the depth of field is always less extensive with larger film sizes when the same type of lenses—telephoto, wide-angle, or standard—are compared. This is because the larger films use proportionately longer focal lengths. For example, a 150mm lens is a standard lens for a piece of 4 x 5-inch film, while a 50mm lens is the standard for 35mm emulsions. When you set both lenses at 8 feet and *f*/22, the total depth-of-field figures are 72.6 inches for the 150mm lens and 201 inches for the 50mm lens. Smaller formats, then, apparently have a decided advantage if your goal is to have large areas of a photograph in sharp focus. So photographers working with the larger formats have to be very concerned with depth of field and are likely to use small apertures ranging from *f*/16 to *f*/64 or even *f*/90 in order to achieve reasonable depth of field. Finally, the closer you are to your subject, the shallower the depth of field. As such, the 2-inch depth of field obtained with the 90mm lens in the earlier example would increase to about 38 inches if you increased the camera-to-subject distance to 8 feet.

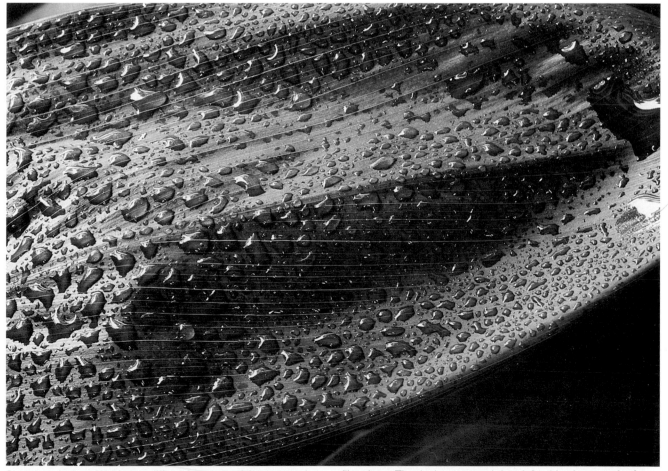

Shooting closeups is always difficult because of the extremely shallow depth of field that results when you come close to a subject. One trick is to keep the subject's plane parallel to the film plane. That is the approach I took for this photograph of a leaf. I used a 120mm macro lens on a 6 × 4.5cm camera and burned out the background during printing.

Shutter Speed. The second way to control the amount of light reaching the film is via the *shutter*. The "door opening and closing" analogy is often used to explain the relationship between the shutter and the aperture. How far you open the door to allow light to enter a darkened room represents the *f*-stop, while how fast you open and close the door corresponds to the *shutter speed*. This is the time between the opening and closing of the shutter, usually measured in parts of a second. Like *f*-stops, shutter speeds have been standardized. Each successive change in the shutter speed is equal; that is, if you move up the scale, such as from 1/4 sec. to 1/8 sec. or from 1/125 sec. to 1/250 sec., you double the speed and halve the amount of light that is transmitted. Conversely, moving down the scale, such as from 1/60 sec. to 1/30 sec. or from 1/2 sec. to 1 sec., halves the speed and doubles the amount of transmitted light.

Remember, a similar "halving/doubling" principle is at work with apertures. For example, switching from *f*/8 to *f*/11 halves the amount of light reaching the film; this applies to any other change between a larger and the next smaller full-stop aperture. The opposite is also true; when you open up one stop, such as from *f*/5.6 to *f*/4.0 or from *f*/32 to *f*/22, you double the amount of light that enters the lens. What actually exists then is a series of equal steps of change in the amount of light reaching the film two different ways: via the aperture or the shutter.

The aperture/shutter relationship is a boon to photographers because these controls have different effects on composition. Apertures control not only exposure, but also depth of field. Shutter speeds affect the way movement and action are presented in a two-dimensional photograph. So if you want to manipulate one control, the other one will offset any changes in exposure.

You can measure light for proper film exposure by metering either the light reflecting off the subject or the light falling on the subject. All cameras with built-in meters measure reflected light, while measuring incident light requires handheld meters. When you screw these Wallace Expo/Discs on to the front of a lens and aim it at the light source, you effectively convert the lens to an incident meter.

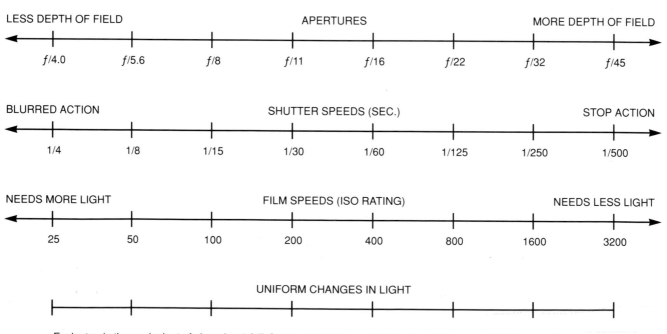

THE RELATIONSHIP BETWEEN APERTURE, SHUTTER SPEED, AND FILM SPEED

LESS DEPTH OF FIELD APERTURES MORE DEPTH OF FIELD

f/4.0 *f*/5.6 *f*/8 *f*/11 *f*/16 *f*/22 *f*/32 *f*/45

BLURRED ACTION SHUTTER SPEEDS (SEC.) STOP ACTION

1/4 1/8 1/15 1/30 1/60 1/125 1/250 1/500

NEEDS MORE LIGHT FILM SPEEDS (ISO RATING) NEEDS LESS LIGHT

25 50 100 200 400 800 1600 3200

UNIFORM CHANGES IN LIGHT

Each step is the equivalent of changing 1 full *f*-stop, or doubling or halving the shutter speed or film speed.

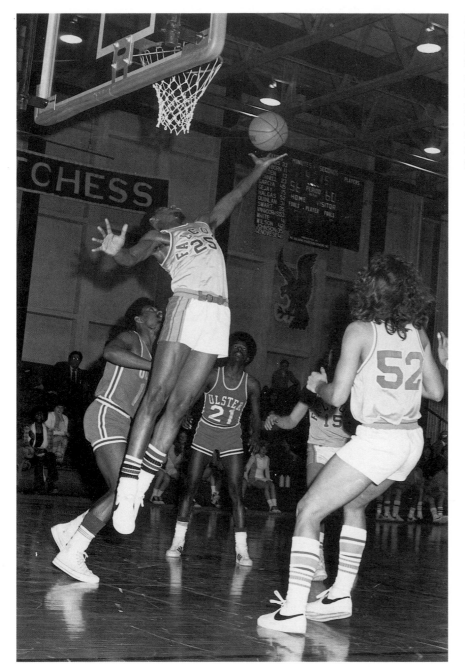

Flash photography offers the fastest effective shutter speed, and for years enabled people to see action sequences that they couldn't otherwise see clearly. For example, the shutter speed for this flash picture of an outstretched basketball player was in the 1/8000–1/10,000 sec. range. Today's faster films and higher shutter speeds allow photographers to record such fleeting moments without flash.

Suppose, for example, that when you photograph a race car at *f*/16 for 1/30 sec., you decide that you don't like the blurred effect that ordinarily occurs when this shutter speed is used with moving objects. You know that a much faster speed, such as 1/250 sec., will freeze the car and produce the desired result, which is a stop-action picture. The difference between 1/250 sec. and 1/30 sec. is three shutter speeds less light: 1/30 sec. to 1/60 sec., to 1/125 sec., to 1/250 sec. In essence, this is the same as closing down three *f*-stops. Therefore, if you start at *f*/16 and open up three *f*-stops, *f*/16 to *f*/8 to *f*/5.6, you'll compensate for the loss of light with a three-step change in shutter speeds, by switching from 1/60 sec. to 1/250

sec. So the new exposure is *f*/5.6 for 1/250 sec., which provides the same amount of light as *f*/16 for 1/60 sec., but at a much faster shutter speed.

Automatic metering systems reestablish the original correct exposure by making changes in the aperture settings equal to those that you make in the shutter speed, and vice versa. When photographers use the phrase "open up one stop of light," they know that they can achieve this effect by either increasing the size of the aperture 1 stop or slowing the shutter speed 1 "stop." The choice depends on the effect a shallower depth of field will have on the final image versus that of a slower shutter speed. This rule applies to closing down, too.

1000mm lens

600mm lens

300mm lens

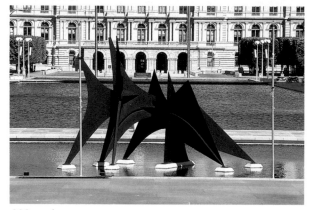
200mm lens

135mm lens

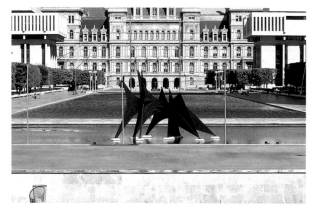
105mm lens

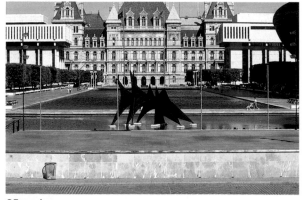
85mm lens

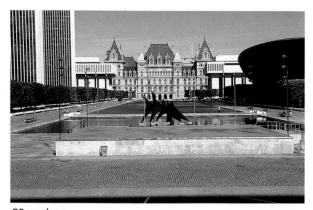
50mm lens

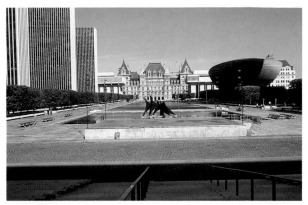

35mm lens

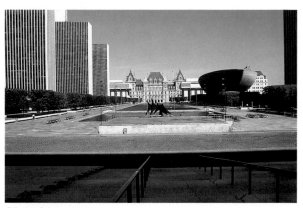

28mm lens

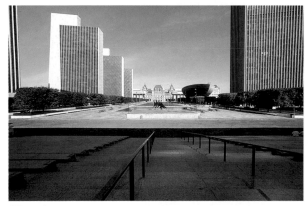

24mm lens

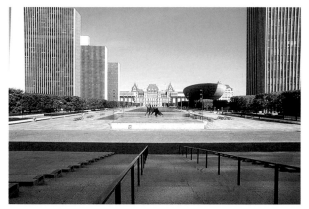

20mm lens

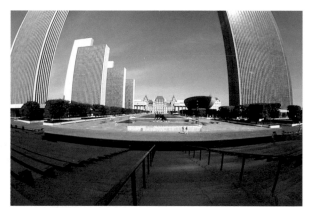

15mm lens

Fisheye lens

These photographs of a plaza show the differences in angle of view of various standard, wide-angle, and telephoto lenses. All of the pictures were taken with a 35mm camera from the same viewpoint.

Shutter Designs. Modern photographic lenses and cameras use one of two types of shutter designs: the *leaf*, or *diaphragm*, shutter and the *focal-plane* shutter. The usual range of speeds for leaf shutters, which are built into the lens, is 1 sec. to 1/500 sec. For slower speeds, you set the lens on "B," which stands for *bulb*, or "T," which means *timed*. In the "B" setting, you usually fire the shutter via a cable release and keep it open by holding down or locking the *cable-release plunger*. To close the shutter, you simply release the plunger. In the "T" mode, one press of the *shutter-release button* opens the lens; pressing the button again closes it. At these two settings, the choice of very slow shutter speeds is endless.

The leaf shutter, located in the lens barrel, works by opening its overlapping blades from the center outward. This action exposes the diaphragm opening (aperture setting) and then closes completely. This type of shutter, then, operates an all (open) or none (closed) principle. Leaf shutters, also called *between-the-lens* shutters because of their location in the lens, come in three large-format sizes: #3, which is the biggest, followed by #1 and #0.

Focal-plane shutters, on the other hand, are folding doors built into the camera body right in front of the space for the film. These shutters are made out of cloth or metal. Designers have been able to combine complex, ultralight folding mechanisms with electronic controls to develop shutter speeds as fast as 1/8000 sec.; however, a top speed of 1/1000 sec. is standard. These maximum shutter speeds are a real help to action shooters. The newer, high-speed lenses and films enable you to offset the loss of light that characterizes fast-shutter-speed images. As with leaf shutters, you can achieve basically any slow speed via the "B" setting and the less commonly available "T" setting.

There are some other important differences between the two shutter designs. The focal-plane configuration provides the shutter for all lenses used on the camera, so its accuracy (or lack of it) is translated to all lenses. Advanced focal-plane designs are generally more accurate because they're electronically controlled by the camera. Conversely, leaf shutters more often have mechanical timing controls. And leaf-shutter lenses are usually heavier because of the shutter mechanism.

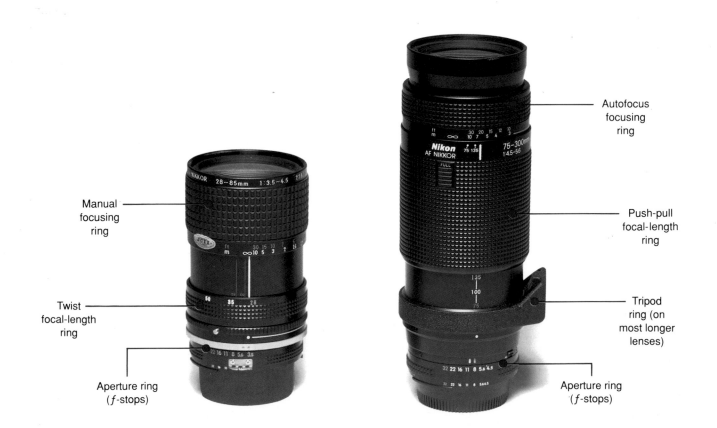

Manual focusing ring

Twist focal-length ring

Aperture ring (*f*-stops)

Autofocus focusing ring

Push-pull focal-length ring

Tripod ring (on most longer lenses)

Aperture ring (*f*-stops)

Some of the essential parts of these two Nikon zoom lenses, a 28-85mm lens (left) and a 75-300mm lens (right), are the aperture-setting ring, the manual and autofocus focusing rings, the twist and push-pull focal-length rings, and the tripod ring, which is available on most longer lenses.

Leaf shutters do have one advantage, however, that makes their design the choice of many photographers. This is their ability to synchronize, or "sync," with electronic flash at all shutter speeds. Most 35mm cameras with focal-plane shutters can sync with electronic flash to only 1/60 sec. or 1/125 sec., and medium-format cameras to only 1/30 sec. This is because the electronic flash has a very short duration, ranging from 1/750 sec. to 1/10,000 sec. or more. Since the light occurs suddenly and doesn't last very long at all, you have to be sure that the shutter is completely open when the flash fires. With focal-plane shutters, one door opens, and then a second door follows to close the shutter. Depending on the shutter speed, there are only a certain number of times when the first door is open completely before the second closing door begins its run, which is when the lens and flash are in sync. (In fact, because of this problem, designers make lenses with built-in leaf shutters for focal-plane cameras using 120 film. These in-lens shutters are fired after the focal-plane shutter is locked up or are first set off at a very slow speed to prevent them from interfering with the leaf shutter. These are generally referred to as *leaf-shutter*, or *LS*, lenses.)

The recommended electronic-flash shutter speed, called the *"X" setting*, is the fastest possible speed that you can use. But you can also take advantage of much slower settings to combine the freezing effect of fast electronic light with the effects of slower shutter speeds in available light. The only times that the entire film frame is exposed are when you use the "X" shutter speed or settings below it. If you set the shutter speed higher, you'll catch the second door and only part of the frame will be properly exposed.

The double-door design of a focal-plane shutter might be a somewhat limiting factor with flash, but it is the reason why you can attain much faster shutter speeds than you can with a leaf shutter. At very fast speeds, the focal-plane shutter resembles a slit moving across the film as the second door follows closer and closer to the first. This means that only a portion of the film is being exposed at any given moment of the exposure. In this configuration, the focal-plane shutter doors can fly across film at fast rates, up to 1/8000 sec., particularly across 35mm film. The leaf shutter, however, can only open like the petals of a flower and shut again in one motion. This limits the top speed to about 1/500 sec.

But the speed of the focal-plane shutter comes at a price. As the double-door slit moves over the film, it might catch a moving subject in different positions. For example, if a subject is moving fast from left to right in a scene and the shutter is moving in the same direction, the subject might appear shortened or compact in the final image at the point where it was overtaken by the shutter. Conversely, when the shutter moves in a direction opposite to that of the subject, a stretching of the subject might result in the final picture.

Although leaf shutters don't produce such distortions, they have their own idiosyncracies at high shutter speeds. Specifically, when you use small *f*-stops, such as *f*/22 or *f*/32 for 1/500 sec., you might get as much as 1/2 to 1 full stop more exposure. Test your leaf-shutter lens at its two fastest shutter speeds to see if that combination gives more exposure than moderate shutter speeds. For example, *f*/32 for 1/500 sec. and *f*/64 for 1/60 sec. should give you the same exposure. This *fast-blade phenomenon* is the direct result of the physics of a leaf shutter: the inertia of moving parts arriving at their closed position after traveling from a fully opened position, with the small center section of the aperture exposing the film for the entire period of the shutter movement.

MODERN CAMERAS AND LENSES

Today's cameras offer a wide variety of designs for different types of lenses. Conveniently, though, they share certain features. Basically all modern interchangeable-lens 35mm and medium-format cameras have bayonet-type locking mounts, which are usually designed to fit only one brand of camera. Large-format lenses are mounted to camera lensboards. You can release most bayonet lenses from the camera body by pressing a button to unlock the mount and then turning the lens until you can take it off easily. To put on a lens, you match up the colored dots on the lens and the mount, place the lens into the mount, and turn it in the direction opposite to the release direction until you hear a click.

The lens' distance scale mentioned earlier provides another piece of information. This is the *infrared correction line* or *dot*. Located just slightly to the side of the marker indicating your focus point, it is intended for use with infrared color or black-and-white films. Because this type of light doesn't focus at the same point as white light, you need to correct for it. Since you can see white light, you can make this adjustment by first focusing in the usual manner and then moving the focusing ring until the infrared marker lines up at the point where the white light was focused.

Beginning with the use of the first photographic camera in the mid-nineteenth century, all camera designs have

been governed by two somewhat conflicting functions: to view the scene by eye and then to "show" the film the same view so that it can record the image. Over the years, an ingenious number of ways around this paradox have been tried. Four basic camera designs have survived the process.

View Cameras. The first and oldest design is that of the *view camera*. Here, the lens focuses an image on a groundglass at the rear of the camera. You compose and focus this inverted, laterally reversed, and rather dim image, usually with the aid of a dark cloth to prevent the intrusion of extraneous light, while the camera is perched on top of a tripod. Then you place a single sheet of film in a light-safe holder in front of the groundglass in such a way as to allow the groundglass to move back. The film is now on the *focal*, or *film, plane* where the image was

focused. Next, close down the lens and the shutter, which were both open so that you could view the subject, set the exposure, and cock the shutter. Open the film holder facing the lens by withdrawing a thin dark slide; at this point, the shutter is released. All in all, this is a slow, laborious process in which the subject must be static and the photographer meticulous.

Why go to all this trouble when you can pick up a 35mm, motor-driven, auto-everything marvel? It is worth it to get an image that is unsurpassed in terms of both detail and overall quality? Furthermore, the view camera can control most of the apparent distortion that all other types of cameras produce. These are the cameras of choice for photographers who need to create the highest-quality images possible and to have maximum control over perspective, such as architectural and small-product photographers.

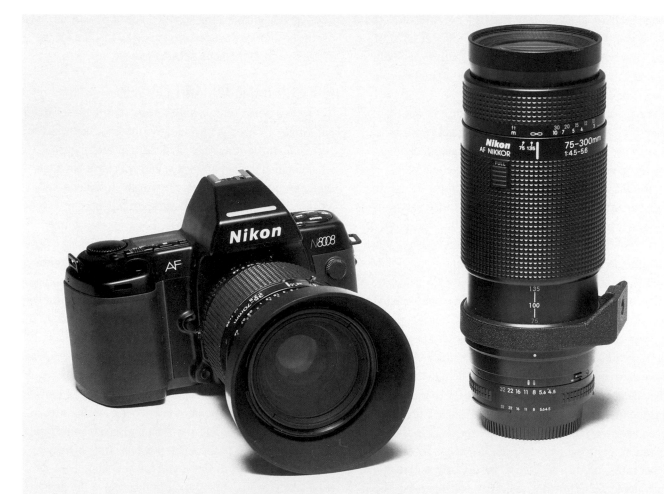

Part of the new generation of cameras and lenses is the "auto-everything" phenomenon. The 35-70mm lens on the Nikon 8008 camera (left) and the 75-300mm autofocus zoom lens (right) offer you several manual and autofocus metering choices, as well as many electronic options. These special features include automatic multiple exposures and the ability to estimate the speed of a subject when you use the autofocus option for action shots.

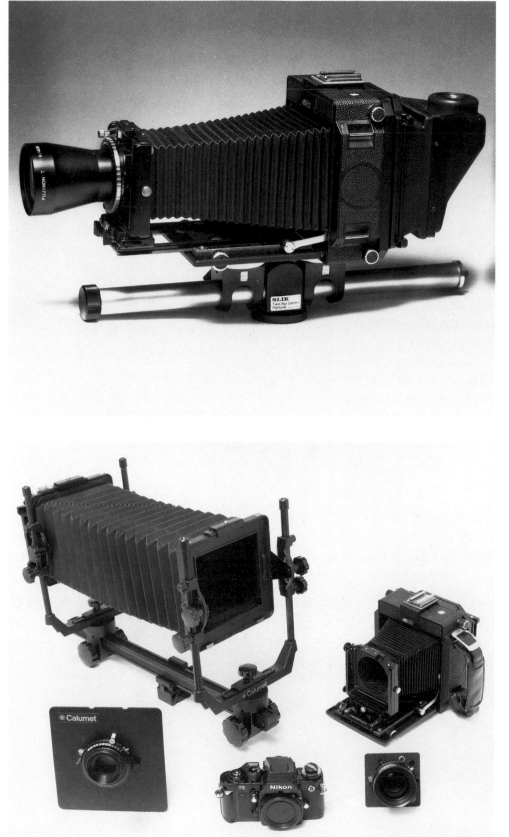

In large-format photography the size of the bellows extension should equal the lens' focal length, but long lenses sometimes exceed the maximum extension, or draw, of the bellows. The 400mm telephoto lens on the field camera is set at infinity even though the bellows is capable of only a 260mm draw.

In this shot, you can see several 4 × 5-inch large-format camera designs, from the Calumet monorail camera (top left) to the more compact Horseman field camera (top right). The field camera closes up like a clam shell to a size about twice that of a Nikon 35mm camera. Lenses are attached to lensboards (bottom left and right) and then clipped to the front of the cameras via various mechanisms.

Lenses for view cameras have certain characteristics that set them apart from most other optics. First, these large-format lenses have to be able to cover the largest film areas in photography. But because the lenses are often moved off-center when you shift the view camera's front up and down or from side to side, they must be able to cover more than just the size of the film format as in the unshifted position. Other design requirements are that the lenses have built-in shutters and can be attached to the flat lensboards that are fitted to the fronts of large-format cameras. In this sense, these lenses can be fitted to many different large-format cameras with just two restrictions.

First, the lensboard must be large enough to accommodate the lens shutter. On occasion, a smaller large-format camera won't be able to accommodate the large #3 Copal diaphragm shutter and/or the section of the lens attached to it that fits inside the bellows. Also, the lens' focal length must be within the limits of the bellows. Remember, a particular focal length is determined by the distance the lens needs to focus an object when it's set at infinity. So, for example, a 150mm lens on a 4 x 5-inch view camera needs a 150mm bellows draw. This isn't a problem because all general-purpose cameras can easily handle middle-focal-length optics. But you'll run into trouble when you start using very long

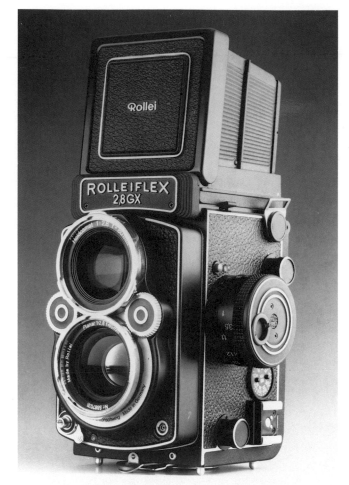

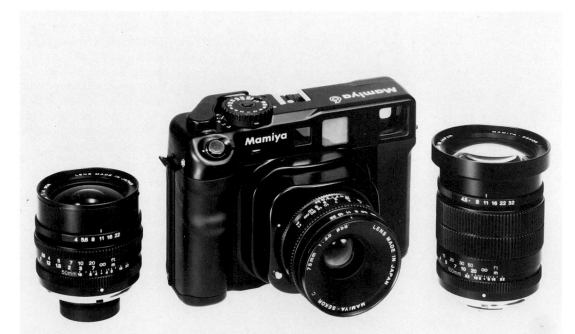

A few years ago it seemed that virtually all photography would be based on one camera design, the SLR. Today, however, such cameras as the venerable Rolleiflex TLR camera (above) and the Mamiya 6 interchangeable-lens rangefinder camera (left) offer photographers alternatives. Courtesy of H. P. Marketing and Mamiya America.

Fast lenses are valuable because they permit you to shoot in low-light situations and at faster shutter speeds when the light is ample. The tradeoff, however, is their larger size and additional weight. This is particularly true of telephoto and zoom lenses. To achieve sufficient depth of field while photographing Peter Wilkinson, the editor of *Photography Yearbook*, at work, I shot ISO 1000 film at *f*/16. Fast lenses and fast film enable you to photograph in just about any lighting situation.

telephoto focal lengths, such as 400mm or 600mm, on smaller *field* or *press* cameras. Because these cameras are more compact and as such are easier to use, they don't have the long-focusing ability that conventional view cameras do. Here you'll exceed the bellows draw, and you won't even be able to focus the camera at infinity, much less closer.

Rangefinder Cameras. This type of camera makes use of a separate viewing system based on a rangefinder. The camera's lens is intended only to take the picture, and the shutter can be either a built-in leaf shutter or a focal-plane shutter. The *rangefinder-lens principle* is based on looking at a subject from two points simultaneously. You'll see one of two results on the viewfinder. *Coincident-image focusing* occurs when two images of the subject overlap exactly. *Split-image focusing* results when two halves of the same image are brought together. Rangefinder focusing is very accurate at distances between 2 feet and 30 or so feet. Longer distances require much smaller changes in focus, which is sometimes difficult to achieve with either coincident or split-image focusing.

And at close distances, the problem involves camera design and mechanics. The triangle formed by the two views of the subject is squeezed together. Sooner or later, the demands of the closeup force the frame of one

of the viewing points into the picture; furthermore, the focusing mechanism of the lens can't easily make the minute changes necessary for exact focus. Another complication with rangefinder cameras is *parallax*. This takes place when you try to close-focus on an object with one viewing system and take the picture with another. The problem here is that the two systems don't see the exact same picture (see page 56).

Twin-Lens-Reflex Cameras. TLR cameras feature a unique approach based on the use of two lenses of the same focal length arranged one on top of the other. The upper, or *viewing*, lens, without any shutter or aperture, provides you with an image of the scene, and the lower, or *taking*, lens, complete with aperture settings, shows about the same image to the film when you open up by releasing the built-in shutter. The image is "about the same" because the taking lens introduces changes in depth of field and as with any system of two separate lenses, parallax can occur. No matter how close together the two viewing systems are, there is a slight variance in the view each has. For distant or moderately distant scenes, this difference isn't significant. But if the focusing distance is only about 10 feet, you have to adjust for parallax; if you don't, the image on the film won't cover the same area that you see in the taking lens. Many TLR cameras, particularly Rollie models, have an automatic parallax-correction feature, and the Mamiya C series cameras, which are the only TLRs with interchangeable lenses, also have a built-in correction factor that is indicated on the viewing screen by a pointer.

Single-Lens-Reflex Cameras. The most advanced camera configuration is the SLR design. This ingenious approach comes closest to solving the problem of viewing the image and taking the picture. Here, the image from the lens strikes a mirror, which then reflects it to your eye via a prism groundglass screen. The orientation of the view is correct—not reversed as it is with TLR cameras—and enables you to focus as you watch the subject. Then when you depress the *shutter-release button,* the mirror moves out of the way a split second before the shutter opens to expose the film. As such, only a single lens is necessary for you to both view and expose the film. Furthermore, this arrangement solves the problem of parallax.

CHAPTER 2

Composition

When photographers select a lens for a shot, they choose that particular optic because it gives them an advantage over other focal lengths. This might simply be a matter of convenience, as in the case of a zoom lens that makes changing focal lengths easy; otherwise, it might be a necessity, such as using a wide-angle lens to photograph a large group in a small room. But whenever possible, you should base lens selection on the lens' design and characteristics. These enable you to interpret and record reality the way that you want to see it in the final image. Lens selection, then, requires an understanding of how the lens treats such components as proportions, distance, and foregrounds.

In addition you have to take into account other influential factors, including where to place the camera, whether action is present in the scene, and how to record it. Then, too, there is the question of focus. Does everything have to be in focus, or can the composition benefit from certain areas being out of focus? Obviously, picture-taking involves much more than just snapping a lens on the camera and clicking away. There is a series of important steps—a process—with various points of departure that provide you with many opportunities to affect the outcome of the final image.

After you decide what to photograph, the single, most important step is lens selection. For this, you need to have a thorough knowledge of what a lens can and can't do. Such a level of appreciation comes first from understanding the technical characteristics of the lens, and then familiarizing yourself with it through use and experimentation. This doesn't happen overnight; it takes time and perseverance, as well as the acceptance of inevitable failures. Perhaps that explains why some lenses are purchased in a burst of enthusiasm and then are left on a shelf to gather dust when the expected results don't magically occur.

As this landscape photograph shows, wide-angle lenses typically spread out subject matter.

and Lenses

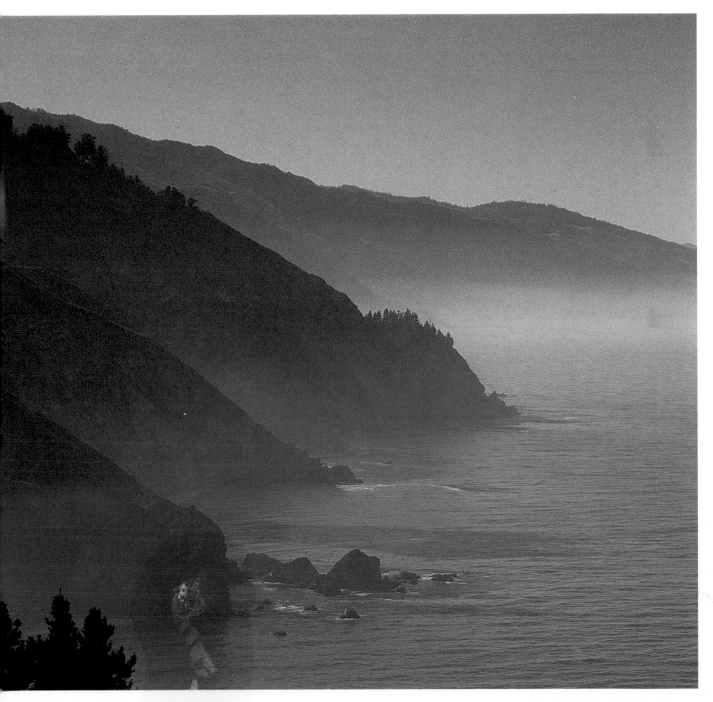

The best way to get started down the road of lens selection is to always remember that a photograph should reflect some sort of intention on the part of the photographer. This might be as vague as wanting "to capture beauty on film" or as specific as trying to show the intricate and interrelated textures of a species of lily. Whatever the reason, your intentions must merge with the equipment and materials of photography in order to represent a certain reality on film. Understanding what you want is imperative. The approach of a skilled technician favoring documentation is one option; a less concrete, more esoteric "artistic treatment" is another choice; and an approach that falls somewhere in between these two extremes is still another possibility. Whatever your intention and style, sooner or later you'll have to make specific decisions about what lens to use, where to put the lens in relation to the subject, and what *f*-stop and shutter speed to use to obtain particular depths of field and interpretations of action.

BASIC LENS EFFECTS

One of the main objectives of this book is to describe how specific lenses record the visual environment on film. So in terms of composition, you need to understand the fundamental optical properties that form the basic pattern for each of the three main lens categories: standard, wide-angle, and telephoto. These features enable you to achieve various effects as desired.

Telephoto and closeup lenses are credited with recording patterns more often than wide-angle lenses are. But for this photograph, I chose an ultrawide-angle lens to graphically isolate these large buildings.

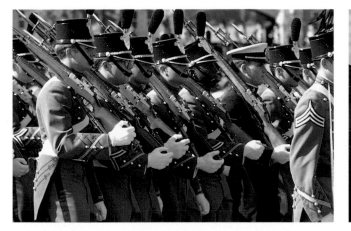

Unlike wide-angle lenses, which are ideal for sweeping vistas, telephoto lenses compress and magnify subjects (above right). For example, these marching Army cadets seem to be huddling around their visitor from the Naval Academy (above left). Wide-angle lenses exaggerate foreground subjects, such as the rocks at the Devil's Postpile in California (left).

Standard lenses are most likely to show a correct rendering of the people and their distance from one another. This is why they are the lenses most capable of recording a scene with the proper proportions and shapes of the geometric forms that make up the subject matter.

Telephoto lenses magnify the size of an object on film. They record less of the scene from a narrower angle of view than standard lenses do on the same piece of film. So what is there appears larger and in addition, the apparent distance between subjects seems to be smaller, causing a compression of depth. Think about this another way. You're looking down a street where a line of people are spaced 2 feet apart from each other and are standing perpendicular to your position. You see all this through a standard-focal-length setting on a zoom lens that can ex-

tend to telephoto. Then as you slowly move the zoom ring into the telephoto range, four simultaneous effects occur: magnification (the people get bigger and seem to draw closer to you); *compression* (the apparent distance between the people decreases as they're "pulled" in); the lens' angle of view gets smaller and smaller (you see less); and *f*-stop for *f*-stop, the depth of field decreases.

Not surprisingly, wide-angle lenses have the opposite effects. If you used a wide-angle lens to photograph the people standing on the street, they would appear farther apart as the angle of view increased and the depth of field would be more extensive. In the final picture people in the foreground would look much bigger than those in the middle or background, who would decrease progressively in size. This effect is *foreground dominance*.

TRANSLATING THREE-DIMENSIONAL REALITY INTO TWO-DIMENSIONAL IMAGES

Every photograph is an illusion in the sense that it is a two-dimensional representation of three-dimensional reality. That is, photographs have length and width, but no physical measurement for depth. This is something that the photographer must put in a picture by using such visual effects as depth of field. Parenthetically, photographs don't have the "fourth dimension" of time either. Fortunately, the human brain can be made to accept two-dimensional alternatives for the missing dimensions, al-

Framing a scene is determined in part by the combination of the film format, the lens' angle of view, and the camera viewpoint. But you can also use framing devices to achieve different effects. In this shot, taken with a medium-wide-angle lens, the branches and leaves act as a subtle framing device.

lowing you to feel comfortable with the legitimacy of the image you're looking at.

Everyone has heard the phrase, "The camera doesn't lie." Under some conditions that may be true, but for the most part a skilled photographer has to be keenly aware of how to translate three-dimensional reality, perhaps even with a sense of movement, so that viewers can believe the two-dimensional illusion the camera produces. The first step in this process is to organize and arrange reality, so that you can speak of it as a whole and understand the role of its parts. Usually, this means thinking about a subject in its visual environment: the background and the foreground. Since camera lenses have profound effects on all three compositional elements, you must understand how a particular optic treats each one.

Subjects. These are the part of the picture that attracts the most attention and are the reason the picture was taken. An advertisement might feature a beautiful car parked in the driveway of a large mansion, for example, and a fine-art, black-and-white photograph might show majestic, snow-capped mountains framed by clouds and set off by a mountain lake. Both pictures contain many elements, but the primary subject in each stands out and, therefore, attracts the eye. The most important subject is supported by and relates to the other parts of the picture, including the foreground, background, and secondary subjects.

One of the critical roles of photographic lenses is to help draw the viewer to the center of interest in a composition. Telephotos bring the main subject closer by magnifying its size on film, and wide-angles show it within a complex environment framed by the foreground or background.

Foregrounds and Backgrounds. Backgrounds and foregrounds, as well as secondary subjects, can play many different roles in composition. They might be vital, just supportive, or nonexistent. Single-subject formal portraits often have no foregrounds, and backgrounds that are simply white seamless paper. If a background and a foreground are present in a scene, the type of lens you use can significantly affect their visual relationship to the subject. For example, wide-angle lenses tend to

Because depth of field is one of the most important tools of photographic composition, giving some thought to it for almost every shot is essential. I used a moderate-telephoto lens in order to isolate this member of an honor guard by throwing the background out of focus (above). I approached the shot of the tree branch the same way, but because I was working with a standard lens, I had to get much closer (directly above).

exaggerate foregrounds and reduce backgrounds; how much and in what way depends on their angle of view and their placement. In fact this exaggeration is so pronounced with wide-angle lenses that the phenomenon is called foreground dominance (see Chapters 3 and 4 for more information).

Backgrounds are often overlooked by many beginning photographers because they are farther away from the main subject, so there is less interaction between them. But backgrounds are critical because their positions— behind and/or above the subject—provide a frame for the subject, so be careful not to ignore them. You don't want to be disappointed with a photograph because you "didn't see" the tree branch that appears to be growing out of a subject's head.

Before you select a lens, you should have some idea of the relationship that exists or is intended between the subject and its environment. When you shoot a portrait, your purpose might be to take a photograph that includes the person's work place; in this situation, objects, such as tools, are probably in prominent positions in the foreground. Furthermore, you might want the background to form a frame around the individual to give a sense of place. At other times, you might want to try a completely different approach, making every effort to isolate the subject to convey a strong feeling of loneliness or detachment. Experienced photographers often make these types of decisions first, and then they select the lens or camera position accordingly. Your choice controls, or at least strongly influences: *framing*, or what to include in the picture; *viewpoint*, or where to place the camera; depth of field, or what and where to focus on; and shutter speed, or how to deal with action or change if either is present in the scene.

Framing. After you determine what to photograph, the first compositional choice you usually make is the framing, or what you want in the picture. Many photographers make this decision cognitively while scanning the scene. By and large, though, most photographers start composing by moving around and/or changing focal lengths to see the effect. Framing depends on both the lens' angle of view and camera viewpoint. As you'll discover, this is a critical point in picture-taking.

To isolate the primary subject in this image, I shot from a low perspective with a full-frame fisheye lens.

There are usually two framing scenarios: photography by discovery and photography by design. In other words either you come across a situation or object that catches your eye, or you get an idea for a specific composition. In both cases, you should first identify the main subject. For example when you "discover" an image, you might notice the way that sidelighting accents the texture of an old barn or how a friend's laugh triggers a responsive chord. The challenge is translating your perceptual experience into a photograph. Most often, photographers raise the camera to their eye and start looking for the right framing. It is at this point that the more experienced and skilled photographers are separated from other picture-takers. Inevitably, they take the time to understand exactly what has attracted their attention and think more about how to best present it. This takes patience, discipline, and a bit of introspection, to say nothing of an understanding of photographic composition and what a specific lens can offer in a particular situation.

Framing a shot should be a flexible process. I call this the "mind vs. machine" stage: resisting just for a few moments the temptation to look through the lens in order to think more about what it is that you want to photograph. This also applies to situations in which you have an idea for a picture. As a matter of fact, in these scenarios you're more likely to think the image through and consider how to carry it off. Although this approach is too slow for a "critical-moment" picture that requires you to act quickly or lose the shot, the more expert you become at the deliberate approach to photography—the more likely you'll be able to automatically determine framing, camera viewpoint, and focus in a situation demanding fast shooting.

Camera Viewpoint and Perspective. The selection of the angle of view produced by a particular focal length to include what you want may change as you look for a camera viewpoint. This is because perspective depends on where you place the camera. For example if you first position the camera parallel to the ground and at eye level, you can either tilt the camera up or down, or raise or lower your position, such as by going up on a roof or kneeling down. All of these positions can be extreme. The worm's-eye view results when the camera is on or very near to the ground, and the bird's-eye view is obtained when the camera is almost overhead.

The type of lens used only refines the *perspective*; it won't change it. But changing the viewpoint, and therefore the perspective, is almost like having a built-in lens modifier. It enables you to easily change the appearance of objects within a scene, as well as the scene itself. I am always amazed by how many different interpretations one lens can give you if you just change the camera position. Some photographers call this "working for the shot," and rightly so. You're certainly concentrating and searching. Most photographers also shoot during this step to see what type of image each position-and-lens-choice combination will produce on film. Spending time afterward analyzing and evaluating the results can provide excellent feedback. It is one of those special efforts a photographer makes to learn more about creating images.

Camera viewpoints influence the appearance of a subject in relation to the ground. In these high-angle shots, the subjects look unusual because they weren't photographed straight-on. In the closeup of the little girl, taken with a standard lens, the camera viewpoint emphasizes her cherub-like face (left). Similarly, by shooting down on the surfer, I was able to record a different view of the action as he struggled to stay in control (below).

Apparent Distortion. One outcome of changing the camera angle frequently is the risk of producing apparent distortion in the photograph. For example, tipping the camera up or down from a level position causes straight lines of the subject, such as a building, to *converge* in the direction of the tilt. Like a pyramid, objects at the base of the picture appear larger on film than those in the direction of the tilt at the peak. This is because the film plane, which was originally parallel to the plane of the subject, now runs on a diagonal to the subject. Here, the basic law that close objects appear larger than identical objects farther away holds true. Specifically, in the tilt-up position the top of the frame is farther away from the building, while the bottom is closer. In essence, the top half of the photograph is being taken at a slightly wider angle than the bottom half. If the camera is tipped downward, the reverse is true; the effect might seem different, however, simply because you are very close to the ground.

All lenses produce this convergence effect, but wide-angle lenses really can exaggerate it because of their propensity for expanding the size of foregrounds and any objects in that part of the image. For some photographers, this is a dramatic compositional option; for others, it is heresy. Cameras whose lenses and film backs can be shifted and tilted in relation to the film plane are able to correct for this (see Chapter 5).

Apparent distortion also occurs when you raise your camera position to a higher point or even to a bird's-eye view, as in photographing people. In this situation the subjects' height is compressed, so heads and bodies seem to merge. And because there rarely are foregrounds from very high viewpoints, subjects often seem to be part of the ground on which they're standing. Compositionally you have to give viewers a two-dimensional reference point, such as shadows cast by the subjects, in order to suggest the separation between the subjects and the background.

Lens selection in these situations is difficult since telephotos further compress the composition, while wide-angles produce what some photographers refer to as the "space-helmet effect." This occurs because wide-angle lenses tend to exaggerate objects closer to the lens. Using a wide-angle lens in this case would produce people with huge heads on small bodies. The best choices are lenses that come close to maintaining a normal perspective of size; these are standard, moderate-wide-angle, and moderate-telephoto lenses. If you want to play with

Such distortions as converging lines or foreground exaggeration are shunned by some photographers and exploited by others. For this shot of a Slavic church I used a medium-wide-angle lens and a low angle to produce both of these effects. I also chose to solarize the print to reinforce their unreal quality.

proportions, the more extreme lenses are the way to go.

The worm's-eye view, on the other hand, is a unique situation because the ground dominates the bottom half of the picture. You can avoid this by tilting the camera up. But the point of getting that low is often to photograph a subject on the ground or a view that includes the ground. The main problem here is depth of field since the ground runs right up to the lens in the picture. Wide-angle lenses produce the most depth of field, but keep in mind that they exaggerate foregrounds. Long telephoto lenses are a real problem in this regard because of their shallow depth of field, while moderate-angle lenses obviously fall somewhere in between.

The easiest way to change the angle of view without changing focal lengths is to move in close or back. But many photographers neglect—or forget—this simple technique. Once some people raise a camera to their eye, their feet take root. This is especially true when the camera lens is a zoom. One of the most effective ways to

control composition and determine the proper focal length for a shot is to see what moving in and out does to the composition. This practice can greatly expand the usefulness of these lenses (see page 79).

When you come in close to a subject, there are new factors to consider. For example when you use a standard lens, the size of the subject shows some apparent distortion. The natural look you are able to achieve shooting from, say, 10 or more feet begins to give way to both the exaggerated appearance of near subjects and a significant loss of depth of field. Wide-angle lenses have the advantage of offering greater depth of field, but they actually increase the already inflated size of close subject matter and make the apparent distortion of the subjects' shape much more noticeable. Telephoto lenses, especially moderate to long ones, magnify the subjects, maintaining a more natural look, but they decrease depth of field. This decrease may not be, however, any more or even as great as really coming in close with a standard lens.

The Horizon Line. In most landscape photography the camera viewpoint has a major effect on the placement of the *horizon line*, which is the point where the earth and sky meet. And lens selection has an impact on foregrounds, backgrounds, and subjects in relation to the horizon line. If the viewpoint is low or if the camera is tilted down, such as in a beach shot, the foreground spaces will dominate the picture; here these are the areas below the horizon line, the sand, and the people lying on it. Wide-angle lenses amplify this effect. Furthermore if the angle of view is extreme, there might be a bend in the horizon line. Changing the camera viewpoint to a high level or tilting it up reverses this effect; now the sky dominates.

The placement of the horizon line in a composition divides the picture into parts. This is further influenced by the choice of lens. For this shot of the moon, I decided on a medium-tele-photo lens to "bring in" the mountains in the lower half of the image (above). I wanted to keep the tree small in relation to the large negative space of the mist-covered lake, so I selected a moderate-wide-angle lens (top right). To capture the reeds at sunset, I used a moderate-telephoto lens (bottom right). I placed the horizon line at just about the center of the image to reinforce the evenly balanced geometric proportions of this scene.

It is common practice to avoid placing the horizon line in the dead center of an image because this divides the picture into two equal parts. This, in turn, creates a doubt about where the center of interest is and gives the impression that there are actually two pictures within one frame. (The important exception to this are panoramic photographs, which use the horizon line as a reference point for composing vistas. When shooting panoramas, photographers usually try to keep the horizon line undistorted and somewhere near the middle of the picture in order to establish a line of continuity for such expansive compositions as skylines and mountain views.)

Rule of Thirds. Placing the horizon line high or low within the frame is based in part on the *rule of thirds*, a technique of visual organization used by painters for centuries. While this is more of a guideline than a rule, its premise is that an image is more pleasing to the eye if the frame is divided into horizontal and vertical thirds.

Furthermore, the intersections of these lines are strong centers of interest.

Negative Space. What actually happens when you apply the rule of thirds is a kind of visual organization that uses either subjects or space to establish a balance within the frame. For example, you might decide to include *negative space* in a picture. This is composed of large areas that are chosen not because they have eye-riveting value, but because they don't. These areas are uniform, as in the side of a building, or are empty or dark, as in large shadows. A typical use of negative space is to place a person at one of the horizontal-vertical intersections and throw the rest of the picture out of focus. In this situation, manipulating depth of field via large *f*-stops with a standard or telephoto lens is the easiest way to create negative space.

The key to using negative space is to avoid subject matter that is too busy in its own right, or in some way

RULE OF THIRDS
The rule of thirds is meant to help organize a composition, not dictate it. While composing this scene with a moderate-wide-angle lens on a 6 × 7cm camera, I liked the combination of the woman, the windows, and the tapestries, and eventually found a viewpoint that balanced them. Each of the three elements fell into one of the horizontal and vertical thirds of the final picture.

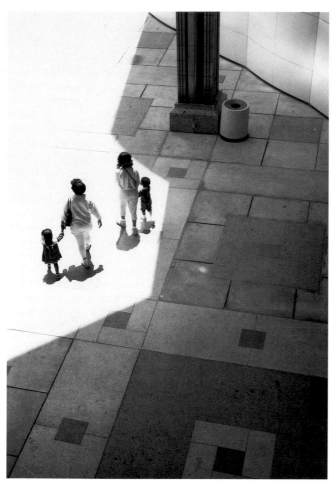

Photographing these people from a high angle enabled me to effectively use the negative space in the light and dark areas.

distracts from rather than helps in balancing the subject. The best choices are very dark areas or ones with uniform patterns or textures. The question of whether to keep the area in or out of focus is up to you. Generally out-of-focus compositions impart a stronger sense of isolation, while focused arrangements show more of a relationship with the environment.

There are, of course, many situations when these guidelines don't apply, such as large group shots. Here, you have the problem of getting everyone into the picture. But even in these cases, the people are usually arranged so that their heads are on or near the upper horizontal line. It is, in fact, disturbing to see a group shot in which people's heads touch the top of the frame and the rest of the figures dominate the image.

Balance. For a photograph, *balance* shouldn't be compared to the mathematical concept of equality because this comes too close to giving the impression that a picture can be divided into definite parts with very specific values. I've seen this done in attempts at analyzing composition, and the result for me robs the image of its real visual quality and reduces it to items on a scale. A better way to think about balance is to use the concept of *completeness.* Here, the image conveys its message or makes its impression by effectively using all of the space within the frame in a variety of ways.

A standard lens allowed me to create the sense of balance and the completeness of this nude portrait.

Balance, therefore, comes from using tone, color, form, focus, perception, and viewpoint to construct an image in which viewers see something, are attracted to it, and are moved by it. So balance is part of the final picture. In fact, it is as much a part of the composition as the subject, foreground, and background—whether you're creating a photograph from an idea or capturing an image that comes your way. And lenses enable you to manipulate the components of the picture through such effects as magnification and compression in order to achieve the completeness of your intention.

Size Perception. One of the most effective ways of obtaining some sense of value, or importance, among the parts of photographs is through *size perception.* This is controlled by two factors: the actual size of the subjects and how close to or far away from the camera they are. The type of lens you select significantly affects both of these. For example, wide-angle lenses see more of a scene and, accordingly, increase the distance between subjects. This, in turn, makes distant subjects seem farther away and smaller. Conversely near subjects move even closer to the camera, and their proportions seem larger in relation to the rest of the scene.

Suppose that you choose several lenses in a range of focal lengths to photograph two subjects that are 25 feet apart. After each picture, you change the lens but move the camera so that the closer subject always appears the same size in the viewfinder. As a result, the more distant subject seems to move farther away as the focal length decreases and the angle of view increases. If you reverse the procedure and keep the farther subject's size constant in the viewfinder with each lens change, the result is a continual increase in the apparent size of the close subject as you use a wider and wider angle. The angle of the lens allows you to separate the two subjects and emphasize one instead of the other.

Keep in mind that the camera's angle of view is level in these illustrations. If you use a low or high angle, you would be able to change the dominant subject's proportions as well. For example, a low angle would make a person's legs seem longer, while a high angle would make the head and shoulders prominent. But even if you position the camera straight-on, there is a greater possibility that the subject would be distorted as it seemed to get closer and closer. For example, any part of the subject near the camera would be exaggerated in size, such as an outstretched hand.

Here I needed a medium-wide-angle lens in order to take in enough of this large circular room to give a sense of its actual size.

What happens when the angle of view narrows? Telephoto lenses are designed to magnify the size of a subject on film. In the vernacular of snapshooters, telephoto lenses bring everything closer. But they also change the perceived distance between subjects in a scene. If you repeat the size-perception exercise using telephoto lenses, two forms of compression would occur. When you keep the close subject's size constant in the viewfinder, the distant object appears to come closer as the lens' focal length and the telephoto effect increase. Conversely when the distant subject's size remains the same in the viewfinder, the near object draws closer to the distant one.

The ability of telephoto lenses to magnify and compress the size differences between separated subjects on a line moving along the lens' axis in the picture gives you the compositional option of "placing" objects that are scattered in a scene closer together. You can also increase the apparent proximity of subjects that are already close together to the point of making them seem right next to or even touching each other.

Depth of Field. One important side effect of wide-angle-lens expansion and telephoto-lens compression is the change in the perceived depth of field. Since the depth of field increases with the wide-angle effect, you are less likely to have dramatic drop-offs in focus that allow you to isolate a subject. In fact, with ultrawide-angle lenses, the hyperfocal distance may be as small as a few inches. This means that you'll have to rely more on the exaggeration of size to lead the viewer's eye to the center of interest rather than on any effective changes in focus through the depth of field. You can also take advantage of the increased depth of field to draw attention to the center of interest. For example, foreground lines running roughly parallel to the lens' axis will appear to converge into the picture—and will take the eye of the viewer with them.

The opposite happens with telephoto lenses. Here the depth of field narrows with both the decreasing angle of view and greater magnification, enabling you to isolate a subject quite easily. But the magnification multiplies the effects of camera shake, forcing you to shoot at faster shutter speeds when handholding the camera. Consequently, you need to use wide apertures to offset light loss. So you must pay very careful attention to focusing. (Wide-angle lenses, on the other hand, offer less magnification and greater depth of field; this makes focusing far less critical and handheld shooting at slower shutter speeds less prone to camera shake.)

Remember that size perception and depth of field are the result of a lens' two-dimensional translation of three-dimensional reality. You aren't reducing the actual depth of field and size; you're just using lenses to manipulate the appearance of distance through focus and size changes. So in the example in which two subjects are 25 feet away from each other, that distance never really changes no matter how close the subjects look in the photographs. If you were to take a 35mm photograph of the two subjects with a 50mm lens and a 200mm lens and print them both full frame, the 50mm image would show more of the scene and a greater space between the subjects than the 200mm shot. If, however, you enlarged the 50mm shot to take in only the area around the subjects as in the 200mm shot, the two prints would look exactly the same.

Slow vs. Fast Shutter Speeds. Photographers can add the illusion of movement to a picture or show a moment of time that is usually beyond regular perception in a number of ways. Manipulation of shutter speeds is a particularly effective method, which offers two basic choices and

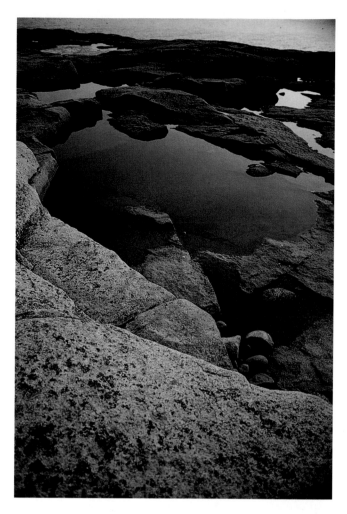

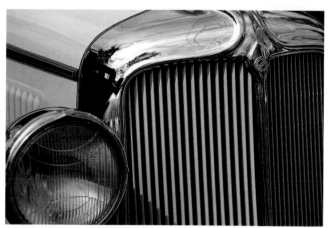

Determining depth of field must be done carefully. This photograph of rocks shows how you can use an ultrawide-angle lens to hold an entire image in focus (above). But in the car shot, taken with a moderate-telephoto lens, the headlight falls just out of focus (directly above).

many variations. One way is to use very fast speeds to capture something on film you might otherwise miss or to give you time to examine an event that happens too quickly for you to savor. This is called *stop action* and usually requires shutter speeds of at least 1/250 sec.

Stop-action shots have been a mainstay in sports photography and photojournalism for years. In addition to fast shutter settings, high-speed flash has been used to freeze very fast events, such as a bullet passing through an apple or the details of a single drop of milk hitting the surface of a glass of milk. For average photographers, shutter-speed settings of 1/500 sec. or 1/1000 sec. are sufficient for recording interesting, frozen moments in any number of action situations. And the newer cameras

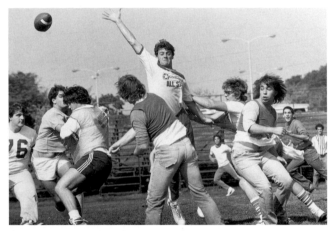

Stopping motion via a fast shutter speed is most effective when you also capture a critical moment. For this picture of intramural football players taken from a rather short distance, I used a 105mm lens set at 1/250 sec. to freeze the action.

with top speeds of 1/8000 sec. increase the opportunities for capturing such moments in razor-sharp detail.

Another option is to provide a sense of motion by allowing parts of the picture to blur and relying on the brain to interpret such an effect as movement. This is called *implied action.* Slower shutter speeds can capture everything from the slightest hint of movement in a picture of a couple slow-dancing photographed at 1/30 sec., to what seem to be eddy currents around the moving arms and legs of long-distance runners in an abstract picture shot at 1/2 sec. These latter shots are done by *panning,* a technique in which you follow the subject with the camera while taking the picture. As a result, the background and the most active parts of the subjects (here, the runners' arms and legs) blur and streak. Their bodies, however, stay in fairly good focus because the camera moves at the same speed, and the runners usually hold their trunks rigid. Another popular approach is to pan a car moving perpendicular to you at shutter speeds of 1/30 sec., 1/15 sec., or 1/8 sec. In this case the background and car wheels blur, but the body of the car remains sharp.

Subjects moving toward the camera show far less implied action because they change very little in relation to both the background and the camera. You can, however, take advantage of the blurring of subjects that move parallel to the still camera by putting it on a tripod (this keeps the background sharp), and by using very slow speeds, between 1/2 sec. and 1/8 sec., while shooting moving subjects to form streaks and long blurs.

For this shot of a car approaching a toll booth, I used a 75-105mm true zoom lens set at 1/8 sec. to produce a streak effect.

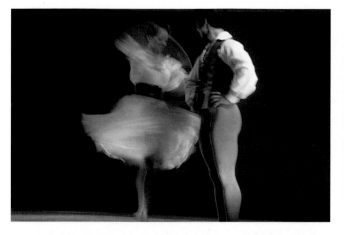

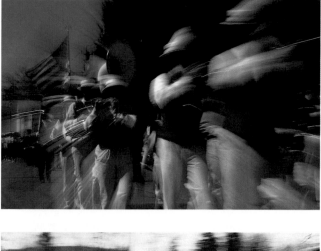

Shooting at slow shutter speeds can result in blurring, thereby creating the illusion of motion in the final images. One way to imply action is to place the camera on a tripod before you shoot, which I did when photographing these dancers (top left). While photographing both the members of the marching band (top right) and the football players (bottom left), I held my camera still and moved the true zoom-lens ring on my camera. The picture of the tombstones and fence was taken from a slow-moving car as the photographer looked back at his subject. Courtesy of Tom Zetterstrom (bottom right).

One especially striking effect results when you photograph a moving crowd, such as at a busy train station, and ask one person to remain perfectly still. With an exposure time of several seconds, the crowd appears as blurred swirls around the still subject.

You can also combine stop-action and blurring at relatively moderate shutter speeds. This is possible when the main action reaches its peak, such as two people jumping for a basketball and hanging in midair for a split second during a game while the other players are still moving fast, or a couple on a dance floor holding a move for just a moment, while the rest of the dancers continue to move. You can record this type of situation at shutter speeds of 1/15 sec. or even 1/30 sec. for a subtle effect, and at much slower speeds for a very dramatic rendering. Incidentally you usually want to capture the peak moment of action even in fast-shutter-speed shots, not only because this gives you sharper pictures, but also because

that precise moment often is more dramatic than the awkward, confusing actions preceding it.

Dynamic Angles. You can give the impression of movement in a picture via methods other than shutter-speed manipulation. The most common approach is to use camera views that capture some vital quality about the subject. For example, a photograph of a parked car can be static or dynamic based on the framing, the lens, and the camera's point of view. Choosing a view that is straight on, level, and distortion-free reinforces the "subject at rest" impression. For a less static arrangement move in close at a diagonal angle so that the car seems to be about to lunge forward. A wide-angle lens can enhance the dynamic quality by enlarging the front of the car as if it were aiming directly at the viewer. Such compositions suggest that the subject has the potential for movement, rather than try to convey the motion itself.

COMPOSING ACTION SHOTS

You should keep in mind some compositional refinements when you use shutter speed or a dynamic angle to show movement. For example when you pan a subject moving perpendicular to the camera at slow shutter speeds, the impression of forward motion is increased if you place the subject in the right-hand portion of the frame, so that it appears to be moving into the picture. The negative space in front of the subject now acts as the *path of action*. This is also true of situations in which you blur the action via a slower shutter speed. Allowing for a path of action produces a more balanced arrangement: the final image is more complete than one in which the subject seemingly runs into the edge of the frame, thereby cutting off its projected flow of movement.

Timing is everything in an action shot, whether you want to catch the peak moment of action or carefully arrange the subject in the frame. Lens choice affects timing in a number of ways. Very long telephoto lenses are capable of magnifying and seemingly bringing subjects closer so that you can isolate them. But these lenses also, in a way, magnify the speed of the action; if the subject in the viewfinder moves even slightly, it can whiz out of view. This can make it very hard to stay with your subject. And all of your movements with the camera are magnified, making small refinements more difficult as well.

Another point to remember about composing action shots is that the narrow angle of view blacks out the rest of the scene. This eliminates extraneous visual cues, so that you can better anticipate the action of the subject. For example, trying to follow a ball that is being passed often from player to player is very hard. You don't know who will get the ball next. This is why the best sports photographers are those who can anticipate the action, which is something that no lens can do for you.

Although selecting the most appropriate lens for action shots depends largely on the conditions of the shot, there are certain guidelines. In general, shorter wide-angle lenses aren't as effective as moderate-focal-length lenses for shooting pan-blur pictures because they force you to get too close to the action. Furthermore, their extraordinary angles of view require the subject to be moving very fast in order for you to get significant blurs. The lower the magnification (the wider the angle of view) the less blurring there is because the subject has far more of the frame to cover than a subject photographed with a telephoto lens, where one or two steps take the subject out of the picture. There are some unique exceptions to this. For example, sitting on a merry-go-round enables you to be close to your subject. To take in the whole figure, you might choose a wide-angle lens. And because you are so close to the subject, the moving background will more likely blur because it isn't that far away. Furthermore, the distortion of the subject—a result of the lens' short focal length—might add to the whole effect of motion.

In general, the differences in depth of field between wide-angle and telephoto lenses aren't particularly critical in panned shots since everything in the background and foreground blurs anyway. Sometimes the fact that the background is within the focus range causes the streaks to be sharper or more like straight lines. In subject-blur, slow-shutter-speed shots, backgrounds and foregrounds are often your only reference points for what is and isn't moving in the scene. Therefore, having them in focus or,

To photograph this intramural hockey game, I used the 200mm setting on an 80-200mm zoom lens. While composing the shot, I left some negative space to the right of the players to provide a path of action.

MOTION-STOPPING SHUTTER SPEEDS FOR STANDARD-FOCAL-LENGTH LENSES

Speed		Type of Motion	Distance		Direction of Motion		
MPH	KM/Hr		Ft	M	Horizontal	Diagonal	Vertical
5	8	Slow walk, hand work, sitting or standing people	12	4	1/500	1/250	1/125
			25	8	1/250	1/125	1/60
			50	16	1/125	1/60	1/30
			100	33	1/60	1/30	1/15
10	16	Fast walk, children and pets playing, horses walking, slow-moving vehicles	12	4	1/1000	1/500	1/250
			25	8	1/500	1/250	1/125
			50	16	1/250	1/125	1/60
			100	33	1/125	1/60	1/30
25	40	Running, sports, very active play, horses running, vehicles moving at a moderate speed	12	4	1/2000	1/1000	1/500
			25	8	1/1000	1/500	1/250
			50	16	1/500	1/250	1/125
			100	33	1/250	1/125	1/60
50	80	Fast-moving vehicles, birds flying, race horses running	25	8	1/2000	1/1000	1/500
			50	16	1/1000	1/500	1/250
			100	33	1/500	1/250	1/125
			200	66	1/250	1/125	1/60
100	160	Very fast-moving vehicles	25	8	—	1/2000	1/1000
			50	16	1/2000	1/1000	1/500
			100	33	1/1000	1/500	1/250
			200	66	1/500	1/250	1/125

Estimate between table values.
Courtesy of *Kodak's Encyclopedia of Practical Photography.*

conversely, forming sharp streaks, is more important here. This is another good reason for using the more moderate focal lengths rather than a telephoto: you'll be able to see more of the surroundings.

Using fixed-focal-length lenses for action shots limits you to a certain distance range, which can be a problem when you're photographing such sports as soccer, hockey, or baseball. Under such wide-open conditions you have to pick a spot and shoot within a certain action zone, such as the hitter's box in baseball or the goalie's net in hockey. This is precisely what many sports photographers who work with very long telephoto lenses do. Sometimes they have another camera with a short lens or a zoom lens ready to shoot a second, much closer zone. Not surprisingly, longer-zoom lenses are popular with many sports photographers. The ease of moving from one focal length to another is a distinct advantage. In this regard, however, variable-focus zooms aren't as effective as the faster-operating, true zooms.

Both designs, however, give you the capability to do *zoom streaks.* This is a unique way of suggesting a sense of motion, especially with subjects standing still or moving directly toward the camera. Simply set a slow shutter speed, between 1/15 sec. and 1/2 sec., and during the exposure activate the zoom mechanism. The result is a series of streaks zeroing in on the subject, who is fairly sharp.

To create an effective zoom streak you must first make sure that there is something in the background or foreground that will blur into streaks, and that the zoom range between the shortest and the longest focal length should be at least a 1:3 ratio to give some length to the streaks. Focus your zoom on the subject at the longest focal length first, and then pull it back before the actual exposure. Finally, you must use a shutter speed slow enough to take in the whole zoom while still keeping the subject sharp. While zoom-streak shots are usually spontaneous, using some form of support, such as a tripod, improves the pictures. Variable-focus zooms often don't hold their focus from one end of the scale to the other. You might find yourself with a slightly blurred image when pulling back. Use aperture settings that produce extensive depth of field to hold focus.

USING FOCUS PROPERLY

The center of interest in any photograph is that part of the image that attracts the viewer's eye. For example, bright colors and sharply focused objects are more appealing than neutral grays and out-of-focus areas. Saying that in *every* photograph the main subject is always in focus is too rigid, but this usually is the case. As you decide to center the optical focus, you should think of that spot as a plane extending across the entire frame, parallel to the film plane. Since the depth of field follows that plane, if the sharp area extends, for example, 15 feet behind a subject in the center of the picture, it extends the same length at the edges. (An exception to this occurs when a lens aberration, such as astigmatism or field curvature, is present.) Assuming that your lens is sufficiently corrected and aberrations aren't a factor, your primary consideration is to determine exactly how your camera position will affect what is in and out of focus within the plane of the depth of field.

Suppose you're photographing a house. For the first shot you position the camera so that the film plane is parallel to the front of the house, which is 40 feet away. The hyperfocal distance is 30 feet and the depth of field extends to infinity, so there isn't a problem. Next you move the camera to photograph the side and front of the house, and its front runs diagonal to the film plane. Moreover the corner is now only 25 feet from the camera, which is outside the depth of field. Almost automatically you'll probably refocus so that the corner is sharp.

But where is the new center of focus? That is a critical question. A quick focusing change like this often ruins the final picture because no thought was given to the shift in the depth-of-field plane, which is a result of moving the focus point closer to the camera. This could conceivably reduce the far portion to a distance less than infinity, throwing part of the background out of focus. The solution is to make sure to always check the depth of field with each camera-viewpoint change, either by looking through a stopped-down lens via the preview button or by using the distance scale on the lens.

This highlights how essential it is for you to think more about exactly where in the picture you're choosing to focus. More often than not, it is where the center grid of the viewfinder is placed as you frame the subject and choose a camera position. But the focus point also determines the radiation points for depth of field. In both 35mm and medium-format SLR cameras, the scene in the viewfinder is at the shallowest depth of field because almost all SLR models now have automatic diaphragms. As a result, you're always focusing at the maximum *f*-stop until you take the picture. Even though you are cognizant of this, there is the possibility of assuming that the scene your camera shows you is the one you will get, particularly when shooting fast.

Photographers who use view cameras might also be affected by wide-open-aperture composition. Their lenses are routinely set at maximum *f*-stops to make the groundglass image as bright as possible when they focus. However, most view-camera users make it a practice when composing to stop down to the exposure setting in order to check the depth of field. Photographers who use rangefinder cameras have the opposite problem; most of these viewing systems show maximum depth of field, so everything is in focus. This is the nature of the rangefinder viewer, which has no provision for aperture changes and their effects. TLR cameras are equipped with a viewing lens that may match the maximum aperture of the taking lens or be within one stop of it; again, there isn't any provision for seeing the effects of *f*-stop changes. Keep in mind, too, that if you change *f*-stops, such as when you bracket exposures, what is in and out of focus in the image will also change.

Clearly, action photography puts great demands on your ability to accurately focus and compose simultaneously. This takes quite a bit of practice and concentration, especially with longer-focal-length lenses. One technique is to *zone*, or *spot, focus*. Here you get into position and prefocus on one, two, or three areas where action is sure to take place. To do this, aim the lens at the area, focus, check the depth of field, and then note where the center of focus is on the distance scale. As the flow of action proceeds from one spot to another, you simply move the focusing ring to a specific number on the distance scale and start shooting, concentrating on composition.

A variation is to find a spot in the zones and to quick-focus on that rather than try to follow the action. Suppose you're photographing a basketball game using two zones. One is a close zone in which the spot-focus point is a painted line on the floor that forms the "key" of the court. The other zone is a far spot at the top of the key. Using an 85mm or 105mm lens on a 35mm camera with a motor drive, you shoot body-contact pictures at lower key positions and such wider compositions as defensive plays on a ball handler at far positions. Zone focusing is an old photojournalism technique, calculated on the basis of hyperfocal distance. Street photographers use it as well, prefocusing

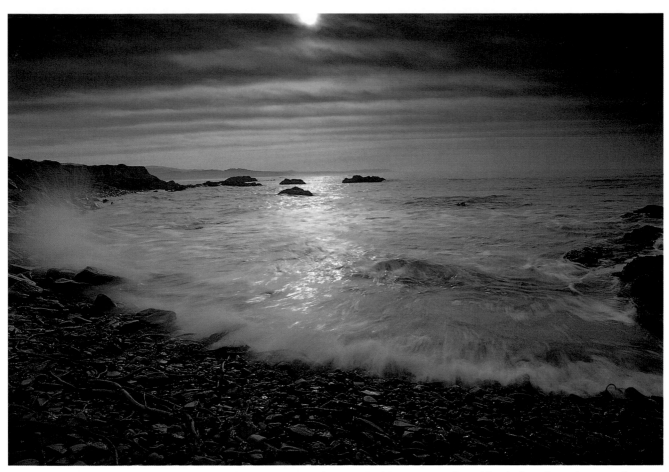

In order to capture the action of the wave, which is the center of interest in this seascape, I combined a low viewpoint, a moderate-wide-angle lens, a high horizon line, and a slow shutter speed. Flare was controlled by the clouds, a magenta filter, and slight underexposure.

their cameras so that all they have to do when somebody comes into their zone is raise the camera and shoot before the subject has a chance to react.

A note of caution about zoom lenses. Many photographers zoom in on a subject to critically focus and then zoom out for a wider composition. Whether your lens is a true zoom or a variable-zoom lens, you can't be sure that focus remains the same from one end of the zoom range to another. Check your lens by testing. Perform this procedure with your camera at its widest opening, and check the focus for the two extremes in the final image. Repeat at least five times on a roll of film. If there is a consistent loss of focus, then your lens is showing *focus shift*; this lens problem makes it necessary for you to refocus with each new zoom setting.

USING AUTOFOCUS-CAMERA LENSES

One of the technological breakthroughs of the last few years was the *autofocus* camera. Today many photographers use these cameras routinely. Their response time

is becoming faster, and there is every reason to believe that they'll continue to improve. For example some autofocus cameras are now capable of following a subject and anticipating the speed of movement to help the lens react more quickly and accurately.

Although the cameras differ greatly from brand to brand, they do have some features in common. Autofocus cameras are useful tools for action shots because the subjects are more often centered. Also the autofocus concept is based on zeroing in on a very small area of the viewfinder on a specific part of the image, usually the subject. If you move off the subject to recompose, such as in a shot with negative space, the camera will refocus. The solutions are to use the *focus-lock button* to hold the focus or to switch to manual focus. Finally, one of the biggest problems associated with autofocus cameras is determining depth of field. Unfortunately, the trend today is to not include depth-of-field markings on zoom and some other autofocus lenses. This omission forces you to rely on the preview button.

THINKING IN TWO-DIMENSIONAL TERMS

Obviously, technical knowledge about lenses is only a part of translating reality onto film. You also need to understand how you perceive the world, and whether or not that perception interferes with your photographic techniques. In other words you must have an idea of what you want to photograph, and you have to think like a camera and its lenses to get this idea on film. On the surface, this might seem to be a natural process since the human eye bears so many similarities to a camera and a lens. But a closer look shows that this isn't necessarily the case.

For example, human vision is based on a focal-length lens of about 15mm, giving an angle of view somewhere around 90 degrees. The iris (the aperture) has a range between $f/4$ and $f/8$ for very quick changes in light, but it can extend this range to between $f/1.8$ and $f/22$ over longer periods of time. The retina (the film) is incredibly sensitive to low light—perhaps 300 to 400 times as sensitive as the fastest films—while resolution of lines that are 1/200 inch apart is possible at the center of the image but drops off dramatically toward the edges. The range of brightness that the human eye can tolerate and still see tones, colors, and focused objects is immense: this extends from the brightest sunny day to the dimmest moonlit night, and from up to 10,000 foot-candles during the day to as low as 1/1,000,000 foot-candle at night. Similarly, the human eye's sensitivity to color is extensive. It can distinguish between about 150 separate colors, from dark violet to deep red. Some research even suggests that the average person is capable of seeing nearly 1,000,000 different hues and shades of these 150 colors.

This very brief description of human vision proves that we are biased observers of our environment because of our visual superiority over lenses and films. Also, our eyes are binocular, thereby providing depth perception (something only a stereo camera can begin to duplicate). However our brain is what actually presents problems since we see through it, not through our eyes. This ultimate processor takes all the information from the eyes and superimposes memories, emotions, and motivations.

Before you shoot, you must give some thought as to how you want a subject to look on film. This black-and-white picture of a beach shows how you can use a telephoto lens to make a subject appear abstract.

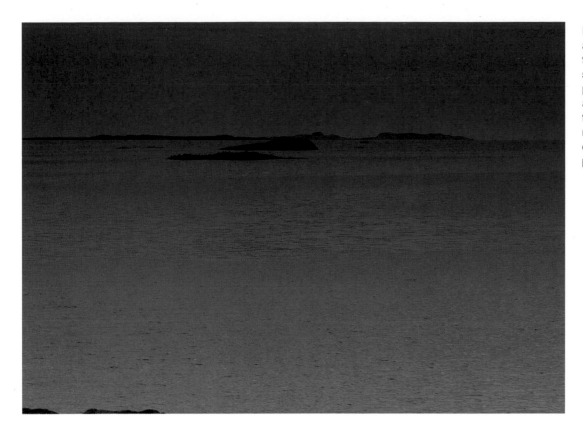

I wanted to record a graphic interpretation of these small islands, so I placed the horizon almost at the center of the image to maintain the evenly balanced proportions.

It has the input of many visual stimuli, but tends to concentrate on a few at the expense of the rest. Of course, the brain is used to perceiving all objects and events in a state of motion or change as it scans the environment.

THE MIND'S EYE

I call the dominance of the brain "the mind's eye." Understanding that human perception isn't the same as that of a camera lens is just as important as grasping such concepts as depth of field, focal length, and angle of view. You must always be aware of how the brain is using the information coming from the eye, so that you can understand what is actually in front of you and how to use your equipment to record it. You must realize that the brain pays attention to things it likes, feels comfortable with, or is curious about. It tends to ignore other photographically important elements. Stimuli that are interesting bombard you on the conscious level, isolated from such other important visual factors as backgrounds and foregrounds, and in the final image other subjects will later compete with the one that first attracted you.

How many times have you looked at your pictures and were satisfied with the main subject but thought that an intrusive element, such as a branch of a tree, a bright spot of light, or a shadow across the subject, spoiled the final image? "How did I miss that?" might be a question you often ask yourself. Most likely, the problem was that you rushed to slip on your favorite lens and shot away without much thought beyond capturing this main subject.

It is essential that you take the time, when the situation allows, to figure out exactly what you're attracted to in a scene, and why, before you select a lens and camera viewpoint. Take that one step further, and get into the habit of looking at a scene as a place where certain laws of physics are at work, and remember that lenses follow those laws: perception, convergence, depth of field, angle of view, compression, and expansion. Otherwise, you'll allow your camera and lenses to "give you" your picture.

You can't rid yourself of the brain's influence, nor can you think completely like a lens. For example, you can't even duplicate the two-dimensional perspective of a photograph by blocking the sight in one of your eyes. The human brain is so filled with information and experiences that such a technique really doesn't work. A more effective approach to discipline yourself to see "correctly" is to be aware of all factors in a scene, to set up shots in your mind, and to imagine what effect a particular focal length will produce. Then raise the camera to your eye, take the picture, and see how close you came. This can give you some feedback about how good your understanding of a particular lens is.

Another way is to carefully review your photographs. Ask yourself: What didn't work? What failed to come together? What interfered? What did work? Was it what you

expected? Really look at and analyze your "outtake" failures, as well as your successes. In addition to your work, critique the images of other photographers and try to figure out what lens they used and where they placed the camera before reading through the technical information. One of the most effective ways to develop a better idea of what you like photographically and to gather information about the effect of various lenses is to keep a clip book. I have several looseleaf books containing images cut out of magazines, and snapshots of pictures from books and other publications. Over the years, these collections have grown to be great sources of ideas. This isn't copying; it is just a way of stimulating and motivating my own imagination. Besides, it tells me quite a bit about what I like in lens use and composition.

VISUAL AIDS

Sometimes using a visual aid isolates you from the interpretive role of the brain when you look at a scene. You can hold a simple framing device, such as an index card with a window cut out of it to match the *aspect ratio* of the film format, at certain distances from your eye to produce the various angles of view. The aspect ratio is the proportion of the width of a film format to its length. I find this approach very convenient when I work with large panoramic or view cameras because it saves time setting up. These index cards immediately establish what will be included in the scene, leaving me free to consider the effect of, for example, distances and depth of field. Optical viewfinders that are used on top of certain field, press, and panoramic cameras can be taken off and slipped into your pocket. Most of these rather expensive oculars are excellent because you can put them right up to your eye and can adjust them for various focal lengths. Photographers who work in black-and-white sometimes use a dark green or dark blue filter when viewing a scene in order to see a monochromatic translation of colors. Visual devices are useful to a point, but keep in mind that they are no more of a magic wand than lenses.

THE ROLE OF FILM FORMATS

Early in my career, framing cards made me aware of the effect of film format on composition and lens selection. There are 3 major types of film available today, on which at least 15 differently shaped formats are exposed, by perhaps 100 or more cameras. The three types of film are: 35mm rollfilm; 120mm or 220mm medium-format rollfilm; and sheet film, commonly 4 x 5 inches and 8 x 10 inches. The majority of 35mm film is exposed as 24 x

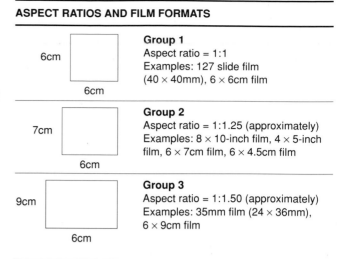

ASPECT RATIOS AND FILM FORMATS

6cm × 6cm
Group 1
Aspect ratio = 1:1
Examples: 127 slide film
(40 × 40mm), 6 × 6cm film

7cm × 6cm
Group 2
Aspect ratio = 1:1.25 (approximately)
Examples: 8 × 10-inch film, 4 × 5-inch film, 6 × 7cm film, 6 × 4.5cm film

9cm × 6cm
Group 3
Aspect ratio = 1:1.50 (approximately)
Examples: 35mm film (24 × 36mm), 6 × 9cm film

OTHER FORMATS

Conventional		Panoramic	
Film	Aspect Ratio	Film	Aspect Ratio
6 × 8cm	1:1.33	24 × 56cm (Widelux)	1:2.33
5 × 7-inch	1:1.4	6 × 12cm	1:2
11 × 14-inch	1:1.27	6 × 17cm	1:2.8

36mm frames on 12-, 24-, or 36-exposure rolls, although there has been some renewed interest in half frames, which are 24 x 18mm in size. Medium-format cameras offer just about every possible size that can be measured off on a roll of 120mm film.

When you compare conventional film sizes based on aspect ratios, notice that there are actually only 3 categories not 12 different formats. For example if you double a 4 x 5-inch negative, you'll get an 8 x 10-inch enlargement; conversely, if you halve an 8 x 10-inch negative, you'll get a 4 x 5-inch print. Also, both 6 x 7cm and 6 x 4.5cm negatives enlarge nearly perfectly to 8 x 10-inch prints. You can think of these four formats as having a similar symmetry so that if they were all used uncropped as illustrations in a book in various sizes, you wouldn't be able to tell them apart on the basis of shape. The same is true of the popular 6 x 6cm format and the 127 super slide, which is 40 x 40mm in size and is shot and cut from 120/220 rollfilm to fit 2 x 2-inch slide mounts used in 35mm slide projectors. Both of these formats are, of course, square. Finally, the standard 35mm format enlarges almost exactly to 6 x 9cm.

So forgetting for the moment the less common 5 x 7-inch and 11 x 14-inch formats, as well as the unusual 6 x 8cm format, you can use representatives from each of the three groups (35mm, medium-format, and large-format

films) to show how film-format shapes affect subject matter. Whether the lens is a wide-angle, standard, or telephoto lens, the visual impression is at least partially influenced by the aspect ratio of the film format. This is especially true of panoramic film sizes, where the aspect ratio begins at 1:2 and can extend beyond 1:10. Keep in mind, too, that since there are really only three non-panoramic or conventional configurations—square and two types of rectangles (short and long) for conventional films—I decided to show typical examples for each group instead of every format for every type of lens.

How exactly a film format influences lens selection and composition is a larger question that often finds its answer in the nuance of an effect. Nevertheless, there are some generalizations. For example, longer aspect ratios (longer rectangles) favor wide landscape shots horizontally, while shorter aspect ratios seem appropriate for vertical full-length poses. Portrait framing, on the other hand, works very well with the short vertical format and, of course, the square format. Then, too, lens selection has a different effect, depending on the format. Consider the two extremes, the square versus the longer rectangular format. Using the same wide-angle lens with each produces different results because in the square format the vertical and horizontal angle of view are proportionally the same, but in the rectangular format the horizontal has much more film space. Obviously, then, since you go to great lengths to compose a shot by moving around and selecting lenses that "fill up" the frame, perhaps you should give equal time to selecting an appropriate film format.

View cameras are able to record fine details because of their large negatives. For this picture of a mansion along New York's Hudson River, 5 × 7-inch film was used. Courtesy of Peter Klose.

Standard and

As a group standard lenses and their closest relatives, the moderate telephotos and wide-angles, are by far the most frequently used optics in photography. Typically a standard lens has a horizontal angle of view between 43 and 45 degrees, while moderate telephotos cover between 20 and 25 degrees and wide-angles cover between 54 and 59 degrees. The moderate lenses represent the first level of the telephoto and wide-angle effects. As such, they serve as a transition between the normal view and the much more pronounced effects of the medium and very long or wide categories. In practical terms, then, the moderate group retains many of the characteristics and uses of the standard lens.

Some photographers argue rather persuasively that a moderate telephoto, such as an 85mm lens for 35mm photography or a 210mm lens for 4 x 5-inch work, is a more useful standard lens. In fact, the decision to use a moderate-angle lens in lieu of a standard optic is very often based on a need or a desire to just slightly extend the effect of a normal view rather than to produce a true wide-angle or telephoto effect.

STANDARD LENSES

The standard, or normal, lens is a reference point for all other photographic lenses since by definition a wide-angle lens shows more of a scene while a telephoto lens shows less. From time to time other slightly wider or longer focal lengths have been touted as more appropriate choices as standard lenses, and recently short-range wide-to-tele-zoom lenses have become popular alternatives. Despite all these challenges, standard lenses remain the most versatile, easiest to use, and least expensive photographic lenses on the market. As a group, they also offer some of the best levels of sharpness and contrast, and easily the fastest maximum apertures. If photographers had to choose one fixed-focal-length lens, most would undoubtedly opt for the standard lens.

When a standard lens is used correctly, it produces images that contain natural-looking subjects with normal proportions. For this shot of the three boats at a dock, I used a 55mm lens on my 35mm camera.

Moderate Lenses

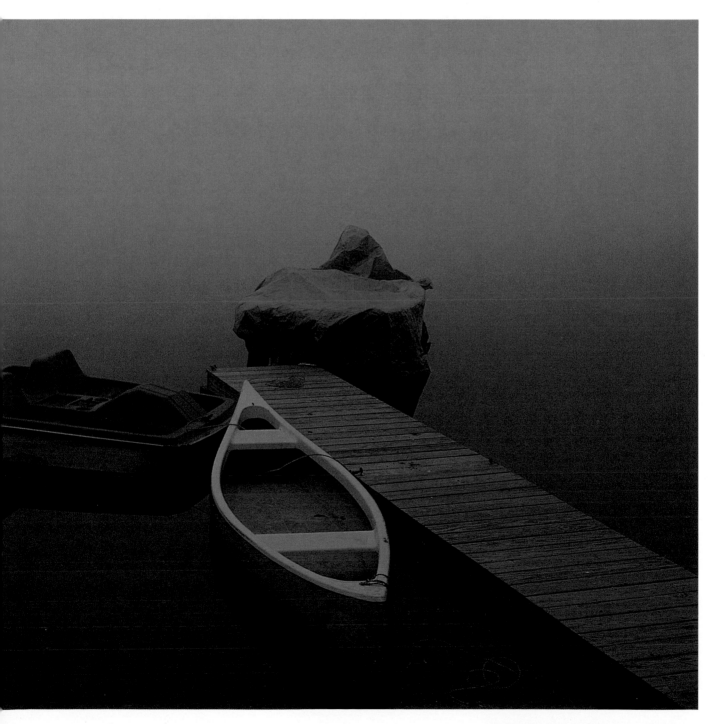

Standard lenses are known for their versatility and their unsurpassed ability to render subjects realistically. I selected a 105mm lens on a 6 × 7cm camera to shoot this classic automobile.

The labels "standard" and "normal" came into use for a number of reasons. In the past, the overwhelming majority of 35mm SLR cameras sold were equipped with one focal-length lens, the 50mm. In addition, when various medium-format camera models were first introduced, they usually were equipped with a standard focal-length lens. So it might be appropriate to say the word "standard" comes from the marketing practices of the manufacturer. The word "normal," however, conjures up some optical or mathematical concept. Accordingly, the normal focal length is defined as the focal length that is equal to the diagonal of the film format. This is the measured distance from one corner of a negative's frame to the corner diagonally opposite, usually given in millimeters. Some photographers object to this mathematical approach since the specific figures don't necessarily match the size of common standard lenses; for example, the diagonal for 35mm formats is 43mm long.

Other photographers have attempted to draw a parallel between the normal focal length and human vision, but this doesn't work completely either, for at least three reasons. First, the human eye views the world in an elliptical rather than a square or rectangular frame. Also, the eye's angle of view is said to be somewhere around 90 degrees, which far exceeds that of a standard lens. Finally the brain, as pointed out earlier, is the primary controller of perception so if something is going to appear normal, it has to do so to the brain first.

To understand this concept, try this practical demonstration. Look through the viewfinder of an SLR camera equipped with a standard lens with your right eye, keeping your left eye closed. Now compare the two images by blinking, holding the view for 3 or 4 seconds. The viewfinder image shows slightly smaller sizes, but the perspective between subjects appears the same in both images. If you were to increase the focal length to a moderate telephoto, both fields of vision (the eye looking through the viewfinder and the unaided eye) would show subjects of about the same size, but the perspective between subjects would no longer look the way the eye shows it. Next, compare the effects of a wide-angle or a longer telephoto lens. You'll undoubtedly discover that subjects look natural, or normal, with standard-focal-length lenses.

This normal perception has a number of advantages. First of all, there is a more comfortable feeling about the image (critics have even called it ordinary). You don't need to make the significant adjustments to the visual changes caused by wide-angle and telephoto optics. That in turn means you can move around, change viewpoints, and even swing around to catch quick-action sequences without having to take that moment or two for adjusting to "non-normal" perceptions. Perhaps most important,

STANDARD FOCAL LENGTHS

Format	Actual Image Size (mm)	Diagonal (mm)	Standard Focal Length (mm)
Disc	8 × 10.5	13.2	13
Super 8	4.2 × 6.2	7.5	14
16mm	7.2 × 10.2	12.5	25
35mm movie	18 × 23	25.0	50
110	13 × 17	21.5	23
35mm half-frame	18 × 23	29.0	28
126	27 × 27	38.0	40
35mm	23 × 35	43.0	50
6 × 4.5cm	45 × 56	72.0	65
6 × 6cm	56 × 56	79.0	80
6 × 7cm	56 × 70	89.5	90
6 × 9cm	56 × 84	101.0	105
5 × 4-inch	100 × 125	160.0	150

Courtesy of Clyde Reynolds, *Lenses*, Focal Press.

To include more of this Maine coastline than a standard lens would have provided, I decided on a 65mm moderate-wide-angle lens and my 6 × 6cm camera.

the subject is recorded on film as close to three-dimensional reality as possible. That makes standard lenses ideal for all kinds of applications in which the subject matter must be portrayed as accurately as possible, whether it is a product advertisement; an applied scientific documentation, such as in archeology or at a crime scene; a full-length portrait; or one of several forms of copy photography. If your camera has no means for correcting perspective, the standard lens will produce the smallest number of apparent distortions.

Another benefit is that standard lenses are also less prone to optical aberrations because they don't require the number and type of corrections that wide-angle and telephoto lenses do. Furthermore, many of the lens formulas have been around for a long time and have been perfected to the point where manufacturing costs are low; in addition, more standard lenses are made and sold than any other focal-length lens. In short, standard lenses represent the best lens buys in photography.

As a group standard lenses also have the largest maximum apertures in photography, which is another advantage. This design feature enables you to shoot in low levels of available light. And when standard lenses are used with the newest ultrafast films, the range of shooting possibilities exceeds that of any other type of lens. Such aperture designations as $f/1.2$, $f/1.4$, and $f/2.0$ also translate into very bright images in SLR viewfinders. This makes focusing much easier in dim light, and it can provide very shallow depth of field for isolating subjects. In the last five years, some undesirable qualities, such as the standard lens' inability to focus closer than 3 feet, have been minimized. Most standard lenses can now focus down to around 18 inches. The lenses have also become smaller and lighter, with filter sizes for even the very fast models staying within reasonable limits. For example, 49mm and 52mm are common, as opposed to the enormous 72mm, 77mm, 82mm, and even 92mm filter sizes for ultrafast wide-angle and long lenses.

Using Standard Lenses. These are the best choice for the full-figure photograph, whether you're shooting in the studio or the field. The usual camera position is straight on but even when the camera is placed at a slightly lower or higher angle, the standard lens still conveys that sense of natural proportions. Using a wide-angle or telephoto lens noticeably increases apparent distortion. The appropriateness of this lens extends to the accurate recording of bigger three-dimensional objects as well, including cars, houses, and gardens.

Standard lenses can be used for a variety of shots, including the 3/4-length portrait seen here and the full-figure photograph.

Even larger views, such as landscapes, benefit from the normal perspective because it gives you a reference point from which you can interpret a scene. For example, looking straight on at a landscape shows you a view of natural proportions. But by lowering or raising the camera, you can select the position of the horizon to begin to emphasize one part of the scene. You can then go on to exercise other options, such as moving in closer to a foreground subject, like a rock or a tree, to further organize the composition. All of these changes seem like subtle rearrangements because you don't have to be concerned with extreme alterations in perspective. Most landscape photographers begin their careers with the standard lens and then branch off to other lenses, especially wide-angles, but they continually return to—and rely on—it as one of the two or three lenses that they use most.

Not only can the standard lens capture normal views of the universe, but it also can function as a wide-angle or telephoto optic. All you have to do is change the distance between the subject and the camera. It is true that other lenses can do this, too, but not without creating some problems. Using a telephoto lens, for example, to take a normal or wide shot requires that you move farther back than might be practical; it also causes compression. Conversely moving in on a subject when shooting with a wide-angle lens exaggerates the foreground, leading perhaps to unwanted distortions in the final image. But

Standard lenses are even appropriate for larger subjects, such as this sprawling landscape.

To capture detail in this desert palm with a standard lens, I simply moved in relatively close to the subject.

you can literally turn your standard lens into a moderate, wide-to-tele-zoom lens just by using your feet.

To get an idea of how you change the focal length when you move, keep in mind the relationship between distance and the size of the lens: halving the distance between you and your subject is equivalent to putting on a telephoto lens twice the size of your standard lens while remaining in the same spot. For example, a 50mm lens focused at 10 feet and then moved to 5 feet and refocused is comparable to a 100mm lens focused at 10 feet.

Photographing flat subjects, including paintings, prints, and other two-dimensional objects, is something for which standard lenses are especially suited. Because they aren't plagued by, for example, *pincushion* and *barrel distortion* (which reflect these shapes) or chromatic aberrations, they faithfully record medium-sized works of art. Also, their middle focal lengths are perfect for the size of artwork that is shot on copystands. Telephoto lenses, including moderate-length ones, are often too long to be used on the copystand, even if they focus that close; wide-angle lenses, on the other hand, can't accurately record geometric patterns that are so close.

One type of closeup photography is completely dominated by the standard lens: small-product, or tabletop, work. In work areas that are anywhere from 2 to 6 feet square, the lens' distortion-free, natural perspective, and adequate middle-distance depth of field on small-, medium-, or large-format cameras are incomparable.

The general-purpose standard lens excels at small-product photography, as this 4 × 5-inch tabletop shot of a paintbrush, paint, and palette clearly shows. Courtesy of Petra Liebetanz.

Standard lenses can also be thought of as photography's "general-purpose people" lens. In addition to their appropriateness for full-length portraits, these truly are the lens of choice for couples and small groups of about 10 or 12 because of their natural rendering and depth-of-field control. Group shots come in many forms, from snapshots of friends to formal pictures. Any photographer who makes a living at group photography will probably tell you to shoot with a standard lens

Standard lenses are the perfect choice for all types of people pictures, such as this informal shot of a small group of friends.

whenever possible and retreat down the focal-length scale to wide-angle lenses only when the backup space runs out. These photographers will also mention the quality of the image because, as a rule, standard lenses provide the highest degree of sharpness. And since group shots are more likely to be blown up to a larger-than-average size, the need to have an edge in image quality is critical.

Another advantage is the way typical portable-flash units match up with standard lenses. The amount of light reaching a subject decreases, or drops off, as the distance between it and the flash unit increases. You can calculate the exact amount by using the *Inverse Square Law*: The illumination of a surface by a point light source varies inversely as the square of the distance from the source. The light also drops off more at the edges than in the center for the same reason; it has to go farther to reach the edge of the image. With most small-camera, hotshoe-mounted flash units as well as the larger "potato mashers" that fit onto brackets on the camera, the angle of the flash easily covers the area captured by the 43-degree angle of view of a typical standard lens. This results in an evenly illuminated picture.

Similarly, a moderate-wide-angle lens with its 54-degree horizontal spread is pretty well covered. But once you reach medium-wide-angle lenses of about 65 degrees and ultrawide-angle lenses in particular, you must place some type of auxiliary wide-angle-lens attachment over the face of the flash unit. This will enable you to decrease total power output. Standard lenses on the other hand use the portion of the flash beam that goes the farthest and results in the least amount of falloff and, therefore, the most even illumination.

Another point to consider is that it is much more efficient to compensate for light loss due to increased distance by opening up 1 or 2 stops on a standard lens, than to use a wide-angle attachment with a short-focal-length lens. With the attachment, you can lose 2 to 3 stops of power and still not get an even light spread. Incidentally the loss of depth of field caused by opening up with a standard lens is usually negligible; you're actually moving farther away from the subject, which increases the depth of field. For example, when you use a 6 x 6.45cm camera equipped with a 75mm lens focused at 3 meters, the total depth of field for an f/8.0 setting is 1.09 meters. This is the difference between a near-focus point of 2.55 meters and a far-focus point of 3.64 meters. If you then move the camera twice as far away from the subject, to 6 meters, and open up 2 stops to f/4.0, the depth of field will be 2.14 meters; this is the result when you subtract the near-focus point of 5.11 meters from the far-focus point of 7.25 meters.

The one closeup situation in which standard lenses are unable to function is when the subject matter is quite small and requires a very close shot. Here you have to use an accessory in order to increase the lens' near-focus range, such as a closeup lens or extension tube (see pages 114–119). The special-purpose lens intended to handle these very short distances is a *macro lens* and is commonly available in the standard focal length of 55mm in 35mm photography. (Some photographers use these macro lenses as their standard lenses.) In medium-format photography, close-focusing optics tend to be slightly longer, typically 120mm or 135mm.

Film-Format Effects. A film format affects the look of a photograph to a certain degree, regardless of the lens used. Not surprisingly, then, some photographers feel that the balanced, natural perspective of a standard lens is even more evident in the square format. This is especially true of head-and-shoulder portraits, in which the balance of the person's features is paralleled by the balance of the equal sides of the frame. On the other hand, rectangular formats are more appropriate for compositions in which a wider impression is the point, as in a cityscape. This is because of that format's greater aspect ratio.

Standard-Lens Limitations. Although standard-focal-length lenses are the most useful lenses in photography, they do have limitations. For example, coming in very close for a portrait pushes the appropriateness of the lens

when the subject is photographed straight on. First, it is rather distracting for subjects to have a camera—and the photographer—just a couple of feet away from their face. More important in terms of the picture, though, are the noticeable exaggeration of the subject's nose and the "unnatural" face shapes that result. Also, the depth-of-field loss is extensive when you shoot that close.

There are, however, ways to overcome these problems. You can get around the apparent distortions inherent in a face-to-the-camera pose by having the subject shift position slightly, so that the final result is more of a profile shot; here, neither the closeness of the camera nor the asymmetrical effect of the camera position on the subject's face is a problem. Another approach is to photograph your subject straight on from twice the close-focus distance that originally produced the tight composition, and then to enlarge the negative to duplicate the original framing. The quality of your enlargement might suffer a bit since you're using less of the negative

To prevent the distortion of facial features that usually results when a standard lens is used to take a tight portrait shot, change the angle of the subject. Here I asked the model to turn her head to the side and photographed her profile against the soft backlighting from the window.

area, but a softer, even grainier, effect is more acceptable for a portrait. Also, if you're shooting medium- or large-format film, the loss of sharpness due to enlargement is less apparent.

The depth of field can also be a problem with standard focal lengths if your lens performs very poorly in terms of contrast and sharpness at its minimum and maximum *f*-stops. The rule of thumb here for best sharpness is to close down 2 stops from the maximum aperture to the middle-range settings, avoiding the aberrations at either end of the aperture scale. Unfortunately this can force you to use the shallow depth-of-field ranges associated with *f*/2.8 or *f*/4.0, such as with very fast 35mm format lenses whose wide-open setting is *f*/1.4 or *f*/1.8. Once again, you have to test your lens to determine both how much of a tradeoff takes place and how much of a mixed blessing an ultrafast lens is. Keep in mind that the bright images produced by these very wide openings are great for focusing, especially in dim light.

The use of a standard lens is also a problem in any situation in which you can't change camera positions to achieve the desired viewpoint. For example room interiors, especially those of smaller rooms, are just about impossible to shoot with a 43-degree optic. All you can do is shoot segmented panoramas. This calls for mounting your camera on a tripod; taking two or three consecutive, overlapping shots at various angles; and splicing them together afterward. Of course this is unacceptable for professional work, but otherwise it provides a good overall view of the room.

On the other end of the distance scale, standard lenses lose their effectiveness when you can't get close to your subject. The only optical solution is to use a *teleconverter*, which multiplies the focal length of your lens. Known also as *tele-extenders* these devices are themselves lenses manufactured in various strengths, such as 1.4X, 2X, and 3X. These designations indicate the factor by which the lens' focal length is multiplied. So, for example, a 2X extender on a 100mm lens yields an effective focal length of 200mm. In the past the performance of lens/teleconverter combinations was somewhat disappointing, and you had to compensate for the loss of light by opening up 1 or 2 stops, depending on the factor. Recently, however, the optical quality of these devices has been improved, to the point that results with tele-extenders compare favorably with equivalent focal-length lenses, particularly when they're used on fixed-focal-length lenses. (When tele-extenders are used with zooms, the results aren't

quite as high in quality.) The best effects in all cases are obtained when the *matched extender* designed for a specific lens is used.

If you can't get close to your subject or shoot with a tele-extender, you have two alternatives. One is to simply enlarge the image's area of interest when printing, as discussed earlier for portraits. This approach works very well with medium and large formats. The quality of the results depends greatly on the enlargement size in relation to the format size. My guideline is to enlarge the 24 x 36mm frame of a 35mm negative no more than eight times. The result, given good technique at both the camera and the enlarger, is a fine 8 x 10-inch print. When I enlarge a section of a 35mm negative, I don't exceed the 8X enlargement ratio; this usually means stopping at a 5 x 7-inch size enlargement. The other solution is compositional in nature. After identifying the distant center of interest, try to frame it with supporting—not interfering—foreground objects to compensate for its small appearance. In other words, fill the empty space that makes the object look so small, such as by using tree limbs in the foreground to frame a house in the distance.

If I had to describe the technical value of standard lenses in just one word, I would choose "versatility." Such design features as their large maximum aperture, medium angle of view, compact size, and light weight, as well as the minimal distortion they produce, combine to allow you to use these lenses under more conditions than any other type of optic. And with a knowledge of what the lens can do, a little imagination, and a willingness to move

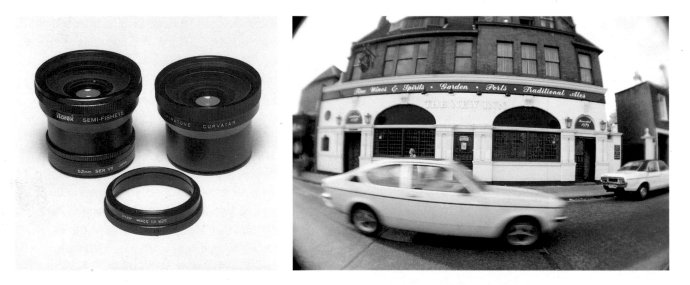

When the angle of view of a standard lens is not adequate, you can convert the lens by attaching a wide-angle (directly above on the right), or even a fisheye lens (directly above on the left) to its threads via an adapter ring (directly above in the center). I used a 50mm lens and a semi-fisheye-lens attachment to shoot the plaza (right), and a wide-angle-lens attachment for the restaurant (top left).

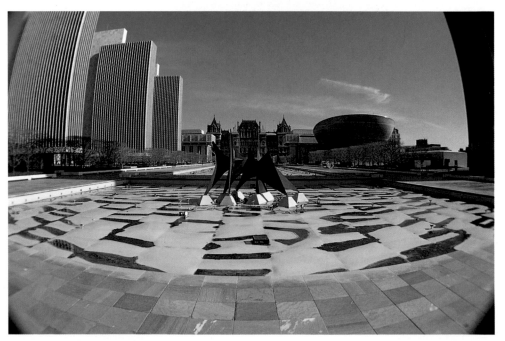

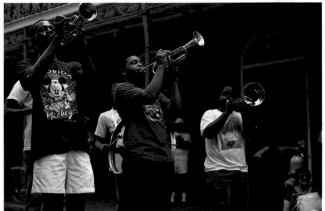

For this photograph of a ship (top left), I chose a 35mm moderate-wide-angle lens, a 35mm camera, and a red filter. I used a moderate-telephoto lens on my 35mm camera set at about 30mm to record this Mono Lake landscape at sunset (left), and at about 40mm for this New Orleans band (top right).

in relation to your subject, you'll find that there are very few shooting situations that you can't handle perfectly well with a standard-focal-length lens, and many at which it excels. As a matter of fact, the standard lens can be a great teacher since it has so much potential, provided that you're willing to resist the temptation to reach for another lens instead of changing camera position. It is worth pointing out in this regard that any collection of the "world's greatest pictures" will always contain a preponderance of standard-lens images. Furthermore, I find it very beneficial from time to time to just go out and shoot with a standard lens in order to reestablish my reference points and remind myself of the control I ultimately have over my photographs.

MODERATE-ANGLE LENSES

Moderate-wide-angle and moderate-telephoto lenses are just one step removed from standard-focal-length lenses, and the differences between them can sometimes be subtle. Still, there are very important ways in which moderate focal lengths do a better job than standard ones. At the same time, however, as you move up and down the focal-length scale, there is a noticeable reduction in the number of situations when that particular lens can be used. Nevertheless, moderate-angle lenses are very versatile. In fact, they can be thought of as having focal lengths that refine and/or extend some of the functions of standard lenses while maintaining that type of lens' natural, distortion-free look.

Moderate-angle lenses are just slightly larger and heavier than standard lenses. But as their speed increases, they can become somewhat bulky, and their filter sizes increase significantly as well. For example, filter sizes jump from the 49mm-to-55mm range of standard lenses to 72mm in 35mm photography. Although there are fewer examples of ultrafast moderate-angle lenses for medium-format photography (and currently no ultrafast moderate-angle lenses in large-format work), the same general differences in size apply.

Using Moderate-Wide-Angle Lenses. These lenses have angles of view of around 55 degrees and are the best choice for shooting situations when you can't increase the subject-to-camera distance to show a wide view. Moderate-wide-angle lenses come in handy for

photographing such large subjects as room interiors, small groups, and cars in a confined space. Typically these lenses give a wider view than standard lenses, without really losing a sense of natural proportions. Furthermore, moderate-wide-angles are sometimes the most appropriate type of lens when you have adequate space to focus in. These lenses are ideal when you need extensive depth of field, or when you want to handhold your small- or medium-format camera since the wider lens enables you to shoot at faster shutter speeds. You might, for example, choose a moderate-wide-angle lens when you're shooting: in a crowd, out the window of a car or train and want the window to act as a frame for the picture, or in light that calls for slower shutter speeds.

Moderate-wide-angle lenses perform somewhat better in all of these situations than standard lenses do because

By using a 35mm moderate-wide-angle lens on my 35mm camera while shooting in Taiwan, I was able to photograph a candid shot of these boys without interfering with their progress.

Sooner or later every photographer is asked to photograph a wedding, a portrait, or a group. To do this well, you must remember that the client wants a sharp, straightforward treatment. This calls for a standard, moderate-wide-angle, or moderate-telephoto lens. For this picture of a bride and her father, I used a 35mm moderate-wide-angle lens and fill-in flash.

their larger angle of view increases apparent depth of field, which makes focusing easier. In addition, slower-shutter-speed shots are less prone to camera shake. This feature allows you to select a hyperfocal setting that offers a larger focus zone and, if necessary, that can be used with slower handholdable shutter speeds.

Another advantage is the lenses' closer-focusing capability. When your intention is to accentuate objects or people in the foreground or to de-emphasize the distant background, moderate-wide-angles give you a definite advantage over standard lenses without producing the very pronounced effects of wider optics. When you're in close, you'll begin to see the changes in size representation that suggest the lenses' heritage and increase the chance for apparent distortion. For example, noses and facial shapes appear exaggerated in portraits.

But as with standard lenses, you can solve this problem by changing the way the subject is posed. Here, however, simply turning the subject's head won't eliminate the asymmetry. You have to switch to a full-length portrait and shoot from a low angle to take advantage of the stretching effect of the near-far differentiation. This elongates, for example, the legs of a reclining female. Similarly, a slightly-higher-angle shot of a male torso emphasizes its "Vee" shape. Keep in mind, too, that when you tip the camera up or down, its film plane is no longer parallel to the subject, so these effects are part of the apparent distortion of converging lines.

Working with moderate-wide-angle lenses is advantageous for two types of portrait settings in particular: the environmental setting and the large-group setting, especially when camera-mounted flash units are used. When you photograph groups of 20 or so people in two rows of 10, you are able to better emphasize the foreground via a low camera angle. (Shooting straight on produces effects similar to those obtained with a standard lens, but covers a wider area with just a bit more separation from the background. This slight difference might not be discernible, though.) Another advantage is not having to back up quite as far from a large group when you use flash. You do, however, need a powerful unit to compensate for the wide angle of the flash beam required to take everything in.

But moderate-wide-angle lenses aren't so wide that they cause significant light falloff at the corners of an image or subject distortion. In fact, many wedding photographers prefer this type of lens for environmental-setting shots. They not only appreciate its wider field, but also like to raise the camera position slightly for the wedding-party portrait to include the background—for example, the church or the bride's home—in the composition. Here, the flash fills in shadows in people's faces while the daylight provides the main light for the scene. In addition to being an effective portrait lens both for two people and for groups of 20, the moderate-wide-angle enables you to take an environmental portrait of a single subject; once again, you can emphasize or de-emphasize specific areas by utilizing foreground dominance, background diminution, near-far perspective, and high- or low-angle changes.

Most landscape photographers use wide-angle lenses extensively. No less a paragon of the art than Ansel Adams counted them among his most preferred optics. Landscapes are, after all, large spatial areas, so it seems logical to choose lenses with wide views. Nevertheless you must remind yourself that as the angle of view increases, other changes that might be just as important to a landscape photographer are taking place as well. One of the most beneficial is the sense of depth generated by the receding sizes of distant objects. Shots of the great outdoors need all the help they can get to give viewers an idea of the scale of the scene. Such environmental conditions as sidelight casting strong shadows or atmospheric haze cutting down on the contrast of distant areas also adds to the illusion of depth in a two-dimensional photograph.

The arrangement of receding lines from the foreground to a vanishing point in the background can influence the viewer's perception of depth, too. Actually the term *line* refers not only to a thin, long strip, such as railroad tracks or roads, but also to any combination of forms and shapes that leads the eye along a line of sight into the picture. This might be, for example, buildings "lining" an alleyway or the rolling hills of a large valley pointing the way to a confluence of rivers. Whatever form these lines take, wide-angle lenses make them recede even farther into the picture. However, the 55-degree field of view of a moderate-wide-angle lens doesn't do this excessively in large scenic views, but rather just enough to make viewers aware of the effect—whether the camera is pointed straight or down, or is in a low-angle position.

You can make the effect more pronounced by arranging the beginning of the line toward an edge of the frame, thereby increasing the angle in relation to the lens' axis. Another way is to have the line head directly toward or near a subject. In this case, you're literally pointing to the center of interest to achieve a sense of depth. Take, for example, a scene with a twisting road that starts from the left side of a picture and continues into a desert landscape, and a car that is leaving a trail of dust. The eye finds the center of interest quickly because of the road and automatically compares the size of the distant car to the rest of the scene, which provides a sense of depth. The dust trail, incidentally, creates the illusion of motion. Finally, the manipulation of relative size by moderate-wide-angle optics also enables landscape photographers to isolate subjects. So a single tree in a forest can be emphasized by coming in close to one tree that looms large; the others decrease in size as they recede.

Moderate-telephoto lenses magnify subject sizes obtained with standard lenses by 0.5X to 2X. As a result, they are perfect for landscapes that require some compression. I shot this desert scene with a 300mm moderate-telephoto lens on my 4 × 5 camera (right). I chose a 105mm moderate-telephoto lens, a graduated-color filter, and my 35mm camera for this close-cropped picture of a waterfall (above).

Using Moderate-Telephoto Lenses. These lenses lend themselves to situations when you can't or shouldn't come in close to a subject. Although some compression occurs when you use them, it isn't enough to really flatten out the spaces between the foreground, subject, and background. As such, the lenses' 20-to-25-degree angle of view allows you to shoot at more comfortable working distances. At the same time, the magnification of the image size makes it easier to frame your subject tighter without the problems that occur when you focus very close on near objects with a standard lens.

In general, however, moderate-telephoto lenses aren't good choices if you want to bring distant subjects, such as players in a stadium or dancers on a stage, up close. They simply don't have the magnification needed. Rather, as is true of moderate-wide-angle lenses, moderate telephotos refine and extend certain functions of standard-focal-

length lenses. Some photographers call these lenses their "normals" because when they compare the size of the image in the viewfinder with the image seen by their other eye, they find that the two images are very close in size. So when composing, the photographers may feel more at ease with the "normalness" of the image size; in addition, the slight compression of space usually simplifies the composition. What they give up, of course, is the wider-shot option, such as group photographs that by necessity would now include fewer people and would be framed from the waist up.

Because their angle of view across a scene is smaller than that of the standard lens' 43-degree view, moderate telephotos encourage more defined compositions in landscape shooting. If you assume that the camera position is fairly close to the area to be photographed, the composition will probably contain a much stronger, and obvious, center of interest; this is because of the more limited viewing area. For example, shooting a farm setting with a

standard or a moderate-wide-angle lens is likely to set the farmhouse within the frame of distant mountains or trees, while using a moderate-telephoto lens makes it easier to emphasize the house and some of its details, such as weathered doors or sidelit shingles. Here the moderate telephoto makes textures part of the subject, which is something that the other lenses don't do. It is of course possible to back up and take the wide shot, but this lens really works better if you take advantage of its longer focal length for tighter composition.

When photographers are asked about "short" telephotos, they frequently mention that you can stand back and shoot without having to interact with your subject. This allows the action to take place without interference from you or the subject. The subject is more at ease, and the photographers are free to isolate and frame the subject. At the same time the degree of magnification isn't large enough to make following movement difficult or to force them to use very fast shutter speeds to avoid camera

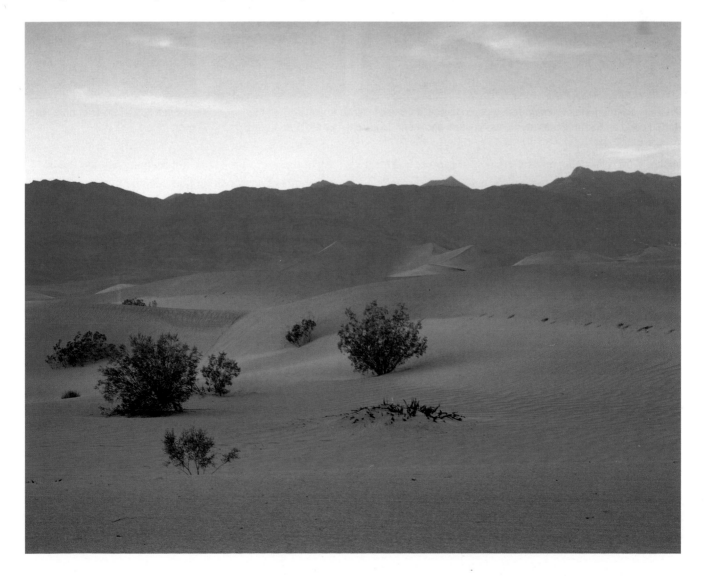

Portraits are the forte of moderate-telephoto lenses. I moved in close to photograph this girl with a 105mm moderate-telephoto lens (left); I used an 85mm moderate-telephoto lens and a soft-focus filter for the portrait of a young woman (right).

shake. And refocusing quickly enough to capture a critical moment at faster shutter speeds is also easy, as is *follow-focusing* for a pan or a blur-pan shot. When you follow-focus, you can change the focus as your subject moves. This technique isn't as much of a problem with the newer autofocus lenses, but it gets more and more difficult with manual lenses as the focal length increases.

So when you shoot, keep in mind that moderate-telephoto lenses manifest that somewhat paradoxical quality common to all long-focal-length lenses: their focusing distance permits you to be more of an observer than a participant, even though the magnified image in your viewfinder is a closeup of the subject. Moderate telephotos isolate you more and more from the wider aspects of the background and foreground as the focal length increases. At the same time, those areas that are included in the picture become more closely associated with the subject because of the lenses' ability to crop the image more tightly; this, in turn, eliminates unwanted distractions and indicates the beginnings of telephoto compression, which pushes the picture elements closer together.

All of these changes have implications beyond the arrangements of composition that become more and more critical as you move up the focal-length scale. Using flash, for example, is a matter of having to base your composition on the power of the flash unit rather than taking advantage of the moderate telephoto's longer focal length. And in keeping with the Inverse Square Law, telephotos mitigate the problem of flash falloff at the corners of an image because of their narrower angle of view. Conversely, though, they compound the problem of light falloff as the camera-to-subject distance increases; you'll be standing farther away from the subjects to frame them full figure. The solution is clear. Stay within the flash range, and use head-and-shoulder compositions. (Incidentally, some flash manufacturers have designed zoom heads into their light units that mimic the moderate-telephoto angles of view and provide more power for distant shots.)

Another consideration is the potential problem of blurred results resulting from subject movement or camera shake. To ensure camera steadiness, follow this simple rule of thumb: For handheld shots, double the mini-

mum camera-shake shutter speed each time the focal length doubles. For example, if you can successfully handhold a 100mm lens set at 1/125 sec. in near-to-far focusing situations, try 1/250 sec. if you change to a 200mm lens. Be careful to remember this if you use a zoom lens. If you start by using the 70mm setting at 1/60 sec. and then quickly zoom to 210mm, 1/60 sec. will now be slow enough to probably cause the picture to be less sharp. You have to increase your shutter speed accordingly, in this case to 1/250 sec. This system holds up pretty well until you get to the very long lenses. Because of their size and weight, using a tripod with them is inescapable. Determining shutter speed based on subject movement involves such factors as the direction and speed of the action, and the distance from the subject.

When you work with moderate-telephoto lenses, you must give some thought to their characteristically smaller depth of field. This makes it easier for you to drop out backgrounds and foregrounds with these lenses than with standard or moderate-wide-angle lenses. But at the same time, this loss of depth of field sets up a series of prob-

lematic conditions for telephoto-lens use in general. For example the longer the focal length, the greater the compression of the foreground and background, and the greater the need for faster shutter speeds to stop subject movement and prevent camera shake. As a result, you're caught between needing more light for fast shutter speeds and needing smaller apertures for greater depth of field. So you must decide which is more important, freezing the action or achieving extensive depth of field. This is less of an issue when your goal is to isolate a subject, but it really presents problems if you want sharp foregrounds and/or backgrounds in lower-light conditions.

A moderate-telephoto lens is the lens of choice in a number of areas. For example, this type of lens by itself or with accessories that allow even closer focusing is much better in closeup photography than a standard lens when the subject is very small. The reason is the moderate telephoto's working distance, either in the field or on a copystand. In both situations, it is easier to work back a bit from a subject so that you don't interfere with the subject or its light by casting shadows.

One of the greatest advantages of using a standard or moderate-angle lens is being able to compose very quickly. I photographed this man and girl boarding a bus in Taiwan with an 85mm moderate-telephoto lens and my 35mm camera using a prefocus, hyperfocal technique.

Another specialized area is aerial photography, where the vibrations of the plane or helicopter are a problem. Moderate-telephotos are a good choice because their angle of view is large enough to capture the subjects in the distance, and shutter speeds of 1/500 sec. or 1/1000 sec. easily control camera shake. Longer lenses, on the other hand, show the effect of vibration from the aircraft, even up to 1/1000 sec. Remember, any means of bolting down the camera in an aircraft, such as with a tripod or a clamp-on pod, simply transfers the vibration to the lens. (The same is true, by the way, of a moving car.) Using a special device called a *gyrostabilizer* is the only way to isolate your camera from the movements of the plane. The camera is mounted on top of this blimp-shaped instrument, which has a built-in gyroscopic movement that cancels out external vibrations.

Moderate-telephoto lenses are also the overwhelming choice for head-and-shoulders or even tighter portraits. This is a result of their working distances, a near-accurate perspective devoid of apparent distortions, and a range of *f*-stops that permits depth-of-field control. The lenses' focal length, which is roughly twice that of standard lenses, doubles the working distances. This, in turn, puts your subject more at ease, and often allows studio photographers to set up lights between the camera and the subject. In addition, with lightboxes and black-backed umbrellas this arrangement reduces the chances of both flare entering the lens and the casting of shadows on the subject from the camera.

While the increased working distance is important, it is the flattering nature of the moderate focal length that makes the final images especially appealing. Faces are flattened just enough to mitigate the chance of a bulbous appearance but not enough to remove the shapes and contours of the cheeks, chin, and nose. This also applies to upper-body compositions in which a shoulder or hand that is closer to the camera is less enlarged with a moderate-telephoto lens than with a standard lens.

The depth-of-field range of moderate telephotos is also quite effective for outdoor portraits in which you can control the background and foreground to just about any level of sharpness. In 35mm photography these moderate focal lengths are available in ultrafast formulations, thereby expanding their usefulness even further; you can use them to isolate and shoot handheld under dimmer lighting, as well as to obtain even less depth of field via their large maximum apertures. For these reasons, moderate-telephoto lenses have a decided advantage over the average, moderate-range zoom lens that can't match their maximum aperture speed. Although faster zooms are very useful optics, they are still one to two stops slower than the fastest moderate-telephoto lenses.

For this aerial shot, I used a 150mm moderate-telephoto lens on my 6 × 7cm camera in order to capture detail.

Using Moderate-Zoom Lenses. Zoom lenses are quite popular with 35mm photographers. And moderate-wide-angle and moderate-telephoto lenses, with typical focal-length ranges of 35mm-70mm and 28mm-85mm, respectively, are among their favorite choices. Medium-format zooms are also becoming more common, especially for the 6 x 4.5cm formats, although their large size and weight have kept their acceptance at a lower level. Zoom lenses for 35mm photography went through a long period of development. Early models were bulky and had lower contrast and sharpness ratings. Today's top-of-the-line zooms are more streamlined and give very good results. Medium-format zoom lenses are also good performers, but their single-focal-length counterparts generally have the edge. No zoom lenses are available for large-format photography.

Moderate-zoom lenses are actually bigger and heavier than single-focal-length lenses, but this difference is often minimal. Moderate zooms generally have larger filter sizes and show dimmer images in the viewfinder because of their smaller maximum apertures. Faster zooms aren't plagued by dim viewfinder images, but they are substantially heavier and larger. Still, the only way to make a valid comparison is to consider lenses of exact maximum apertures. Under these conditions, there really is no basis for comparison because moderate-zoom lenses are 2 to 3 stops slower than their fastest, fixed-focal-length counterparts.

On the other end of the aperture scale moderate-zoom lenses have minimum settings that are 1 or 2 stops higher, a result of their telephoto focal lengths. This design feature enables you to shoot at standard focal lengths, with an added advantage in terms of depth of field. For example a typical 50mm standard lens has a maximum aperture of either $f/16$ or $f/22$, while moderate zooms have $f/32$ settings as their maximum aperture. Close-focus settings are also different because many of these multi-focal-length lenses offer the equivalent effect of a near-focus composition because they have telephoto focal lengths. Also, *macro* settings are quite common, allowing even closer focusing in standard-to-telephoto positions.

Although I think that standard lenses are photography's most versatile optics, moderate-zoom lenses are a real challenge to this title. You might even conclude that they are, in fact, photography's best all-around lens. Certainly, the ability to change focal lengths at will in order to try out different framing is a major advantage. It gives you a chance to see various effects or to crop an image exactly to your liking, minimizing the need for enlarging during printing. In-camera cropping improves image quality because you'll be printing with the full negative. For slide film, this feature is very important because cropping mounted images for projection isn't a popular option, and the results often look odd.

But before you make your decision about the value of moderate-zoom lenses, keep in mind that they seem to come equipped with invisible anchors that hold your feet in one position once you raise the camera and lens to your eye. While you can change focal lengths and, therefore, the angle of view, remember that perspective is based on camera placement. All a moderate-zoom lens does is show you variations within that perspective. Like a standard lens, though, a moderate-zoom lens can be a good—perhaps even better—teacher if you're willing to move and experiment because it shows different framing effects at each position. Next, the slightly larger physical size of a moderate zoom must be judged in relation to how much more convenient they are to use and the number of lenses they replace. Working with a moderate-zoom lens means carrying only one lens as opposed to lugging around perhaps three lenses—and having to take the time to change them when the shooting situation demands a different focal length.

When thinking about a zoom lens you should think about other, more basic considerations. For example, does the front of the *lens barrel* move when you change focal lengths or focus? If so this will change the setting for certain filters that depend on the barrel remaining stationary not rotating, as in the case of *polarizing filters* and *graduated-color filters*. How do you change the lens' focal lengths, via a variable-focus or a true zoom mechanism? The implications for picture-taking are important. True zooms operate much faster, but there is always the problem of shifting focus every time you adjust the focal length, or vice versa. This is eliminated with autofocus lenses.

Another problem is the lenses' tendency to sometimes exhibit *zoom creep* when pointed down. Here, the focal length/focus ring moves slightly by the force of gravity. Variable-focus lenses are far less prone to zoom creep and, of course, prevent the possible change in focal length when refocused because they have a separate ring for each function. But many photographers find it distracting and too time-consuming to move back and forth between two settings.

Finally all zoom lenses run a higher risk of *flare* because of their more complex internal structure, although

Zoom lenses that range from moderate-wide-angle to moderate-telephoto focal lengths are quite versatile. Their compact size and ease of use make them convenient, too. By moving around and changing focal lengths on my moderate-angle, variable-zoom lens, I was able to photograph this dance group at such different settings as 35mm (left), 50mm (directly below), and 85mm (below).

multiple coatings have greatly reduced this problem. A good lens hood should also make a difference. But that is a problem for moderate-telephoto zooms since the hood must be designed around the widest angle of the lens. This means having to use a shallow wide-angle lens hood on a telephoto setting at times. The best way to deal with this is to avoid situations that are conducive to flare by, for example, standing in shaded areas when shooting scenics, being aware of the possible effect of your studio lighting, and avoiding any shots that catch a portion of direct sunlight.

Zoom-lens image quality is very good in modern lens designs among both camera manufacturers and top-of-the-line independent products. These optics are often invaluable in a studio when it comes to making fine adjustments; you don't have to continually move your tripod. And in action shots, the lenses enable you to compensate for a subject whose distance from the camera is continually changing. (Faster versions will soon be on the market, with increasing frequency with special glasses and, accordingly, much more bulk; this is more the case for long telephoto ranges.) The newest moderate-zoom lenses are quite compact with maximum apertures of about $f/2.8$ in the 35mm format and $f/4.5$ in medium-format photography. These lenses may become photography's most versatile optics.

This shot of an Indian taken on a movie set shows that zoom lenses make cropping an image a simple task. Courtesy of Robert Farber.

CHAPTER 4

Longer

With medium-long and very long telephoto lenses, the subject matter photographed literally becomes narrower and narrower. For example, large-group shots and wide landscape views usually aren't appropriate for these lenses. This doesn't mean that you can't take pictures of people or landscapes with them; it simply means that the composition will be different. In fact, one reason why these larger focal-length lenses are divided into two categories is because medium-long telephotos with angles of view between 10 and 20 degrees still maintain some measure of diversity, while very long telephotos limit compositions to angles of view of 5 degrees or less.

To get an idea of how narrow this view is, think of your shoulders as the diameter of a circle, with your head (from a bird's-eye view) as the center. Here, everything in front of you (from shoulder to shoulder) equals 180 degrees. Next, try to visualize areas of 10 to 20 degrees or less within that arc by holding your hands out in front of you. This range clearly doesn't give you a great deal of room to work with. Such small angles of view mean large magnification, thereby producing dramatic images, and make using a tripod or monopod essential.

Even when you focus the longer telephotos at infinity, you can't include a lot of subject matter in such a thin slice of the environment. In contrast shorter medium telephotos operate with as much as a 20-degree angle of view, which allows photographers to handhold them at fast shutter speeds. Some of these lenses even have apertures fast enough to shoot handheld or in low light at reasonable shutter speeds.

Medium-long telephotos are more of a general-use lens that give significant telephoto effects, while the very long models are much more specialized. For example, sports photographers and their gargantuan telephotos perched on top of heavy monopods wait on the sideline for just the right play in specific portions of the playing field. In the meantime, literally hundreds of great pictures along the sidelines and in close areas of the field remain untaken.

Telephoto Lenses

The forte of longer telephoto lenses is their ability to bring subjects closer and to compress the distance between visual elements. I used a 600mm lens on a 35mm camera for this picture of Death Valley's famous sand dunes. The distant mountains are pulled in to provide a background for the dunes.

These photographers, of course, are going for one type of shot that will have a unique look, characterized by a sense of being inside the action—a result of their lenses' large magnification, compression, and attenuated depth of field.

With both very short and very long lenses, you have to keep in mind some practical considerations when composing. In this area of photography, the images on film take on proportions and perspectives that our eyes, and brain, aren't used to. As such unless you've already worked with these lenses, you won't have an idea ahead of time as to what the final image will look like. So novice photographers must be prepared to spend some time looking through the lens to see what effect it has and trying it out from various perspective points in order to develop a sense of the lens' potential uses. Remember, too, that viewers are less accustomed to these types of images; therefore, you have to be careful not to lose the importance of the composition and subject matter in the extraordinary effect of the optic itself. This is where many photographers fail to make full use of a telephoto lens' potential and never get past being impressed by its apparent distortions of size through magnification.

TECHNICAL CHARACTERISTICS

The designs of medium-long and very long telephoto lenses are unique in several ways. Furthermore the improvement in tele-extender devices in the past few years has resulted in their extensive use with longer fixed-focal-length and zoom lenses, so it is quite common to think of

Today's long telephoto lenses feature faster maximum apertures, higher-quality glass, and larger and heavier designs. As these representative medium-format Bronica Zenzanon lenses show, they are available in a variety of focal lengths, including 500mm (rear center), 65mm (rear right), 110mm (front far right), and 80mm (front far left). Courtesy of GMI Corporation.

Long lenses are preferred by sports and nature photographers because they enable the photographers to come in close on a subject when moving toward it is impossible. I recorded this moment of peak action during a college football game with my 35mm camera and a 300mm lens fitted with a 2X tele-extender mounted on a monopod.

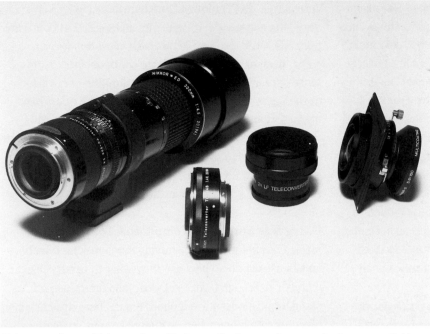

Tele-extenders, which are placed between the lens and camera body, are available in three strengths: 1.4X, 2X, and 3X. Although tele-extenders reduce the amount of light reaching the film, they eliminate the need for carrying a second, longer lens. They can be used with lenses ranging from standard to very long telephoto lenses, but they are particularly valued by photographers who work with longer lenses. Here you see a 2X tele-extender mounted on a 300mm prime lens, which effectively is a 600mm lens (left) a 1.4X tele-extender (center); and a 2X tele-extender for use on a 4 × 5-inch camera (right). With this last arrangement the focal length is limited to 150mm, and the tele-extender must be screwed onto the back of the lens.

Like tele-extenders, the appeal of mirror lenses is their lower weight and smaller size than conventional designs. Almost all mirror lenses, including the 1000mm lens shown here, have medium-long to very long focal lengths and require rear-mounted filters.

these lenses and their tele-extenders as one unit. Doubling the size of your lens with one of these small optical multipliers is quite cost-effective, and the result is far less bulky than a telephoto lens with an equivalent focal length. Excellent tele-converters are expensive in comparison to lesser-quality models, but nowhere as costly as the longer lenses they replace.

Another design difference is the prevalence of *mirror lenses*, which are available in both manual and at least one autofocus style. These unusual lenses are based on a simple principle: A beam of light is internally reflected back and forth off two mirrors rather than passed through refracting lenses to achieve the larger focal length. The result is a telephoto focal length in a very short package. Actually, there are two types of mirror lenses: *catoptric*, also called *pure-mirror*, lenses in which only mirrors are used, and *catadioptric* lenses that employ two mirrors as well as conventional lenses. These ancillary lenses, also known as "field flatteners," reduce the curve of the image produced by the mirrors, so that it can be recorded on a flat film plane.

The concept of using mirrors to enlarge an image dates back at least to Isaac Newton, and such designs have

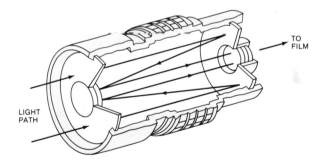

MIRROR TELEPHOTO LENSES
Courtesy of Adrian Bailey, *Illustrated Dictionary of Photography.*

been included for quite some time in microscopes and astronomical telescopes. Mirror optics have also been incorporated into photography for a while. And when you think about their design and makeup, they seem like a photographer's dream come true; they're lighter, much shorter—some are as small as 3 to 5 inches—and can be easily carried. The smaller-focal-length lenses can even be handheld. The unique designs of mirror lenses allow them to escape one of the most common optical flaws of other telephoto lenses: *chromatic aberrations*. Here, the various color wavelengths of light aren't focused on the same point.

But the designs do have certain limitations. For example you can only have one aperture setting with these lenses, typically *f*/5.6 at 350mm or *f*/8 500mm or 1000mm in both the 35mm and medium formats. (There are no large-format mirror lenses.) Only one rather esoteric lens, the Makowsky Katoptaron *f*/8 500mm, features a range of *f*-stops to *f*/32. Other problems relating to design are the doughnut-shaped reflections of the hole in the mirror configuration. These show up in extremely bright areas of a scene, such as highlights off water. Many people find the reflections, which look like small, softly focused circles, distracting. While there may be some mixed reaction to the doughnut effect, the limit of one *f*-stop is an accepted disadvantage. Photographers know that they're locked into one depth-of-field setting, so they can rely on only the shutter speed to control light.

Photographers can compensate for this particular design restriction to an extent by using *neutral-density* filters, or *ND* filters, in bright settings, such as at the seashore or a snow-covered mountainside. These filters are available in various densities and reduce the amount of light transmitted without affecting its quality. All mirror lenses have such large front elements that they can't be fitted with front-mounted filters. As a result these optics require rear-element filters, which you either dial-in via a built-in mechanism or screw in place. And since ND filters change only exposure levels, you still lose the functions of depth of field, focus control, and convenient exposure variation that are characteristic of conventional-lens apertures with mirror lenses.

Special Glasses and Coatings. Medium-long and very long telephoto lenses have special glass lens coatings and designs for both the fixed-focal-length and zoom styles. The result: lenses of better quality with much faster minimum apertures and exceptionally good control of flare. Such manufacturer designations as "ED," "LD," and "FD" refer to the use of fluoride and other special glasses that, in conjunction with special lens coatings, permit high levels of light transmission and much better correction of aberrations. The tradeoff, however, is a significant increase in the lenses' physical size and price. Characteristically, these lenses have very large front portions that taper to more conventional-sized barrels.

To give you some idea of how extensively these new glasses and designs are used, Nikon, an industry leader in these designs, offers eight lenses with focal lengths between 400mm and 800mm: only one doesn't carry the company's "ED" notation. Furthermore, Nikon's two very long zooms (*f*/8 180-600mm and *f*/4 200-400mm) are both ED rated. Similar trends with *apochromatic*, or *APO*, designs are also becoming commonplace. APO lenses are able to have all the wavelengths of color focus at the same point. Telephoto lenses, on the other hand, are notorious for failing to do this with conventional designs and glasses. And all of these newer, faster zoom-lens designs have produced big, heavy units with immense front elements. Nikon's *f*/4 200-400mm lens, for example, has a 122mm front thread.

Using Medium-Long Telephoto Lenses. The majority of photographers buying medium-long telephoto lenses usually do so because they want to bring subject matter closer—and can't get close enough to use a standard or moderate-telephoto lens. There are certainly plenty of situations when getting near your subject is an insurmountable problem. For example, when you shoot such wide-field sports as football, baseball, and soccer, a very long focal length "brings" you out onto the field in order to capture the action. Even small arena events, including basketball and stage plays, call for a lens beyond the moderate range. Medium-long telephoto lenses also come in handy when you want to be an uninvolved observer in order to shoot unobtrusive candids of people from a distance.

Knowledgeable photographers invest in these large optics for the compression of subject matter and/or the isolating power of their shallow depths of field as well. When you use a medium-long telephoto, the background becomes prominent. Furthermore because of the magnifications and the narrowing angle of view (which decreases horizontally and vertically), the foreground is often pushed out of the frame. This means that you have to think more about how backgrounds will affect viewers. These lenses, then, actually give you the power to literally push ordinarily scattered elements of a scene into close proximity, seemingly flattened against their background. Conversely, you can isolate a subject to a much greater degree because of the shallower depth of field of these lenses.

Magnification. Every time you double the focal length, the subject is doubled in size in your viewfinder and on film. (This pertains almost exclusively to SLR camera viewfinders in 35mm and medium-format photography and to sheet-film view cameras. Virtually all TLR and

The magnification capabilities of medium-long and very long telephoto lenses enable photographers to isolate small parts of a scene. I shot the Los Angeles skyline with a 600mm very long telephoto lens and a colored filter mounted on a tripod to achieve a graphic interpretation of the geometric forms.

In order to handhold the camera while shooting, especially when working with telephoto lenses, you should use a shutter speed that is at least equal to the reciprocal of the lens' focal length. This greatly reduces the possibility of camera shake and usually freezes the action of the subject. This is the approach I took for this shot of a surfer. I used a 35mm camera and a 300mm lens set at 1/500 sec. here.

rangefinder cameras are impractical for the longer telephoto lenses.) A good way to determine if you need a longer lens is to keep track of the number of times you couldn't get close enough to have the subject fill your viewfinder. And how much larger did you want the subject, two times, three times? Medium-long telephoto focal lengths are about three to six times the size of a standard focal length, whatever format you're working in. Incidentally that is about the longest focal length available in large-format lenses, and only a few medium-format optics, such as the 1000mm mirror lens, cross over into

the very long telephoto category. So for the two larger formats, lenses in the medium-long telephoto category with magnifications up to about six times are considered the big guns—literally.

You can handhold some of the shorter medium-format telephoto lenses, but using them with some sort of support is recommended. In 35mm photography, the lenses' size and weight permit, and even encourage, handholding. In large-format photography, there is no question about using a tripod. Furthermore, there are also the problems of making sure that the lens physically fits the lensboard of smaller cameras, including field and technical cameras, and determining whether or not the bellows has enough draw for focusing.

This leads to a point about the whole concept of telephoto lenses in large-format photography. The words "telephoto" and "long" refer to two different lens designs. With long lenses, large focal lengths are achieved only by the length of the lens; with telephoto lenses, image magnification comes from optical designs within the groups of elements as well. As a result, "true" telephoto lenses don't have to be as long and don't require the same focusing distance. These design characteristics aren't critical to medium-format and 35mm users when it comes to focusing. Some lenses incorporate true telephoto designs, while others are just longer simply to produce the telephoto effect. In either case, you focus the lens via a *focusing ring* and a *helicoid tube*.

In large-format photography, the situation is different because lenses from large-format cameras are often used on smaller-format cameras. For example if you take a 300mm standard lens from an 8 x 10-inch camera and use it on a 4 x 5-inch camera, you have a telephoto lens of twice the focal length of a 150mm standard lens. But you also have a lens drawing twice as much from the bellows, which exceeds the maximum range of many field cameras. You're actually just using a long lens here rather than one designed as a telephoto with less bellows length. In large-format photography such true telephotos draw only about 75 percent or less of their focal length, which makes them far more useful.

Compression and Depth of Field. The amount of foreshortening that occurs with lenses in the 15-degree and less range is significant enough to make it an important compositional element. Yet at the same time,

This very tight portrait of a young woman in a red hat was made with a 300mm lens. Courtesy of Micci DeBonis.

the foreshortening isn't so dominant that every picture takes on a completely flattened look. You can, for example, shoot very "flattering" portraits with a 15-degree lens, with many photographers preferring the look of a 135mm lens for small-format work or a 250mm lens for medium-format images.

One of the primary applications in which compression is helpful and obvious is shooting a distant scene. Here the objective isn't to capture the wide expanse but to emphasize its layered elements, such as a grassy area in front of a lake that has a treeline behind it and mountains beyond that. The idea is to stack these parts of the scene in closer proximity to each other in order to emphasize their interrelationships and to have the lake become the central element. You can't achieve this effect with either a standard or a moderate-telephoto lens. And a very long telephoto flattens the subjects to the point where you lose the sense of space required to make the illusion work. So for these reasons, the medium-long telephoto lens provides just the right effect.

Isolating a subject via depth of field is simple with longer telephotos. This is so easy in fact that you have to work to avoid it when, for example, coming in close results in an incredibly small depth of field. Suppose that a 50mm lens on a 35mm camera focused at 8 feet and set at f/11 yields almost 6 feet of depth (67 inches) from the near-to-far distances. Using a 210mm lens under those same conditions would reduce the depth of field to just a little over 3 inches! The situation is better for distant focusing, but very critical focusing is still essential and knowing the exact depth of field is a great help. This point is essential because very often in the heat of shooting with one of these longer lenses, photographers pay too much attention to the magnified subject and at the same time not enough to backgrounds or foregrounds—especially when they handhold the camera and the action is taking place quickly.

Operating Medium-Long Telephoto Lenses. In terms of handling and other mechanical characteristics, medium-long telephoto lenses have smaller maximum apertures than moderate-telephoto lenses. This causes you to focus with just a dimmer image in the viewfinder. The problem of *view-screen blackout* often occurs, too. This happens when half of a *split-screen focusing circle* in the viewfinder goes black, thereby preventing accurate focusing. Cameras that have a center microprism are also hard to focus in low light because the tiny prisms in the crisscross design go black; this stops you from knowing

Landscapes are favorite subjects of photographers who work with telephoto lenses because these optics compress subject matter as well as focus in on sections of larger areas. For this shoreline shot, I used a 35mm camera, a 75-300mm zoom lens set at 300mm, and a graduated magenta filter.

when the image is in focus. In both split-screen and microprism focusing, there is a minimal amount of light necessary for the screens to work. Some camera manufacturers have special screens for use with their interchangeable-screen cameras, which require less light to show a focused image. If your center-focusing aids don't work, focus on the groundglass of the viewfinder. Many SLR cameras in 35mm and medium-format photography offer both plain screens for use with telephoto lenses and ones with grids to help facilitate composition.

Other features that you should consider are the size and weight of these medium-long telephoto lenses. They require you to hold them in a balanced way when working with them, rather than cupping the camera and lens in one hand as you do with shorter-focal-length lenses. In addition, one particularly troublesome characteristic of many of these optics is their long *focus throw*. This is the number of total revolutions of the focusing ring from infinity to

close-focus. Although the focus throw is supposed to help you make small adjustments in critical focusing, it can take a great deal of time and feel awkward in fast-action shooting situations. The advantages of autofocus provide a distinct advantage here.

Many photographers forgo using flash with longer-focal-length lenses, but they actually work very well together if you stay within the distances that the flash unit can reach. Composing a shot of couples or a single person in a tight head-and-shoulder pose while using flash is a natural; you can stand within a 10-to-15-foot range and choose medium-aperture settings to compensate for depth-of-field loss without any disturbing light falloff at the corners. I've even had good results when I placed some of the *bounce* accessories on the flash head. These produced a very soft effect. These devices direct the reflected light of the flash over a wide area, but by staying within the 10-to-15 foot range you can obtain some pleasing results. This is because there is plenty of even illumination in the center of the flash's beam. A great way to extend the working distance when using direct flash is to choose a unit that has a focusing head; this design feature narrows the light beam's angle, thereby allowing you to take telephoto shots up to 60 or 70 feet away.

Another option is to stand at quite a distance to make yourself as unobtrusive as possible and yet still be able to fill your viewfinder with your subject. How far away can you stand? Just remember the focal-length distance/image-size relationship. For example, if a 55mm lens gives you what you want at 10 feet, then a 210mm lens will produce the same effect in the final image at a more comfortable distance of 40 feet.

Using Very Long Telephoto Lenses. These lenses produce exaggerated foreshortening and diminutive depth of field. Even when you use them at great distances where some semblance of normal proportions is conceivable, the final images have a very different look. If you pick up one of these lenses and try to handhold it, everything in the viewfinder will seem to vibrate. This is a result of the magnification of camera shake; you must mount the camera on a tripod. Focusing very long telephoto lenses is also a challenge because the viewfinder images are so dim (except with the newer lens designs). Furthermore, the depth of field is quite shallow. But what you get in return for all these technical demands is the opportunity to take some of the most dramatic pictures that photography makes possible.

The compression effect of very long telephoto lenses is one of their primary compositional attributes. To produce this somewhat abstract image I used a 400mm lens and a 2X tele-extender, which resulted in an effective focal length of 800mm, and ISO 1000 film.

Magnification. Very long telephoto lenses are so powerful in their overall visual effect that it is difficult to talk separately about any one aspect, such as magnification, without immediately discussing depth of field and compression. When the angle of view closes to less than 7 degrees, the effect on subject matter is substantive, to say the least. To get a sense of what this looks like, try this experiment. Take a sheet of paper and cut a hole 2 inches long by 3 inches wide in the center. Now hold this about 24 inches from your eye. The tiny rectangle constitutes approximately a 5-degree horizontal and 3-degree vertical angle of view, which is typical of very long telephoto lenses.

These lenses magnify subjects to such an extent that you're forced to consider whole new relationships between objects that you commonly think of as separate entities. Imagine a huge setting sun that takes up 75 percent of a frame and whose magnified form seems to

penetrate a mountain rather than set behind it, or a crowded street where the people appear to be attached to one another in layers instead of maneuvering to avoid bumping or touching. When you work with these lenses in close, they isolate and magnify subjects so extensively that you're struck by the details revealed—and realize how much your ordinary vision misses.

Compression and Depth of Field. Most of these extraordinary lenses are the tools of sports and nature photographers who can't get close to their subjects or who are looking for very different interpretations of the mundane. For both types of photography, the latest lens designs with their special glasses, faster minimum apertures, autofocus capabilities, and extended zoom ranges are a real boon when the photographers deal with moving subjects. Just look at the sidelines of a major-league sport, and you'll see plenty of examples of these new wide-front, very expensive optics. In bright light with medium-speed films, sports photographers can click away at such settings as 1/500 sec., 1/1000 sec., and 1/2000 sec. at *f*/5.6 to isolate and capture action with angles of view of 5 degrees or less.

Extreme compression and shallow depth of field are technical facts of life for them, and they use them to produce remarkable images. Fortunately the pulling in of backgrounds, such as crowds in the stands, isn't as much of a problem in practice because the magnification is so great that the frame is usually filled with players. When this poses a potential problem, photographers can opt for a narrow depth of field to blur the background. Nature photographers can also come in so close that isolating a small subject, such as a bird, through magnification or narrow depth of field is frequently the desired effect.

When you can't get close to the subject, a telephoto lens is a must. Here I handheld a 300mm lens set at 1/250 sec. and panned the scene to capture the exhilaration of these water-flume riders.

For this picture of a short-eared owl, a 400mm very long tele-photo lens was used with a 1.4 tele-extender to render an effective 560mm focal length. The resulting depth of field is quite shallow. Courtesy of Art Gingert.

Longer telephoto lenses enable photographers to capture close views of a subject when their only choice is to shoot it from a distance. I photographed this closeup of soccer players with a 600mm very long telephoto lens mounted on a tripod; however, this setup limited my ability to record fast-paced action.

Of course shooting certain subjects with these telephotos is out of the question, especially with the longest lenses in this group. Obvious examples are large groups and wide-field scenes. Generally when you turn to very long telephotos, you're trying to deal with the inability to get close or looking for inordinate degrees of compression. Depth-of-field isolation isn't as important a factor as either image size or foreshortening. These effects are what compel photographers to invest a large amount of money in these remarkable lenses.

THE NEED FOR TRIPODS

Unsharp pictures can result when the camera isn't held steady enough to record a static scene and when the subject moves (see pages 54–55). Although you can usually control camera movement by doubling the shutter speed each time you double the lens' focal length, which is actually using the reciprocal of the focal length as your minimum, I prefer to establish a handholdable shutter speed first. With the reciprocal rule, you round off the lens' focal length to the nearest fastest shutter speed. For 50mm standard lenses, this means shooting at almost 1/60 sec.; for medium-long and very long telephoto lenses, such speeds as 1/250 sec. to 1/1000 sec. are always used. Obviously many lighting conditions won't permit such fast speeds because the lens' apertures aren't large enough to allow sufficient light in for proper exposure. Then, too,

there are plenty of times when you want much smaller *f*-stops in order to achieve a large depth of field.

The general rule with tripods is to use them whenever you can. When this is impractical, you can use some other support device. For example, shooting from the sidelines and trying to follow a fast-paced game is simply impossible with a tripod if you have to move frequently and pan the action. A *monopod* is far more appropriate in these situations; its single leg allows you to move with the flow of the action and to reposition easily. Some photographers prefer *gunstock mounts* to shoot action sequences, while others opt for a *chest pod*. Whatever the choice, all of these support devices provide ways to minimize the problems of camera shake. But all of them are inferior to the noble tripod, which works best. Without question, a good tripod is second in importance for telephoto photography to only the lens itself.

Keep in mind, however, that not all tripods are created equal; some, I think, were designed to deal more with the stodgy image they have than to function properly. What you need is a solid platform for your camera. If it happens to fold up easily or store compactly, fine. But the most important feature is a tripod's sturdiness; if a tripod isn't stable, you're wasting your time and money. This doesn't mean that you have to use an oversized, overweight monster that is heavy to carry and difficult to set up. On the contrary, there are many good tripods to choose from.

Here are some guidelines to follow when you buy a tripod. Select one that is a comfortable working height for you. This is between 5 1/2 and 6 1/2 feet for most people. You should be able to obtain this height without using the center-column extension. (As a matter of practice, I use the extension of the center column only as a last resort because it is the least stable part of a tripod.) Next, check how sturdy the tripod is with its legs at full extension. By leaning down on the center column of a fully extended tripod, you can see how much it wiggles or if the legs creep back into their retracted position under the added weight. But the real test comes under actual field conditions, which are the circumstances in which you plan to use it. If at all possible, try to re-create these conditions in the camera store before you buy the tripod, or if you can, work out a short test period with the dealer.

On-the-spot testing is easy. Load your camera with a roll of fast-speed slide film, mount the camera on the tripod you like, and snap on your longest lenses. Starting with very slow shutter speeds, such as 1 sec. or 1/2 sec., shoot some middle-distant object that is 20 to 30 feet away. Be sure that the tripod legs are fully extended when you do this and with rectangular-format cameras, in the vertical position as well. Take exposures up to the lens' focal-length shutter-speed setting if possible, such as 1/250 sec. for a 200mm lens and 1/500 sec. for a 400mm lens. Now repeat the process with the largest, heaviest, and presumably the sturdiest tripod in the store as a comparison. There are other tests you can try, such as balancing a penny on the camera body and on the end of the lens barrel, and then releasing the shutter at various speeds to see if there is enough vibration to knock them off. Again, try this on the biggest tripods as well. In all these tests be sure to use a cable release to fire the shutter since this device isolates the pressure of your hand from the shutter-release button.

The combination of slow shutter speeds and longer telephoto lenses calls for a tripod. To string out these thin channels of water and to blend the point where the falling water met the standing water, I used a 250mm lens with a 2X tele-extender and a 6 × 6cm camera mounted on a tripod. I then decided on tungsten film in order to produce the blue hue.

When shooting in the studio with hot lights or in the field, I always try to hang a weight on the tripod to increase stability. Using a camera bag with its 20 or so pounds of equipment works well outdoors: it also makes reaching for lenses more convenient and keeps the bag from getting wet on the ground. In the studio, using a gallon jug of water is ideal. In both situations, you actually place the bag or bottle over the part of the lens or camera that is attached to the tripod screw. To do this easily, place a flat strap over the top of the lens or camera and attach the weight underneath. (Shooting with flash doesn't require these extra measures because the light duration is so brief.)

Keep in mind that very long optics tend to shift the center balance of the weight of your camera/lens unit to about the middle of the lens barrel. Most manufacturers compensate for this by providing an auxiliary mounting ring on the lens. You should attach this to the tripod because it gives a more balanced holding point. Sometimes, particularly with very long telephotos, you can use a monopod or a second tripod to add even more stability. These mounting rings also allow you to rotate the position of the camera from horizontal to vertical without having to detach it from the tripod.

There are several other ergonomic features that you should consider when buying a tripod. For example, see if you can change the leg height easily and quickly without lots of wear and tear on the mechanism or your hands. *Twist-lock* collars are easy to adjust, but many are prone to stripping. When I first began to use this type of collar, I had to learn how much to tighten the screw joints. Although it is automatic now, it took a little while for it to become second nature. Many photographers prefer the *flip-lock* design, in which releasing a button or lever lets the tripod's square-shaped leg move freely.

Take a look at the feet of the tripod, too; many have a telescoping, pointed end for extra grip in loose soil. Other options are round rubber ends to stop slippage on smooth surfaces and self-leveling feet. Again, your preferences and shooting conditions determine the most appropriate features for you. Finally, are the adjustment knobs and levels large enough for you, and do they hold their positions without you having to exert a gorilla grip?

Unfortunately tripods, which can do so much for picture quality, are often scorned by photographers who like to shoot "free and uninhibited." I agree to a point, and whenever possible I enjoy the freedom of handholding a 35mm or medium-format camera. But when circumstan-

ces call for a completely steady camera, I don't hesitate to reach for my tripod; I know that what I give up in maneuverability, I more than get back in technical and compositional control over the image. But I don't overuse my tripod either. When I'm shooting, I first move around and find my picture. Only then do I set up my tripod. And when I'm finished shooting, I detach the camera and go hunting for a new perspective.

Tripod Accessories. There are two accessories you should consider using with your tripod. One is a good-quality, quick-release mechanism, and the other is a ball head. Quick-release mechanisms make it a snap to leave the tripod and explore camera viewpoints, and ball heads make it much easier to position the camera and lens. I find that ball heads permit finer adjustments and are faster to use than the regular two-armed lever head. When working with both devices, though, you have to look for a high level of quality; otherwise, the device won't be able to hold its loads tightly. Also, make sure that the ball head is capable of making and holding small adjustments and allows for vertical shots.

Other Stabilizing Devices. Other stabilizing devices don't have to meet the high standards for sturdiness that tripods do because almost all of these devices, such as monopods, chest pods, and gunstock mounts, are handheld or braced against the body. Very small tabletop tripods are fine when used with medium-long telephoto lenses, and bean bags are great when you can rest very long telephotos on top of a supporting structure, such as a car or a stone wall. Here, you place one bag under the camera and stabilize the barrel with the other. Various clamp-on tripods are also available. To determine how stable they are, clamp them to a car bumper (don't forget to turn off the engine) or on a strong fence railing. If the device is sturdy enough, the resulting images won't indicate any stability problem. Once again, do some comparison testing to find out just how reliable the stabilizer is and be sure to use a cable release.

Keep in mind, too, that most of the camera-shake problems in a stabilized SLR camera comes from the slap of the mirror just before exposure. See if you can lock up the mirror beforehand via a leveler or button. With cameras that lack this feature, try using the *self-timer*. In many cases this operation includes locking up the mirror 1 or 2 seconds before the shutter trips, which is usually just long enough for the vibration to disappear.

ATMOSPHERIC INTERFERENCE

Once you move away from subject matter that is spread out over 40-to-50-degree areas and point a very long telephoto lens set at infinity toward distant subjects, there is a problem with atmospheric conditions. If you keep in mind the extensive compression of foreground to background, you won't be surprised that any imperfections in the air, such as pollution, which is spread out by standard angles of view, are concentrated in the narrow angle of view. Atmospheric haze, smog, heat waves, and other air-quality factors are quite problematic when you want to record a sharp, distant scene with a telephoto lens. At-

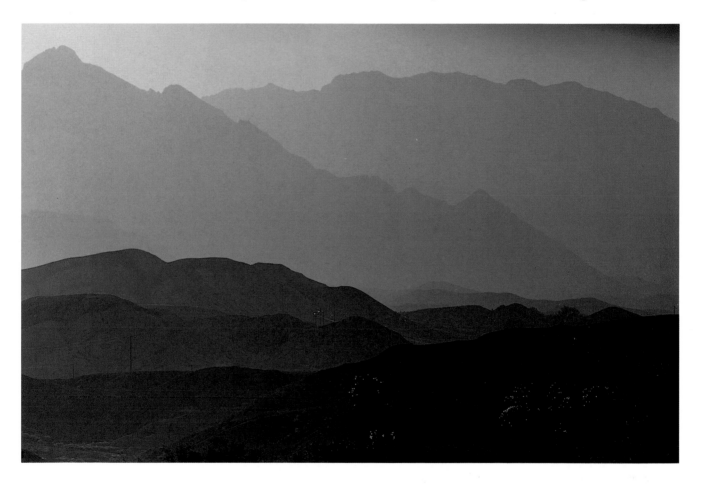

Atmospheric conditions, such as heat waves and pollution-laden skies, increase the compression effect associated with longer telephoto lenses. Shooting in the Southwest one hot day, I noticed that these vehicles seemed to be coming up out of the heat waves (left). I used a 400mm very long telephoto lens and a 35mm to record this scene. For the shot of the mountains, I used a 75-300mm zoom lens set at about 250mm in order to exaggerate the effects of a hazy, polluted layer hanging over the outline of some distant hills.

One way to minimize the problem of atmospheric interference is to use filters. You can choose glass filters that are screwed onto the front of the lens (left), then gel filters that fit into a metal holder (center), and rigid plastic squares that slide into a slotted mount (right).

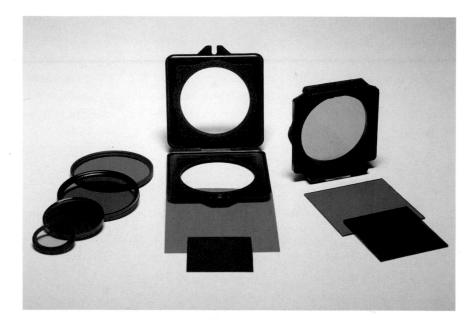

The polarizer may be photography's most useful filter. It changes the density of the sky in both black-and-white and color images. I photographed this scene without a polarizer (left) and with one (below). Notice the much deeper blue in the polarized shot. These filters also cut down on glare, and can even act as neutral-density filters in a pinch to reduce the amount of light reaching the film.

mospheric interference is particularly noticeable with very long telephotos; in fact, the effect usually first appears when you use a 200mm lens in the 35mm format.

You can work around this condition several ways. Shoot on clear, cooler days when the amount of atmospheric interference is less apparent. Warm or hot humid days have the highest levels. Shooting on either cold, dry days or after a good rain anytime of the year is best. You can also try using a *skylight* filter, an *ultraviolet* or *UV* filter, or a polarizing filter. Skylight and UV filters reduce the amount of ultraviolet light reaching the film, which helps eliminate the flat, low contrast these wavelengths have on film. Polarizing filters, or *polarizers*, decrease the amount of reflected light produced by particles in the air, which results in the fogging effect. Another alternative is to either compose your shot with as little of the distance in the picture as possible, or to shoot right into the atmospheric interference to achieve a sense of depth—a result of the hazier objects in the distance. I've also had some success masking the haze on the horizon by using *graduated-color* filters to "dress it up" or make it seem more like unusual light.

Polarizers cut down on reflections, thereby enhancing color saturation. In black-and-white photography, polarizers can also turn clear skies very dark and when used with a red filter, can actually make them black.

CHAPTER 5

Medium-Wide

If I had to guess which type of lens, wide-angle or tele-photo, a new photographer would be more comfortable using after the standard lens, my answer would probably be a wide-angle. First of all human vision takes in a very wide view, and most beginning shooters like the idea of getting a lot of what they see on film. Unfortunately, this often results in busy pictures in which the center of interest competes with other elements. Furthermore, new shooters usually haven't learned the value of looking for the right camera viewpoint. In other words, they don't frame the image from a position that shows both a clear center of interest and its balanced (complete) relationship with the other elements. All this results in images that can be characterized as wide-angle snapshots: they are too crowded and too busy, and lack a well-defined subject. When beginning photographers first use wide-angle lenses, just about all they can do without too much trouble is to photograph large groups and in crammed spaces, such as interiors.

Clearly, wide-angle lenses require more knowledge of composition and more practice composing than any other type of lens in order to be used effectively. Also, moderate-wide-angle lenses really don't adequately prepare new photographers for the more dramatic effects of medium-wide-angle and ultrawide-angle optics. The very wide lenses record much more subject matter on film than moderate-wide-angle optics. This in turn means having to work harder at sorting out more elements in the composition over a larger field of view. In addition if you don't use the wider-angle lenses at a reasonable distance from the subject in a level, straight-on position, all kinds of very pronounced distortions will result. This might encourage some photographers to go for "wild and wacky" wide-angle effects, and cause others to reject the results as unacceptable because of their unreal quality. There is, of course, a middle ground in which the full potential of these lenses to organize reality differently is explored.

I used a 24mm wide-angle lens on my 35mm camera positioned to lower the horizon line in this "spreading skies" picture. I then added an 80 magenta filter to enhance the gloomy day.

and Ultrawide Lenses

Sometimes I like to use ultrawide-angle lenses to "gather up" visual elements in a close shot. For this picture of Southwest Indian sculptures, I chose a 20mm ultrawide-angle lens and a 35mm camera (above). When I used the exact same equipment for the water shot, the water seemed to be getting pulled toward the camera (directly above). This happened because I shot from a low camera position, barely a few inches off the ground. In addition, the foreground was extremely enlarged.

MEDIUM-WIDE-ANGLE VS. ULTRAWIDE-ANGLE LENSES

Very wide lenses produce images that are singular by virtue of their extraordinary angles of view. In addition to the medium-wide-angle and ultrawide-angle forms, there are also two special classes of wide-field photography that offer even larger angles of view: the *fisheye* lens with its curvilinear appearance, and the *panoramic* camera with its ability to rotate to achieve increased fields of view. So unlike telephoto lenses in which the angle of view gets narrower and narrower, resulting in more magnification and compression, very wide lenses have an angle of view that continually increases. This eventually gives rise to lenses and cameras that encompass as much as 360 degrees of the visual world on one piece of film.

The angle of view of medium-wide-angle lenses ranges from a little more than 60 degrees to about 80 degrees horizontally, while the ultrawide-angle lenses begin at 80 degrees and can go as far as 110 degrees. Medium-wide-angles have rectilinear designs. Conversely some ultra-wide-angle designs show curvilinear distortion, but the current trend is to build highly corrected rectilinear lenses. Curvilinear optical distortions are unavoidable in the design of the fisheye lens.

There are two types of fisheye lens: the *circular* lens, in which the entire image appears as a circle within the outlines of the film format, and the *full-frame* design, in which the angle of view is slightly less and the image completely fills the film format. These frame-filling lenses also show less optical distortion. Furthermore it is possible to take a picture with them in which the curving of straight lines isn't obvious, or is at least hidden within the circular contours of a rounded subject, such as elliptical stadiums or arenas.

Panoramic cameras involve a different method of achieving a wide field of view. There are three classes of panoramic cameras, all of which use very long aspect-ratio formats, starting at 1:2 and going up to 1:6 or even 1:10. The class with the smallest angle of view, which is between approximately 80 degrees and 90 degrees horizontal, calls for *fixed*, or *nonrotation*, lenses on special cameras with 1:2, 1:3, or 1:4 aspect ratios. These fixed-lens or nonrotation-lens panoramic cameras, such as the Linhof PC612 and the Fuji G617 cameras, are known for their distortion-free, wide views because they're almost always positioned level and at a distance from the subject. The two remaining types of panoramic cameras are very different machines. In the *short-rotation* or *swing-lens* models, whose angles of view range from 110 degrees to

150 degrees, the lens moves, or sweeps, over the film and lays down an image through a narrow vertical slit; this slit is called the *slit-scan shutter*. With the *full-rotation* models the entire camera rotates in a circle, also using a slit-scan shutter in order to take in views up to and beyond 360 degrees.

With medium-wide-angle and ultrawide-angle lenses, you'll find the greatest variety of lens designs and brands among 35mm models; there are even a few wide-angle zoom lenses to choose from. For medium-format photography, there is a full selection of medium-wide-angle optics, as well as special wide-angle cameras of both fixed and interchangeable focal lengths. These include the Cambo Wide Cameras, the Gowland Flex Wides, and the Fuji fixed-lens, medium-format GSW69011 and GS645W models. While features among these cameras vary, they are all limited to use with medium-wide-angle lenses. There are no wide-angle zooms in either medium- or large-format photography, and no fisheye lenses with a covering power that is big enough to produce full-frame fisheye effects in large formats. You can, however, use one of the several full-frame fisheyes available for medium-format work to produce a circular fisheye image with a sheet-film camera, but you must use one that has a built-in shutter.

As far as ultrawide-angle lenses for medium- and large-format photography go, a few have angles of view of about 80 degrees. With large-format cameras you can theoretically use, for example, a 120mm lens on an

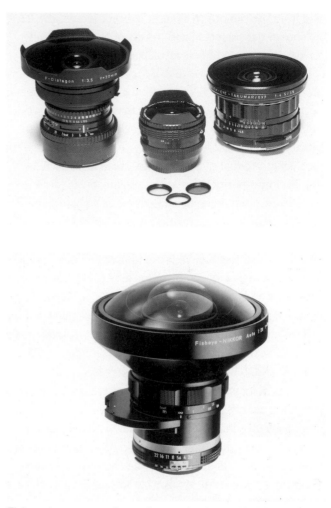

Fisheye lenses come in two forms: circular and full-frame. Lens hoods are minimal, and corresponding filters are the rear-mount type. Some of the fisheye lenses available are the 30mm fisheye lens for 6 × 6cm cameras (left), the 16mm fisheye lens for 35mm cameras (center), and the 35mm fisheye lens for 6 × 7cm cameras (right). No full-frame fisheye lenses are available for larger formats.

8 x 10-inch sheet of film to produce an angle of view of 92 degrees. But the question is whether or not this potential angle of view can be translated into reality. That is, can you get full coverage of an 8 x 10-inch image? Finally, panoramic cameras are available in medium-format and 35mm only. You can, however, convert a large-format camera into a nonrotation-lens panoramic camera with a 1:2 aspect ratio by using a 6 x 12cm rollfilm back. These are available from Horseman, Sinar, and Linhof.

THE EFFECT ON THREE-DIMENSIONAL REALITY

As pointed out earlier, wide-angle lenses affect the translation of three-dimensional reality into a two-dimensional photograph in a number of ways. By increasing the field of view, the lenses produce expansion in the image by increasing the apparent distance between subjects along a

There are several ways to produce medium-wide-angle and ultrawide-angle effects. The 38mm medium-wide-angle lens on a 6 × 6cm camera has a Polaroid back attached (top left), the Fuji 6 × 17cm panoramic camera is equipped with a 105mm lens (top right), the 25mm wide-angle lens is on a revolving-lens panoramic format (bottom left), and the rectilinear 15mm ultrawide-angle lens is on a 35mm camera (bottom right).

line from the camera to infinity. In other words, the lenses spread the subjects out in terms of both width and length. The depth of field also appears to increase.

So, for example, a setting of $f/5.6$ on a 150mm moderate-telephoto lens in 6 x 6cm photography provides a hyperfocal distance of 130 feet. But that same setting on a 50mm medium-wide-angle lens yields a hyperfocal distance of about 6 1/2 feet to infinity. If you then change the focal length to that of an ultrawide-angle lens, such as a 40mm, the hyperfocal distance drops to as little as 2 1/2 feet. Here, then, keeping large areas of a photograph sharp is far less of a factor than it is in telephoto photography. In addition the problem of camera shake is minimized, so shooting handheld at slower speeds is possible with these very wide lenses. This is because the lenses really spread out subject matter, thereby greatly increasing the distance that a moving object has to travel on film.

These wide-angle lenses also have a strong tendency to exaggerate the size of objects or areas close to the camera, and to diminish the size of far objects. So when the focus point is much less than infinity, maintaining realistic sizes and perspective is a problem, especially with very close objects. And even using a very wide lens at infinity requires you to be concerned about how close the foreground is to the camera. At the same time, though, backgrounds are made smaller but are more likely to be in sharp focus because of the extraordinary depth of field. Your best chance for creating natural-looking images occurs when the camera is level and parallel to a subject, and set at infinity. Any other condition produces pronounced apparent distortions in both medium-wide-angle and ultrawide-angle lenses. With fisheye lenses and panoramic cameras the results are also dramatic, but somewhat different (see pages 110–113).

Camera Viewpoint. The best way to think about how camera viewpoint influences composition is to consider how it affects visual lines in a scene, both horizontal and vertical. For example, a low but level camera viewpoint results in exaggerated foregrounds because by definition a low viewpoint usually means putting the camera close to or on the ground. In addition, the extended depth of field that this viewpoint offers can produce a sharp picture right up to the lens.

Some photographers call this the *rug* or *runway* effect. The exaggerated appearances of both the foreground and the depth of field combine to make any horizontal lines in the picture head toward a vanishing point. Suppose you're photographing a desk and position the camera just above it. In the final image the bottom end of a notepad lying on the desk will be larger than the top end and the sides will therefore converge inward toward the top.

I often regard my medium-wide-angle lens as the most useful of my wide-angle lenses. The resulting images are distinctly wide but offer a high degree of believable perspective. In this shot of a monument in the Soviet Union, which is a study of generational contrasts, the massive sky area makes the picture work (above). A 24mm medium-wide-angle lens was used to effectively lengthen the model's legs (left). Courtesy of Robert Farber.

For this shot of a geyser field I chose a highly corrected, 38mm ultrawide-angle lens on a 6 × 6cm camera to stretch out the subject matter a little (above). Sometimes, however, curvilinear distortion can make a good picture a great picture. Moving in close to one end of this already curved row of houses, I used a 20mm ultrawide-angle lens and a graduated filter to create a type of curvilinear distortion (left).

If you then raise the camera above the desktop by just a few feet, the shape of the pad will take on a more natural appearance. This is because the distance between the bottom and the top of the notepad in relation to the film plane isn't as great as it was when the camera was close to the bottom of the pad in the low-angle view. Under such conditions, the movements of a typical view camera along with an extended-coverage wide-angle lens truly come into their own. And by adjusting the film plane

and the lens plane, you can reduce even further the disparity in the distance between the camera and the top and bottom parts of the notepad.

But if the focus point was a distant subject, such as a cityscape, and you held the camera parallel and level to it, you would achieve a natural-looking perspective. In this situation, the distance between the film plane and the entire subject plane (the front of the buildings) is the same. If, however, you make even the slightest change in the camera's parallel position, all of the vertical lines in the scene will converge in the direction of the tilt.

To understand what happens to the horizon line here, think about the notepad example again. Suppose that the desk is in front of a window with a set of (horizontal) blinds and a mountain range in the distance. You can test the effect that tilting wide-angle lenses has on horizontal lines, both near and far. If you tilt the camera down, medium-wide-angle and ultrawide-angle rectilinear lenses won't bend either the blinds or the mountain range; however, a curvilinear lens of any focal length, particularly a full-frame fisheye lens, will bend all of the horizontal lines, near or far. This will be true even if you hold the lens level. Only those horizontal lines that run through the dead center of the picture will appear straight. So if you could place the mountain range in the center of the image, the mountains would show little or no curving.

Using Medium-Wide and Ultrawide Lenses. Wide-angle lenses are designed to record more of a scene on film, and accordingly they are the lens of choice when this is your goal. For example if you don't have the option to move away from your subject when working with a

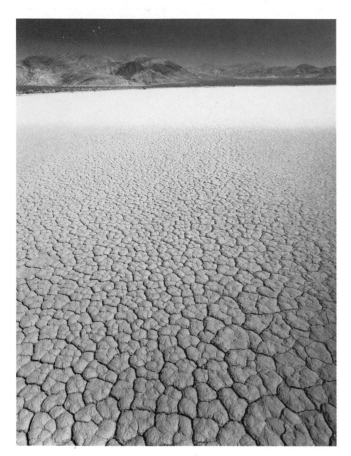

Knowing that wide-angle lenses are ideal for landscapes, I decided to capitalize on the foreground exaggeration that they produce for this picture of a salt flat. I used a 15mm ultrawide-angle lens positioned very low to give a sense of the dried-up desert floor (above).

For this shot taken in Utah's San Juan State Park, I used a 20mm wide-angle lens on a 35mm camera in order to capture the sprawling, twisting river and the channel rock formation that it had created.

moderate-wide-angle or standard lens, you'll have to consider using a shorter-focal-length optic. There are, however, some good compositional reasons to choose a shorter lens. You might, for example, want to take advantage of the way it translates wide-field subjects onto film. More specifically, a shorter lens spreads out the apparent distances between subjects in a scene and generally bolsters the sense of expansiveness. In pictures of a desert landscape or a seascape the diminutive size of specific objects—particularly those in the middle- and far-distant areas, such as trees or rocks—helps create the illusion of a great, sprawling vista. Moderate-wide-angle lenses can't match this effect.

Another compelling reason for selecting shorter lenses is their tremendous depth of field; this enables you to record sharp images from close to the camera all the way to infinity. This feature can have a unifying effect, allowing you to say in one sweeping shot what would require several shots with a longer lens. To help establish this greater sense of depth, you can use such elements as sharply focused tree limbs or fences in the foreground to frame a distant scene. You can also include a wall in the foreground that extends into the background to illustrate the expanse of a particular structure.

Wide-field photographs need as much help as possible in order to convey a sense of depth and detail. This is in part why some of the best shooting times are when the sun is at a sharp angle to the scene, casting long shadows. Under these circumstances viewers get a strong impression of the three-dimensional nature of, for example, trees, rocks, gullies, and houses. This is because the black shadows set these structures apart from the ground. Conversely when the lighting is flat, depth is lost and everything looks flat; objects are devoid of any distinguishing characteristics and blend together.

Furthermore when you photograph the natural environment, the sky—especially one with a mix of clouds—is dramatically affected by very wide optics. Remember, wide-angle lenses squeeze more subject matter on film than other optics. Therefore, if you use one to photograph a field with rows of small plants that ran parallel to the lens axis, these lines will diverge more as they approach the camera than they would with any other type of lens. This is a result of foreground expansion.

The same effect occurs with clouds in the sky, but is often much more clear-cut with them than with ground patterns because there are no single, dominant competing structures. Because the clouds spread out like a fan, they

The ability of medium-wide-angle lenses to emphasize and isolate foreground subjects and at the same time to take in large areas of middle ground have made these lenses a favorite of public-relations photographers and photojournalists. I chose a 24mm medium-wide-angle lens and a 35mm camera to make the purpose of this demonstration clear.

seem to be heading toward a very distant vanishing point. This creates a sense of depth. On the ground, however, houses or tree lines can break up a converging pattern of parked cars. The "spreading-sky" effect is more characteristic of ultrawides than it is of other wide-angle optics, even when you hold the camera parallel to the scene. The lenses' greater angle of view exaggerates the fanning-out effect more than that of either medium- or moderate-wide-angle lenses, and the camera viewpoint is typically directed toward the center of the scene.

Suppose that you're on the ground photographing a seascape with clouds. Here, the level viewpoint automatically places the horizon line in the lower third of the picture. This results in much more sky and a greater degree of *divergence* in the photograph. If you then decided to tip the camera up, the effect will be even more noticeable because the sky area is now proportionally larger and the film plane is no longer parallel to the scene.

Isolating a Subject. It might seem contradictory because wide-angle lenses are able to spread out subject matter and capture wide fields of view, but you can also use wide-angle lenses to isolate and emphasize specific subjects. To achieve this, you must decrease the camera-to-subject distance and manipulate the differences between the foreground and background. Unlike the camera viewpoint for a wide shot in which the camera is usually level to and quite a distance from the scene, the vantage point for a shot in which you want to isolate a subject is close and low. This shooting position makes the selected subject much larger

and therefore dominant, and often causes any lines that are present in the foreground to recede toward the subject. This provides viewers with a visual path to the center of interest and makes it pop out.

Why not use a telephoto lens to magnify the primary subject instead? Wide-angle lenses magnify subjects without compressing them the way telephotos do. In fact, other effects take place instead. First you can place the enlarged subject within a much wider field than the one a telephoto offers. And the foreground exaggeration makes it possible for such elements as receding lines to lead viewers toward a subject placed in what might be called a *middle-foreground* position where it still will be fairly large in size. So wide-angle lenses make it very easy for you to establish relationships between the main subject and secondary elements in a scene.

Photographing Large Groups and Interiors. There are times when medium-wide-angle and to a lesser extent ultrawide-angle lenses are pressed into service to photograph large groups. As discussed earlier when you shoot this type of subject, you should go to your next widest lens only when it is necessary because you have a limited amount of space to back up in or because a more dramatic composition is desired. The main concern with shooting groups with ultrawide optics is the stretching out of subjects at the far ends of the picture, especially when you are in close. Another problem concerns using a flash unit with a beam wide enough to cover a 90-degree or 100-degree angle of view. Even with a wide-angle attachment, most units can't handle these angles. Furthermore if the units are modified to do so, there is a significant loss of power. This drop-off forces you to move in close, thereby increasing the risk of edge distortion. So while you can work with ultrawide-angle lenses for large-group shots, you must pay attention to these drawbacks.

Medium-wide-angle optics, on the other hand, do a better job because they don't push the limits of flash coverage and power. This enables you to position yourself far enough back from the subject so that you can control apparent distortion. But even when you position yourself in close to shoot, the alteration of a natural representation produced by, for example, a 28mm lens on a 35mm SLR isn't nearly as pronounced as that of a 20mm lens.

Tight shots of room interiors or other subjects bring out the best and worst of the shorter wide-angle lenses. In these situations, the lenses supply the wide field of view that you need, but will exaggerate near objects or show convergence if they're not used at a viewpoint that is close to halfway between the ceiling and the floor. Keep in mind, too, the stretching effect at the edges that might distort parts of the room, such as doors or windows. The best approach for tight pictures is to use a camera capable of lens and back movements. Large-format cameras and a few medium-format view cameras are able to make such corrections when used with extended-coverage lenses.

I used a 17mm ultrawide lens on a 35mm camera to bend the wall on which these organ pipes were arranged in this interior shot.

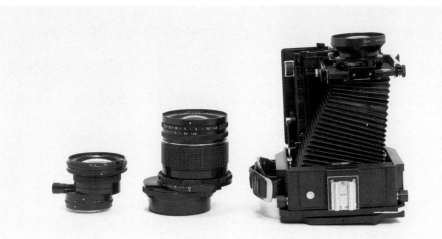

Line divergence can be controlled a number of ways. The simplest method is to find a viewpoint that eliminates the possibility of this type of distortion. You can also use a small-format (left) or medium-format (center) PC lens, or the movements of a view camera (right).

Special Considerations. Before you move on to fisheye lenses and panorama cameras, there are several aspects of conventional medium-wide-angle and ultrawide-angle lenses you should be familiar with. Because of their very wide angles of view, you must pay careful attention to lens flare from light sources. This problem is compounded by the corresponding lens hoods, which have to be quite shallow, and in the case of the widest optics, are only a few millimeters in depth. Fisheye lenses, as you can surmise, are particularly susceptible to flare. To prevent flare from ruining your images when you use a very wide-angle lens, avoid direct light from falling on the lens' front element whenever possible. I often look for a shady viewpoint and shoot just on the edge of the shade, but in such a way that I don't include it in the foreground.

In addition to the small coverage of the lens hoods, the thread sizes of very wide-angle lenses tend to be very large as do, obviously, filter sizes. As such, and because using more than one filter plus a lens hood will probably cause vignetting, many manufacturers make *rear-element* filters for very wide-angle lenses, including fisheye lenses. One drawback is that you can't use many of the more unusual filters, such as graduated-color or even polarizing filters, with these lenses. Most rear-element filter selections are limited to a few colored filters for use with black-and-white films and some type of UV or other haze-cutting filter.

PERSPECTIVE CONTROL

The apparent distortion caused by a viewpoint in which the camera is tilted up or down is a bothersome problem with wide-angle lenses. The resulting convergence of straight lines, or *keystoning*, is perhaps the most common

form of "use distortion" and merits special attention. Both 35mm and medium-format users accept this limitation of the camera design because there is little that they can do besides changing the viewpoint to keep the film plane parallel to the subject. Most large-format cameras, on the other hand, enable you to move just the lens to take in a higher (or lower) view of the subject while having it remain parallel to the film. This is called a *camera rise* or *shift*, and is only one of the many controls over distortion that view cameras provide.

Perspective-Control Lenses. To prevent keystoning, photographers who work with 35mm and medium-format SLR cameras use a wide-angle *perspective-control*, or *PC*, lens. This type of lens is designed so that you can move the front half of the barrel containing the optics horizontally, vertically, or diagonally between 10mm and 20mm while still keeping it parallel to the film plane. As such, this mimics a view camera's shift mechanism and explains why PC lenses are also called *shift* lenses. And like view-camera lenses, these optics must have more covering power than is necessary for the format since they're moving off-axis, or off-center. So the circle of coverage must be large enough to cover the film format when the optics are shifted 10mm to 20mm off-axis.

Using a PC lens is quite simple and straightforward. Mount your camera on a tripod, and compose the shot while keeping the camera level and parallel to the subject. Suppose you're shooting a tall building. Because of the camera viewpoint, the upper half of the building won't be included in the picture. So rather than tilt the camera, shift the lens vertically until enough of the building comes into view. You are now ready to take the picture of the building, which will be devoid of convergence.

Watch out for some potential problems. First of all, the light-transmission levels when the lens is in nonshift and shift positions might be different. This is partially a consequence of the extended covering power of PC lenses and the light falloff that occurs at the edges of images taken with wide circles of coverage. So it is a good idea to test exposure differences by comparing on-axis, or on-center, images in the nonshift position with those taken at various shift distances, all the way to the extremes of the lens' covering power. Use slide film because it is so intolerant of incorrect exposures. Note any differences in meter readings. Most PC lenses have preset designs, and only a few are capable of automatic-exposure operation. Recently, Canon made available the first autofocus PC lenses. Also make sure that the direction of the camera movement—horizontal, vertical, or diagonal—remains within the limits of the lens coverage. If it doesn't, vignetting, which consists of

If you overshift a PC lens, the unwanted effect seen in this picture of a building at sunset will occur.

underexposed areas on the edge of the film, will occur.

PC lenses are larger than comparable lenses, and have slower maximum apertures and larger filter sizes. Otherwise in the nonshift position, they are just like wide-angle lenses of the same focal length. And in addition to perspective correction, PC lenses offer alternative uses. For example, you can make two-shot panoramics very easily with PC lenses. All you have to do is mount the camera on a tripod in a level position for a horizontal shot. Then shift the lens as much as desired to one side, shoot, advance the film, and shift to the other side for a second shot. The resulting two-shot panorama won't manifest the typical distortions caused when you turn a camera to the left and right on a tripod. In this case, the film plane doesn't remain parallel to the subject so line convergence on the horizontal plane results.

Panoramic shots taken with PC lenses are in perfect alignment with one another, so the transparencies can be stripped together into a single perfect image by a lab or printed together by a skilled darkroom worker. Two images can also be presented as two separate parts of a segmented photograph. Whatever approach you decide on, the gain in the total angle of view is significant. For example, a 28mm PC lens that has an unshifted angle of view of 64 degrees can enlarge the view to 92 degrees in a two-shot panorama when each picture is 11mm off-center on the horizontal plane.

The ability to move your lens off-axis also comes in handy when you try to frame a shot from a low camera angle, which otherwise allows the unwanted foreground to dominate. Tilting the camera up eliminates the foreground, but results in convergence. Here subject

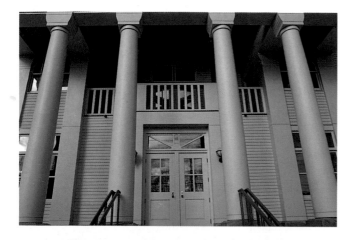

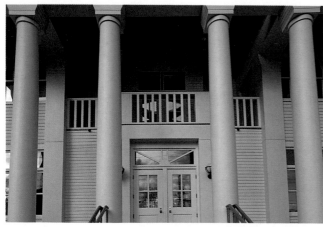
For these pictures of the Salisbury, Connecticut town hall, I used a 28mm PC lens (directly above) to correct the distortion of the building (above).

sizes in the upper half of the picture are generally diminished, whatever appears in the foreground dominates, and converging lines appear. But if you shift the lens up via the PC mechanism, all proportions remain the same and the unwanted foreground is avoided. You can also take advantage of this approach on the horizontal plane to get around such objects as telephone poles when you can't move your camera position. When you compose, you can often just shift the pole either out of the picture or to the edge of the frame and still see enough of the scene to fill the viewfinder.

Another characteristic of PC lenses is that when you are close to a subject and in full shift, the area of greatest shift tends to stretch out close subject matter—just as an ultrawide-angle lens does at the edges. This allows you to exaggerate certain effects, such as a *pan-blur* shot. For example, in a car shot that already shows motion from a blurred background by virtue of a slow shutter speed, the car seems to leap forward because of the "PC stretch" at its front end. To achieve this all you would have to do is shift to the maximum horizontal position in the direction of the car's movement, get in close enough so that the subject takes up about two-thirds of the frame, and place the car's hood in the area of the shift. You would also use the typical 1/30 sec. or 1/15 sec. shutter speed, depending on how fast the car is going. These pan shots aren't as easy when you work with shorter lenses because you have to get in so close.

Finally, you can use PC lenses to create speed streaks in photographs of static subjects, such as a parked fire truck, by mounting the camera on a tripod and setting the exposure to at least 1/2 sec.; 1 sec. is preferable. Next as

When you shift a PC lens during a slow exposure, speed streaks like those in this shot of a fire truck result.

you fire the shutter, shift the lens in the direction you want the streaks to go. Try to select a subject that has areas of light color surrounded by a darker color, such as white letters on a red door. The streaking lighter color will stand out against the darker door.

PC lenses are a favorite of architectural photographers, who need to make geometrically correct images of buildings and other structures. Usually these photographers rely on the superior movements and image quality of large-format view cameras. But there are times when medium-format cameras are adequate. In addition, the photographers often need to shoot 35mm slides for presentation and/or documentation purposes. The convenience of these two rollfilm formats is an irresistible advantage over a view camera, from setup to film loading to processing. Two other types of photographers also prefer PC lenses: landscape and nature photographers. These specialties involve very large vertical subjects, including waterfalls, cliffs, and tall trees.

PC-Lens Accessories. I highly recommend using some accessories when working with PC lenses. Because of the shift feature an oversized lens hood is a must, as are oversized filters. Front lens threads of 72mm are quite common with 35mm PC optics, and medium-format lenses require even bigger sizes. Another helpful item is a *bubble level* that can be slipped into the *accessory* or *hotshoe* of a 35mm camera, while a small *hand level* can be placed on the viewing screen of a medium-format camera to measure its position. I find that a *single-circle bubble level* is the easiest type to use—and that a good ball head is invaluable. Also, the view screen that has two to four horizontal and vertical lines running in a grid pattern across the viewfinder is a real help in composing and can even replace the need for a bubble level.

All PC lenses have the ability to shift horizontally, vertically, or diagonally while remaining parallel to the film plane. A few lenses also permit you to control field curvature by moving the lens in and out of parallel to bring objects that aren't on the same focusing plane into focus. Through this *tilting*, as it is referred to with view cameras, PC lenses come even closer to the capabilities of a full-movement camera; but at best, shift and tilt lenses are limited in the amount of change they produce. All in all, however, these lenses are very versatile optics for photographers who require control over convergence and who are willing to experiment.

Fisheye Lenses. These lenses, with their circular perception and bulbous effect on subject matter, are probably the most unusual lenses used in general photography. They're also considered the most limited in terms of application. The circular type, which records 180 degrees of a scene on film, is referred to as a "true fisheye." Although the resulting round images are appropriate for only a few situations, there are some interesting ways to use them. For example, if you move in very close to a subject—which is possible with these lenses—from a straight-on position, whatever is in the center of the field of view will continue to get bigger until it dominates the picture. Conversely moving away from the subject allows you to have objects on the edges of the scene bend inward and form a frame for the center of the image, such as a group of buildings surrounding a plaza.

The key to composing when shooting from these viewpoints with a fisheye lens is to remember that you can still use distance to emphasize a particular subject. But because of the lens' tremendous angle of view and curvilinear nature, achieving isolation with a circular fisheye lens is very hard unless you come in right on top of an object. Even then you wind up with so much distortion that the optical effect itself causes more of an impression than the subject isolation. A second point to keep in mind is that you almost give up the option of using straight lines to direct viewers toward a subject or to establish depth. The lines are still present, but they are curved toward the center of the picture. This diminishes some of their visual impact and their capacity to direct the eye. As a result, while circular fisheye lenses are considered to be wide-angle lenses, you must use them differently to take advantage of their full potential.

Fisheye lenses work best when the space is so limited that only 180 circular degrees can record enough of the scene on film for viewers to get a sense of the setting. Everyone has seen shots of the inside of space capsules or other small enclosures that were made with these lenses. Fisheyes are also used purposely because of their optical and apparent distortions for photographs of people, ranging from portraits to nudes. Here, the distorted view becomes as much a part of the visual statement as the subject.

You can also shoot from the ground pointing the camera directly up at the sky for a unique 180-degree image. This "worm's-eye" approach draws in the trees or fronts of buildings around the periphery of the film frame. Such an arrangement is particularly effective if these objects are fairly close to the camera, such as in a small plaza or a clearing in the woods. When you shoot from this perspective, the curved vertical lines of the building appear fairly straight as they radiate toward the center of the picture, like spokes on a wheel. And when something is in the center sky area, such as a cloud formation, a

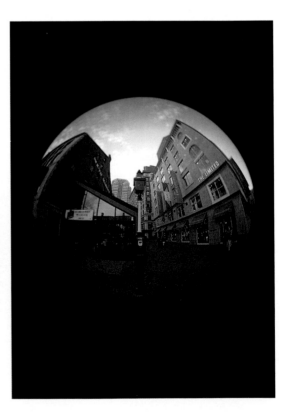

Circular fisheye lenses have only limited applications because of their circular image shape and extreme curvilinear distortion. But the 8mm circular fisheye lens I used to shoot my small yet well-equipped darkroom recorded the entire work area (above). In the shot of a quaint shopping area complete with a cobblestone street taken with a Spiratone 75mm circular fisheye lens, the pole in the center of the image remains straight (right).

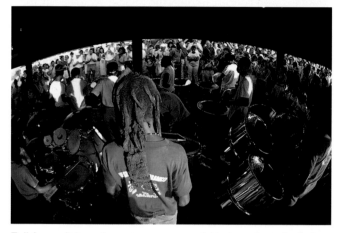

Full-frame fisheye lenses are very useful but much neglected lenses, despite their extraordinary abilities both to isolate a subject and to record large areas of a scene. These lenses work particularly well for photographing a circular or elliptical subject like New York's Madison Square Garden (top left). When used up close, full-frame fisheye lenses enable you to focus on a very specific section of the scene, such as this car logo (right). By using a circular fisheye lens close to this band, I was able to make it the center of interest and to play down the rest of the scene (bottom left).

plane, the moon, or even the sun on a hazy day, you can establish a relationship between it and the objects surrounding the frame.

You might also try a bird's-eye view. It produces the same effect as the worm's-eye view, but it is more likely to seem to have been taken from the air. The one problem associated with the bird's-eye view is preventing the structure you're standing on or in—a building, a ladder—from being included in and dominating the picture. One solution is to suspend the camera from a pole on a bridge or overpass and trigger it remotely. Shooting from a low-flying helicopter close to the scene would, of course, produce the best image.

Full-frame fisheye lenses completely fill the film's format. As a result some but certainly not all of the curvilinear effect is eliminated, and the area that contains the least amount of distortion, the center, takes up proportionally more space than the 180 degrees of the circular fisheyes. The full-frame fisheyes provide wide angles of view of about 150 degrees and can be used in a higher number of shooting situations. Nevertheless, the bending of straight lines is still prevalent.

When you work with a full-frame fisheye lens keep in mind that as you move in on a subject, horizontal lines bend back into the picture, thereby creating an elliptical appearance. This enables you to really frame an isolated subject. Also, low camera angles let you focus very close, and because the curved lines disappear into the background, you can establish a sense of depth. Also, elliptical or semicircular subjects, such as stadiums, can be recorded with more of a sense of their spherical forms. Finally, these optics have an extensive field of view that when carefully used on wide scenes to mitigate the bending of prominent straight lines, can give you a picture of great expanses. This ability is unmatched by the widest of the ultrawide-angle lenses.

All of these points are simply points of departure; you should begin experimenting to see what you can achieve. In that sense you should regard my suggestions as guidelines to follow until a clear idea of what full-frame fisheye lenses can do emerges. Carrying the lens around and looking at various compositions and possibilities is a good start. As soon as the lens feels comfortable and familiar, ask yourself what the effect will be before checking with the lens. Once this becomes second nature to you, you can break away from my guidelines and see what you come up with yourself.

Panoramic Cameras. The three types of panoramic cameras—nonrotation-lens designs, and those in which either the lens or the whole camera rotates—record scenes on a long, narrow format that is at least twice the length of conventional film. Typical film configurations for panoramic cameras are 6 x 12cm, 6 x 17cm, and the less common 6 x 24cm (for the Art Panorama 624 camera). The corresponding aspect ratios are 1:2, 1:3, and 1:4,

respectively, compared to 1:1.5 or less for conventional photographs. Full-rotation 360-degree cameras can produce aspect ratios up to 1:10.

With panoramic cameras, you take pictures level to the subject in the center third of a typical rule-of-thirds composition at fairly long distances. This means eliminating much of the foreground (where size exaggeration occurs), as well as upper areas of the scene, such as "spreading skies." The result: photographs of beautiful, distortion-free vistas that seem to close in on the middle ground of a typical wide-angle composition. This almost gives them a "wide-telephoto" look. Rotation cameras also concentrate on the middle ground, but they obtain their much larger fields of view via the movement of the camera or lens. Furthermore, most of these cameras are equipped with moderate-wide-angle lenses and use slit-scan shutters (see page 101). Clearly, then, panoramic images take in very wide views and have a decidedly different look from conventional wide-angle-lens photographs.

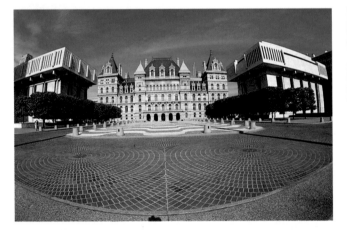

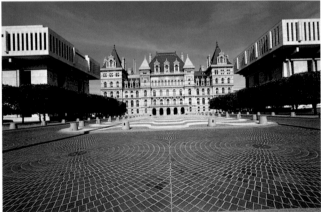

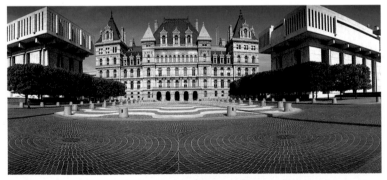

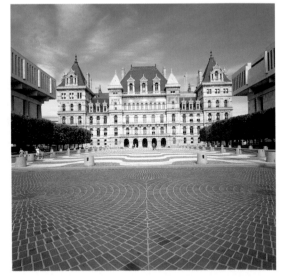

Rotation cameras and square and rectangular formats produce very different results. Shooting this ornate building from the same position, I used a 38mm lens on a 6 × 6cm camera (right), a 16mm fisheye lens on a 35mm camera (top left), a rectilinear 15mm lens on a 35mm camera (top right), and a 25mm rotation lens on a 140-degree short-rotation camera with a 1:2 aspect ratio held horizontally (above).

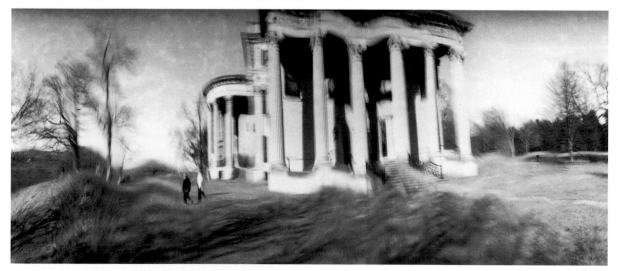

Panoramic cameras are an alternative to wide-angle lenses. Nonrotation-lens models enable you to shoot long, distortion-free images. To take advantage of the unique nature of the panoramic format, I moved a short-rotation panoramic camera up and down while shooting this building with columns (directly above). The distortion produced by rotation-lens cameras involves both the subject matter and the camera perspective. I used a 140-degree camera with a 1:2 aspect ratio to shoot these ships, which appear curved (top). But the same camera equipment produced normal-looking planes; only the lines on the field show signs of bending (center).

CHAPTER 6

Special Lenses

All photographic lenses have applications for which they're very well suited. Certain situations, however, require much more specialization in optical design. The special-purpose lenses discussed here were developed to meet specific needs. Some are even versatile enough to be used in general photography, despite their specialized nature. That is particularly true of *close-focus* and PC lenses. Others, such as *enlarging* lenses, are more limited and can be used for only a few applications.

CLOSEUP LENSES

Most photographic lenses are designed for distances of at least 2 to 3 feet to infinity. If you use a lens at a shorter distance, you should be aware of a number of conditions. First of all, you might not even be able to focus any closer than 3 feet or so, which means that you have to do something to the lens to increase its minimum focusing distance. Next, you have to give some thought to calculating exposure because many of the methods for changing the minimum focusing distance also alter the amount of light reaching the film. This results in the need to increase the indicated exposure. There is also the question of which closeup methods produce the best image sharpness. Finally, you have to consider the effects of camera movement because of the high magnification that results. These changes might seem to present some rather formidable challenges. The real problem, however, isn't how to deal with the complications of minimum focusing distance, exposure changes, and camera stability, but how to choose the most appropriate solution.

Magnification Ratios. Closeup photography is a specialized area and as such has its own terminology and points of reference. The most basic concept is the relationship of subject matter to magnification ratios. Here these ratios, not the lens' focal length, are the primary controllers of how large a subject appears on film.

and Accessories

For this shot, I used a 35mm PC lens at full shift in order to spread out the sky more and to help offset the placement of the horizon line in the center of the composition.

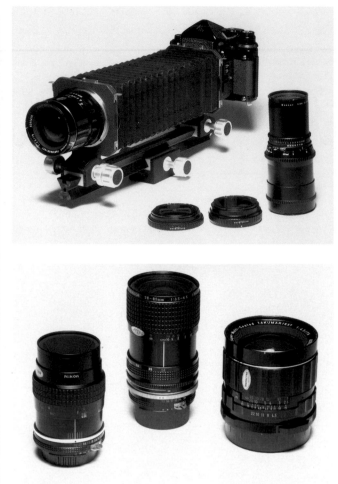

Altering a lens so that it focuses closer can be accomplished three ways. One approach is to attach a diopter lens to the front of the prime lens; for this flower picture, I put a +1 closeup lens over a 105mm lens on a 35mm camera (above). Other methods involve moving the lens away from the camera body via a bellows or extension tubes (top right) or reversing the lens and then attaching it to the camera with a special adapter. Using

telephoto lenses that focus close or macro lenses specifically designed to focus close are other options. These macro lenses have either fixed focal lengths or zoom configurations. For example, there are a 55mm fixed-focal-length macro lens (bottom right on the left), a 28-85mm zoom macro lens (bottom right in the center), and a 135mm medium-format macro lens made for a 6 × 7cm camera (bottom right on the right).

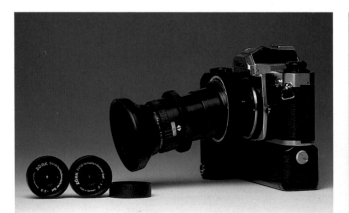

Closeup photography often requires special techniques to overcome problems with shallow depth of field and low light. Some unique solutions include the Zork pinhole adapters that are attached to the front of an enlarging lens mounted on the end of a revolving extension tube (above), and the Macromate from Sailwind that enables you to surround the subject with a translucent hood for very even lighting from a flash unit or sunlight (right).

So a 1:1 magnification ratio, or "life-size" notation, means that you are so close to a particular object that its size on film is equal to its actual size. Consequently a postage stamp measuring 24 x 36mm shot at 1:1, or 1X as it is also termed, will exactly fill a single frame of the 35mm format. You can achieve this magnification with either a 50mm lens or a 1000mm lens; it is the camera-to-subject distance that determines the amount of magnification. Obviously, then, a 50mm lens must be much closer to the subject than a 1000mm lens.

Three terms, *closeup photography*, *photomacrography*, and *photomicrography*, are used—often incorrectly—to refer in one way or another to the various forms of close-focusing photography. Technically closeup photography includes all work done at a lens' minimum focusing distances to a magnification just short of 1:1, "macro" work starts at 1:1, and "micro" work is limited to situations in which a camera is attached to a microscope. The three terms are now used virtually interchangeably. In fact photographers and manufacturers toss around the word "macro," which is used far more often than "micro," so freely that you can't assume that you'll be getting the 1:1 ratio unless the lens specifications indicate this.

The reason why a lens intended for general photography can't focus closer than approximately 2 or 3 feet is that the distance between the lens and the film

Shooting closeups from moderate distances usually calls for working at the close-focusing point of a standard lens and well below 1:1. This applies to copystand photography and shooting artwork. I used a macro lens for the closeup of this paper relief (left). The sculpture was photographed with a 105mm lens (above). Courtesy of Ivan Nosenchuck (above).

plane is limited by the focusing mechanism. This is especially true of 35mm cameras and most medium-format cameras. Large-format cameras with long bellows and some 120mm cameras with bellows focusing aren't bothered by this. To increase the *lens-to-film* distance to focus closer, use some sort of extension apparatus. Each of the two available methods requires the lens to be attached to one end of the device and the camera body to the other. The simpler option is to use a *fixed-length extension tube*. These tubes come in two forms; you can purchase them in various single-length sizes, which can be stacked, and as an adjustable helicoid that enables you to change its size when mounted. The other alternative is to mount the lens on an adjustable bellows that allows a rather extensive *racking out*, or an increase in the distance between the lens and the camera body, along two rails. Either of these approaches used with a normal lens in 35mm and medium-format photography produces magnifications up to and beyond 1:1.

You can determine what magnification these setups will yield via this very simple formula:

$$\text{Subject Magnification (on film)} = \frac{\text{Length of Extension Tube or Bellows (mm)}}{\text{Focal Length of Lens (mm)}}$$

The results obtained with this equation aren't exactly what you achieve on film because of the complicating factors of slightly different lens designs and the variable effect of the focus setting on the lens itself. But it certainly gives you a good working idea of how large the recorded image will be.

Another way to alter minimum focus without changing the distance to the film plane is by using a diopter element on the front of the lens. This term refers to what extent a lens, either single or compound, bends light, or in other words how a closeup lens affects the change in the lens' focal length. More commonly known as a *supplementary* or *auxiliary* closeup lens, it is a positive, single-element piece of glass or plastic that attaches to the threads of the lens' front barrel. As a result the diopter magnifies the image by actually reducing the effective focal length of the lens, thereby allowing you to focus closer. This is a very easy and inexpensive way to move in to your subject. An added bonus is that there is no change in light levels, so no exposure adjustment is necessary before shooting. (Both extension tubes and bellows require an increase in exposure. See page 122.)

Closeup lenses are commonly available in +1, +2, or +3 ratings, although you can find more powerful ones rated +8 and +10. These lenses can also be stacked. For example, using a +2 lens and a +3 lens yields a +5 lens. If you ever have either the opportunity or the need to stack lenses, be sure to put the more powerful lens on the camera first and always set the convex side of the meniscus lens away from the film plane. Some highly corrected double-element diopters are available. They are about as expensive as extension tubes. You can also change a lens' close-focusing capability by mounting it

THE EFFECT OF CLOSEUP LENSES ON CLOSE-FOCUSING DISTANCES*

Diopter Rating	Distance Between Subject and Closeup Lens (inches)	Area Seen (inches)	
		50mm lens, 24 × 36mm negative	75mm lens, 6 × 6cm negative
+1	20 3/8	9 1/4 × 14	14 3/8 × 14 3/8
+2	13 3/8	6 1/8 × 9 3/4	8 7/8 × 8 7/8
+3	10	4 1/2 × 6 7/8	7 × 7
+4 (3 + 1)	8	3 5/8 × 5 3/8	5 1/2 × 5 1/2
+5 (3 + 2)	6 1/2	3 × 4 3/8	4 1/2 × 4 1/2
+6 (3 + 3)	5 5/8	2 1/2 × 3 3/4	3 7/8 × 3 7/8

* With no filter, the lens is focused at a maximum close distance of 3 1/2 feet.
Courtesy of Tiffen Filters, Inc.

front to back on the camera body. This requires a *reversing ring* that has a thread mount on one side to fit the lens' front and a camera-body mount on the other. You can also reverse a lens in combination with an extension device to increase the on-film magnification even further; ordinarily, a standard or moderate-wide-angle lens is used in these situations.

You can also stack two lenses so that one acts as a powerful diopter to the other. In this approach, you place a medium-telephoto lens onto the camera and then use tape to *reverse-mount* a moderate-telephoto lens set at maximum aperture to the front of the prime lens. This arrangement provides a 2X magnification. Enlarging lenses also can be stacked.

The final method of achieving greater subject magnification through close-focusing is to use a lens specifically designed for this type of work. These lenses fall into three general categories: the fixed- or single-focal-length macro lens, the macro zoom lens, and the enlarging-lens adaptation. The macro lenses, in either the fixed-focal-length or zoom style, offer the easiest, most versatile approach. They close-focus by internally changing the lens distance from the film plane to a much greater degree than nonmacro lenses do. You can use macro lenses in typical shooting situations and then by simply turning the focusing ring, you can achieve or at least come close to a 1:1 effect. With the fixed-focal-length models, this magnification usually reaches the macro range, and goes beyond that with the addition of an extension ring made for the lens. With macro zoom lenses, results vary from model to model. Some reach 1:1 magnification, but others don't. Also certain macro zoom lenses require you to press a button to switch into macro mode, while others permit you to focus from infinity to a macro distance.

While macro zoom lenses are more convenient because there are various focal lengths to choose from, the advantage of a fixed-focal-length macro lens is superb image quality. This is also true of enlarging lenses that are attached to camera bodies via adjustable focusing bellows. Single-focal-length macro lenses and enlarging lenses are designed to focus close and are corrected accordingly. In the case of macro zooms the macro mode is a secondary function, so you may or may not get satisfactory results.

Although macro lenses can be used for close-focus photography or for general distance work, enlarging lenses are used most often to copy *flat-field* subjects. They are, for example, the lens of choice in copying slides 1:1. Macro lenses, on the other hand, are used by themselves in

the reverse-mount mode or at the ends of extension tubes or bellows. And with the exception of copying slides, they are the best choice for all closeup situations. Whenever you do closeup work, keep in mind that this type of photography is highly specialized and requires modifications in lighting, camera support, and other important shooting conditions.

Image Quality. The question of image quality among all forms of closeup work is complex. For example, I've purposely hesitated to comment on macro zoom lenses because of the inconsistency among models. This is understandable when you realize that zoom lenses are very complex optics that must be corrected for so many more aberrations than single-focal-length lenses. The best advice is to regard macro zooms as lenses that are purchased first for their general photographic usefulness and then for their closeup capability. The following general suggestions about lens quality might help you choose the right lens for your purposes.

The best lenses are the single-focal-length macros for both closeups and shots taken at macro work distances in forward or reversed positions and with or without extension devices. But for flat-field closeup and macro work, enlarger lenses that are extended are most suitable. The next group on the list in terms of image quality consists of standard lenses, and most moderate-telephoto and medium-telephoto lenses mounted forward or reversed with extensions up to closeup settings. Using these lenses with two-element +1 diopters is equally effective, as are the very best of the macro zooms, stacked medium-telephoto lenses, and moderate-focal-length lenses reversed.

When it comes to the last group of possible lenses, either convenience or cost is ordinarily the most important factor. For closeups, most macro zooms are acceptable choices followed by standard lenses and moderate- to long-telephoto lenses with +1 diopters. For macro-distance work, all telephoto lenses and standard lenses with +2 or higher diopters can be used. These guidelines are based on test reports and my experiences. There are exceptions, but this overview will provide someone trying closeups for the first time in 35mm or medium-format photography with a framework.

In large-format photography, the lens options are somewhat more limited. Reversing rings, which make the aperture and shutter speed controls inaccessible, aren't available. No manufacturer makes extension devices

The various close-focusing approaches produce comparable effects. Shooting at maximum focus and with 35mm film, I used a 50mm *f*/1.4 standard lens (top left), a 50mm *f*/1.4 standard lens with a +1 diopter (top center), a 55mm macro lens (top right), a macro lens with a tube to provide 1:1 aspect ratio (bottom left), a reversed macro lens (bottom center), and a reversed macro lens with a tube to provide an aspect ratio greater than 1:1 (bottom right).

either since lenses are already mounted on a bellows. The only choice left is a closeup lens, but these are usually unnecessary because of the bellows. All you can do is to use general-photography lenses on long bellows or special macro lenses, such as the Schneider G-Claron lens, the Rodenstock Macro lens, the Sironar lens, the Fujinon CS lenses, and the Nikkor-AM series lenses. These lenses might also have greater circles of coverage because of the need for perspective and depth-of-field control when working close with three-dimensional objects as well as APO corrections for critical work.

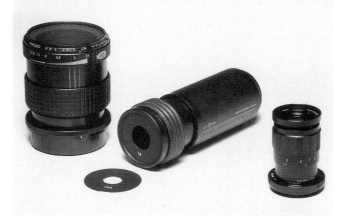

Controlling the soft-focus effect created by this 120mm soft-focus lens for a 6 × 7cm camera requires altering the aperture (left). With very simple lenses, the soft-focus effect is controlled by inserting aperture discs (center). Other, more complex lens designs make changing the aperture setting unnecessary for determining the extent of the effect. But the two-element Spira-tone Portragon soft-focus lens offers no soft-focus control at all (right).

Large-format cameras differ in design from both 35mm and medium-format cameras. Attaching lenses to lensboards calls for the use of recessed locking rings that are more easily tightened with fork-like tools (left). Using a tester is a good idea because most large-format lenses have mechanical shutters (right). And when you close-focus, a Calumet bellows correction scale can be very helpful (front).

Adjusting Exposure. Whenever you focus a lens closer than its infinity setting, it sees less of the entire scene because it is now concentrating on a near object. This means that you're changing the focal length. Remember, the *f*-stop is determined by the ratio between the lens' focal length and the size of the aperture opening. For example, if a 50mm lens has an aperture opening of 25mm, then that particular opening is designated as *f*/2.0 (50mm ÷ 25mm = 2). If you change the focus and the focal length, the *f*-stop must change. It becomes slightly smaller mathematically since less light reaches the film even though the actual size of the aperture opening hasn't changed. Suppose that the 50mm lens is focused so that its effective focal length is now 56mm. The new calculation is 56mm ÷ 25mm, which equals *f*/2.24.

In practice, such a small difference doesn't significantly affect the image on film. But what happens when you're focusing very close, such as with extension tubes? Here, the change in focal length is such that it alters the effective *f*-stop by 1 or even 2 stops of less light. So if you left the lens on the *f*/2.0 setting in this situation, your film would be underexposed 1 or 2 stops. You can measure this change very easily if your 35mm or medium-format SLR camera has a built-in *through-the-lens* (*TTL*) meter. Large-format cameras require you to use a special meter to measure the light reaching the groundglass. In all of these cases, the meter registers the loss of light and makes adjustments accordingly. These meters are very accurate since they measure the light that eventually strikes the film.

CALCULATING CLOSEUP EXPOSURES

Symmetrical Lenses

For symmetrical lenses (including most normal and moderate-wide-angle and telephoto lenses), the following formulas will give values for conditions beyond those found on the dial:

Exposure Factor $= (M + 1)^2$

$Exf = (M + 1) \times f$

$M = \dfrac{\text{Image Size}}{\text{Subject Size}}$

Exf = Effective *f*-number for Extended Lens

f = Engraved *f*-number

Nonsymmetrical Lenses

The dial and the above formulas will give inaccurate results when used with nonsymmetrical lenses, which include most modern wide-angle lenses with lens angles greater than 75 degrees and true telephoto lenses with lens angles less than 20 degrees. Use of the following formulas will give increased accuracy for nonsymmetrical lenses:

Exposure Factor $= \left(\dfrac{M}{P} + 1\right)^2$

$Exf = f\left(\dfrac{M + P}{P}\right)$

P = Pupillary Magnification $= \dfrac{\text{Front Pupil Diameter}}{\text{Rear Pupil Diameter}}$

To find the pupil diameters, open the diaphragm fully and measure its diameter as it appears through the front lenses, and then through the rear lenses. Divide as shown to get the value of P.

Courtesy of *Kodak Professional Photoguide.*

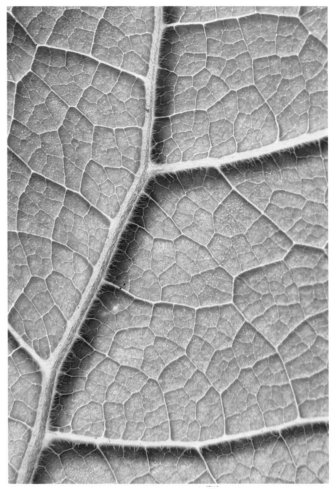

Shooting closeups outdoors means waiting for the perfect light, hoping for no wind, and having the subject face in the right direction, using a close-focusing lens, and metering correctly. When all of this comes together, exquisite images can be created. This photograph of a wood lily was taken with a 100mm macro lens and a 35mm camera (right); adding extension tubes to that setup made this extreme closeup of a common burdock possible (above). Courtesy of Art Gingert.

If you can't measure exposure in this manner, there are complications. You have to meter the scene using a handheld meter and calculate a correction. To do this you must first determine what type of lens you're using because certain designs focus differently in relation to the film plane, thereby changing the means of calculating light transmission. The two types of lenses are: *symmetrical* lenses, which include almost all standard, moderate-wide-angle, and telephoto lenses; and *nonsymmetrical* lenses, which include modern wide-angle lenses with angles of view greater than 75 degrees and true telephoto lenses with angles of view of less than 20 degrees. Each of these lens groups requires a different formula for calculating exposure modifications taken with an *incident-light* meter or a *reflected-light* meter off a *gray card*. Incident-light meters measure the light falling on a subject; conversely reflected-light meters measure the light reflecting off a subject. Also, the use of a reversing ring with a lens as a method of closeup photography works best with symmetrical lenses.

Finally keep in mind that all of these closeup-photography methods get you close to your subject. On the other hand, some work fine if your subject is in a flat field, but not as well if used on a round or three-dimensional subject. This is a function of the lens design or the effect of an accessory. For example a closeup lens works well with flat work on a copystand, but its performance drops off with three-dimensional objects. Then, too, the extensive compression of the depth of field means working with small aperture openings and, therefore, slower shutter speeds. It also means running up against the problem of image-degrading diffraction at the smaller *f*-stops. Testing your lenses will give you an idea how much diffraction is present (see pages 138–139).

As far as slower shutter speeds and large magnification of image sizes are concerned, this is similar to working with long telephoto lenses. So, not surprisingly, the solutions are the same: using a solid tripod, very careful focusing, and depth-of-field previewing or calculations. But there is one advantage to close work. The ability to use a small flash allows you to handhold the camera at small aperture openings.

SOFT-FOCUS LENSES

Photographers have used various devices and techniques for producing softer images almost since the first photographs were made. In fact, around the turn of the century it was considered "correct" to present such subjects as

I made this photograph of a classic car with a 120mm soft-focus lens set at maximum spherical aberration on a 6 × 7cm camera. This setup produced the circular effect on the pinpoint reflections off the fenders, bumpers, and headlights.

A soft look can also be achieved without a soft-focus lens via a double-exposure defocusing technique. Here the subject is in focus in the first exposure, and out of focus in the second one. The only problem with this technique is how unpredictable it is. Courtesy of Art Gingert.

landscapes in a soft-focus rendering, thereby mimicking to some extent the landscape paintings of that time. Today, the reasons for making soft-focus images are as varied as the ways to make them. With all of these choices, you might sometimes get confused trying to figure out just how the softening of the image occurs.

When an image appears sharp to viewers, it is because they are able to discriminate between various parts of a photograph and to see the smallest detail. So in a landscape shot not only are the scene's larger objects—trees, rocks, branches—discernible, but also such details as leaves, pebbles, and blades of grass. If you were to throw the image out of focus, or *defocus* the image, viewers would no longer be able to see both the main areas and details clearly. Here, the whole image isn't sharp. But this result generally isn't what you strive for when attempting a soft-focus effect. Your intention is usually to keep some of the picture in focus, probably the larger ele-

ments, and to eliminate the details. Furthermore because of the way defocusing occurs, you can sometimes see a shimmering halo around the main elements, particularly in bright areas. It is, however, possible to obtain some of these effects by manipulating the lens to take part of the exposure in focus and the other out of focus in a double exposure. But overall, this cumbersome method doesn't ordinarily approach the more controllable effect obtained with soft-focus lenses.

Soft-focus lenses range from inexpensive, one-element designs to complex six-element, four-group designs. Many of the light rays coming in on or near the lens' axis are focused at the same spot, but rays refracting from the outermost areas of the lens aren't. This effect can easily be controlled by stopping down, so the soft focus occurs only at the widest lens apertures. Although optical designers ordinarily work to prevent spherical aberrations by making corrections that cause all of the light rays to focus at the same point, they produce soft-focus lenses by allowing the light rays to focus on various points. To be functional, however, these lenses must also have a provision for focusing a sharp image. Furthermore, photographers find it helpful to be able to control the degree of aberration separately from stopping down, which decreases the number of spherical aberrations. How the designers achieve this and the number of elements and groups used are what set these lenses apart.

In addition, the control over the aberrations extends from lenses that provide no control to those that enable you to selectively choose just about any effect possible from a number of spherical-aberration configurations. The simplest and least expensive soft-focus lens is the Spiratone Portragon, a single-element, fixed-aperture (f/4.0) 100mm lens intended for use on most 35mm cameras via a *T-mount* adapter. This adapter attaches to the lens via a fitted collar and screws. The other end is equipped with a mount to fit the camera of your choice. To alter exposure with this lens you must change shutter speeds or the amount of light, such as by reducing or increasing flash power, which is as basic as it can possibly be.

To increase control over exposure and the degree of softness, you can fashion your own aperture insert at the rear of the lens. These can be as simple as opaque disks with holes corresponding to various f-stops. This enables you to manipulate both the exposure and the amount of aberrations because using a smaller f-stop not only reduces light, but also begins to sharpen the image. As a matter of fact, most of the other, multi-element soft-focus lenses control the extent of the effect in just this way.

Like the Portragon, the Sima SF lens is a single-element, fixed-aperture (*f*/2.0) 100mm lens. But it also comes with its own aperture disks set at *f*/4 and *f*/5.6. Exposure with both the Sima and the Portragon can also be controlled by using ND filters across the front barrels. These filters reduce the amount of light that passes through a lens and come in various grades.

The next level of sophistication comes in the form of more elements and simultaneous control over exposure and softness via an aperture ring. The Pentax Soft lens, available for the 35mm and 6 x 7cm formats, is an exam-

ple. To operate the lens you turn the aperture ring to an *f*-stop at which the aberrations provide the effect you want and then carefully focus, keeping in mind the reduced depth of field. The aperture ring is controlled manually, so when you turn it the lens opens up or closes down as you watch in the viewfinder. Usually all aberrations are controlled by *f*/8, so you have anywhere from 3 to 5 stops to choose from depending on the lens' maximum aperture.

The Minolta Varisoft and the Canon Soft lenses, which are both *f*/2.8 85mm lenses, offer aperture control, as

Another way to achieve a soft effect is to exploit certain atmospheric conditions. I photographed this solitary tree just as the sun broke through in order to produce the light streak.

well as a separate mechanism independent of *f*-stops that alters the degree of softness. This control comes from changing the distance between a pair of elements, called *floating* elements, which in turn changes the amount of spherical aberration. Tamron, an independent lens manufacturer, even made an *f*/2.8 70-105mm lens in a zoom configuration. You can also control aberrations in all of these optics, just as the Pentax lens does, by using different *f*-stops. The Minolta lens has four soft-focus settings, while both the Canon and Tamron lenses have three.

The highest level of aberration control comes from a design that uses special disks inserted into a lens barrel. These have a large hole in their center that allows the light that focuses at the same point to pass through unimpeded. The disks also have a series of equidistant small holes around the edges of the lens field to control those light rays that don't fall on the focus point; these rays are the ones that actually produce the soft effect. Because of this design you have much greater control over not only the amount of correction, but where it occurs. This is because these perforated disk designs use *waterhouse* stops, which are sometimes seen in fisheye lenses. In this basic design, the disk revolves in the lens and the holes correspond to specific *f*-stop sizes. As a result, there is no adjustable aperture opening.

When this design is used in a soft-focus lens, the holes are equal in size on each disk but are set at different distances from the axis. This arrangement affects different parts of the aberration areas. Furthermore, you can change the size of the holes by turning a ring on the lens. The main exposure control changes the size of the center hole via a series of disks of different sizes that operate on the same principle as a conventional aperture. The Rodenstock Imagon is the oldest of the disk designs, dating back to the 1930s. Today it is available for use on medium-format and large-format cameras. The Mamiya Camera Company makes a similar design for some of its medium-format cameras, as does the Fuji Company for large-format work.

Achieving Soft-Focus Effects. When are soft-focus effects appropriate? In portrait work, a soft-focus lens eliminates facial blemishes and other imperfections. In some other shooting situations, such as landscapes and seascapes, you might want to create a very soft, ethereal appearance, perhaps with a halo-like effect in the highlight areas. There are four popular ways to produce a softer, diffused impression. The oldest method is to use one of

the lens aberrations based on a condition in which much of the light is focused at a single point, while some of the light falls outside this plane of focus. This is the principle governing the soft-focus lens or spherical aberrations.

The second and more common method of achieving a soft-focus, or *diffused*, effect is to use a special filter that causes some of the light to be diffracted rather than focused at a specific point on the film. This can be done many ways. There might be an even pattern of superficial irregularities on the filters' surface that look like tiny ripples or a series of small bumps or bubbles to the naked eye. Each of these minor imperfections produces diffraction. In all cases, enough light passes through the filter unimpeded to render the main elements of the image, while the means of diffraction controls how much detail is translated onto film. Furthermore these filters vary in strength, and the corresponding number system is based on how much light they bend and to what extent. Generally the lower the number in a series, the fewer rays that are affected and, therefore, the less the soft-focus effect. (Another group of filters, called *fog* or *mist* filters, works on the same principle but has a slightly different effect. See page 130.)

The third approach also involves using a filter, but in a different way. Here you stop some of the light across the lens field from reaching the film, while those rays that hit the edge of the obstruction are refracted. This prevents a complete resolution of the image at the focus plane. This is a unique method of softening the image since instead of a surface irregularity there is a combination of blocking and edge refraction. The usual method is to place a piece of finely woven fabric between two pieces of glass. The amount of softening is controlled by the tightness of the weave. Also, the color of the material—black, white, or amber—can add its own effect. For example, an amber color can warm up an alabaster complexion. This fabric technique is an old trick of portrait shooters, who placed black silk stockings across their lenses to help minimize skin imperfections.

Finally very fast, grainy films with ISO ratings of 800 to 1600 that are processed normally or even *push-processed*, which means shooting the film at a higher ISO than normal and overdeveloping it, produce soft-focus effects. These emulsions contain such a large grain structure that the entire image seems to take on a pebbly texture, giving an overall softer look. The main elements, however, retain a high degree of sharpness and can be readily discerned. Here the particles in the film emulsions

actually become visible, as well as combine in their usual role to render the shapes and colors in the scene. You can obtain a similar effect by using print-paper developers to process black-and-white film.

When image sharpness is altered by these methods, both the smaller details and the clear division between main elements are affected to a degree. In portraits the objective is usually to eliminate much of the very small detail before the strength of the filter reaches the point where it begins to change the appearance of the main elements, such as with the halo effect. If the filter is strong enough, it will affect the sharp delineation between the three primary areas in which light is reflected—

specifically, the *highlights*, *midtones*, and *shadows*. In a black-and-white photograph, these high-reflectance areas form the blacks, the whites, and all the shades of gray in between; in a color shot, these areas form the brightest and darkest colors.

Generally for both color and monochrome pictures, the highlights are the lightest areas of a picture in which detail is retained; the shadows, the darkest detail areas; and the midtones, everything in between. *Specular* highlights are any areas whose reflectance is so high that there is no detail and, in fact, can be thought of as light sources themselves. The shine bouncing off a chrome bumper or light reflected off a body of water are examples of

NO FILTER

NIKON SOFT #1 FILTER

COKIN DIFFUSION #1 FILTER

HARRISON DIFFUSION #5 FILTER

MIST MAKER FILTER

specular highlights. Pure black areas, then, are parts of the image in which no details were recorded, such as an open cellar door or the dark sky in a night shot.

The highlight, midtone, and shadow areas help define the main elements, while small details are sprinkled throughout. For example in a portrait, the person's black hair is the shadow area made up of the details of each hair, some shining, some in shadow. The subject's face might have a combination of midtones under the neck where enough light is reflected to see the details of muscles and veins; the cheek facing an umbrella flash is the highlight area, with blemishes and pores making up the details.

SOFT-FOCUS FILTERS

As pointed out, these filters diffract and refract light. The filters change the path of some of the light rays, so that they don't focus at the same point or on the same plane as the unimpeded rays. Manufacturers have come up with just about every conceivable type of surface irregularity to bend the light or cause it to flare in order to soften and diffuse the image. Zeiss Softar filters, for example, have tiny bubbles spread over the glass, while Nikon soft filters have a thin layer of silver particles on one outside surface. B&W filters use a series of blurred concentric circles, while the Cokin diffusion filters have a rippled surface. Each variation produces its own unique effect, so you

COKIN DIFFUSION #2 FILTER

SOFTAR #2 FILTER

HARRISON DIFFUSION #3 FILTER

SOFTNET BLACK #2 FILTER

Using diffusion filters to modify lenses in order to create soft-focus images is a popular method, as is placing crumpled cellophane or a thin layer of petroleum jelly on a lens. But manufactured filters are standardized, thereby providing constant, predictable results. Each soft-focus filter offers a slightly different look. In addition, these filters come in different strengths, and many are very dependent on over- and underexposure to be effective. These photographs show the subject without a filter (opposite page, top left), how the filters affect contrast (bottom right), create a halo effect where the blue blouse meets the black background (above right; opposite page, bottom right), and soften both small details and large areas (opposite page, top center; above center).

have to test to see how the image will be altered by the filter design itself, as well as the strengths available.

Although fog (or mist) filters are sometimes used as soft-focus filters in portraits, their rather strong overall reduction of contrast and sharpness limits their appropriateness. The principle is the same: the light rays are diffracted, but the texture of the diffraction points across the filter surface is much more dense. As a result sharpness and contrast are reduced more evenly, which is the way actual fog with its infinite number of tiny water droplets interferes with the light. These filters are also available in a graduated form; here, the diffraction points are spread over only a portion of the surface to simulate ground fog.

The light-blocking (refraction) type of diffusion filter—the "silk stocking over the lens"—used to be one of the most common homemade filters in photography. Today the Tiffen Filter Company makes them in standardized strengths and mounts. The effect of these filters is unique for portraiture because they are able to "drop out" small imperfections without introducing an overall softness into

Soft-focus effects can be achieved by using very fast, grainy films. I used Agfa ISO 1000 slide film for this portrait.

Darkroom workers sometimes use various diffusing materials, such as nylon or silk stockings, to soften portraits during the printing process. To create the overall soft look of this image, which was made with a 75mm lens on a 6 × 6cm camera, I used a Softar #2 filter for half the exposure time while printing. I particularly like the shimmering horn, a result of the bleeding of the black areas.

soft-focus filter in the darkroom, print through it for only part of the total time. I work with a percentage of the exposure time, such as 20 percent or 40 percent. Beyond 60 percent, I find that I run the risk of losing so much clarity in the main areas that the picture begins to look defocused.

Another point to consider is that when you use a softening approach in a camera, the highlight areas tend to manifest the soft-focus effect far more. This is especially true when the highlights are against a dark area; sometimes they even appear to have halos. But if you use that same filter during printing, the reverse happens. The dark areas spread, or "glow," into light areas, especially in black-and-white prints.

Also, when printing you should watch out for the textures on the filter surface showing up as designs in the picture. To prevent this from happening with, for example, Softar lenses, I move the filter up and down slightly under the enlarging lens. Finally, keep in mind that different films react to filtration in various ways. For example, contrasty emulsions tend to emphasize the glowing effects; with less contrasty films, the loss of contrast is often extreme. Slide films, in general, show a greater range of effects, whereas print films produce more of an overall softening.

ENLARGING LENSES

These are designed to be used underneath a negative in an enlarger to focus the light that comes through the negative on to the photographic paper. Unlike camera lenses, enlarging lenses work at both ends (negative and print) with a flat field. Furthermore since the exposure time is relatively long—usually 10 or more seconds—there is no need for a shutter. Physically enlarging lenses are smaller and slower than camera optics, but they aren't—or at least shouldn't be—of lesser quality. As a matter of fact, the best enlarging lenses are capable of *resolving* more detail—more lines per millimeter—than a comparable camera lens. So why doesn't everyone use these optics on their cameras? Aside from not having any shutters, their excellent performance is limited to close work in flat-field conditions, such as duplicating slides or in their primary role of making enlarged projection prints from negatives.

All enlarging lenses used in general photography have adjustable manual apertures that ordinarily range over 5 to 8 stops. Their maximum openings can be as fast as $f/2.8$ or even $f/1.9$, but most are 1 to 3 stops slower de-

the image. Not all fabrics placed between glass filters can separate these two functions. For example Tiffen's Softnet white and Softnet skintone filters introduce their own flare-like effects, but the Softnet black filter is the perfect choice when you want to just eliminate the small details. Many photographers experiment with diffusion filters by combining different types, or different strengths of the same brand. This can sometimes lead to very impressive results. You can also combine grainy, ultrafast film and a diffusion filter for an unusual look.

In addition you can use diffusion filters in the darkroom either to minimize some of the blemishes in a portrait or to impart a halo-like quality to a print, especially a black-and-white image. If you do this, keep in mind that the diffraction and refraction that take place in the camera differ from that in the enlarger. First the main elements survive in a typical soft-focus image because more focused than unfocused light comes through, so the out-of-focus light isn't as bright and is scattered around the parts of the main subject. The more you reduce the focused light, the less sharp the image is. Therefore, when you use a

pending on their focal length. So a typical 50mm lens used to enlarge 35mm negatives has a maximum aperture of $f/2.8$ or $f/3.5$ with a minimum setting of $f/16$ or $f/22$. An enlarging lens' focal length designates its ability to cover specific negatives. The general rule is to use a focal length roughly equal to that of the camera's standard lens. But some photographers maintain that you should use the next longer focal length in order to get a better image. The argument usually goes like this: a longer lens is designed to cover a larger format, so it allows you to print only in the center area of the lens coverage where optical performance suffers less from light falloff and loss of sharpness at the edges.

While this idea might seem to offer an advantage, it overlooks the fact that shorter lenses are generally sharper and better corrected, thereby making the center gain of the longer lens negligible. Most test reviews of enlarging lenses indicate that the use of the next larger lens to produce the best image quality is less effective than investing in a top-quality standard lens for your negative size. As a matter of fact, the number of elements within a lens design is a much better indicator of lens quality.

The lenses considered to be the best almost always have six elements in their fixed-focal-length designs, as opposed to four or three. Zoom, or variable-focal-length, lenses that are available are very convenient to use, but they don't match the high image quality of the better single-focal-length lenses. On the other hand zoom lenses are perfect for certain production-type printing situations, such as a high-volume snapshot print operation. Wide-angle enlarging lenses are ideal for photographers who want to make even bigger enlargements, but like the zoom lenses they aren't among the very best performers. The wide-angle designation means that the lens coverage enables you to use it on a format whose diagonal measurement exceeds the focal length of the lens. For example, a 40mm lens can be used for 35mm work when a 50mm lens is the usual choice; similarly a 60mm lens can be used for 6 x 6cm negatives, which are routinely printed with 75mm or 80mm lenses.

Another consideration when selecting an enlarging optic is whether or not the lens is designed and corrected for optimum performance at a certain magnification. Many lenses are used to enlarge a negative anywhere between 2 and 8 times, and sometimes even more. But some lenses are intended for a specific range. For example, Rodenstock's Rodagon-G lenses are specified for use with very large, mural-size enlargements. Clearly, it is important to know something about the enlargement range in which a particular lens obtains its best results. If you work consistently with a certain size print from the same format, you might find buying a lens designed for that type of enlargement well worth it.

There has also been a great deal of excitement recently about APO lenses in darkroom work. These optics are especially effective at controlling lateral chromatic aberrations, a condition in which not all wavelengths of light focus at the same point on the lateral axis. There is no doubt that you must have control over this lens flaw in the darkroom, particularly if you're printing in color. Next, you should think about whether or not you need an APO formula to control these aberrations. The answer is not a simple "yes" or "no." Most six-element enlarging lenses are very well corrected for all aberrations, and the only major difference between them and APO lenses is apparent in only the most critical work; this includes highly refined color separations in the commercial print industry for quality magazine and book reproduction. Yet even in this situation, APO lenses seem to be used more out of habit; these lens designs were used in graphic arts years before they became the rage in general photography.

Once you move down the list of enlarging lenses in terms of quality and start talking about four or three-element designs, the differences become very real, and APO lenses are clearly the best choice. Finally some photographers swear by their APO enlarging optics and claim all sorts of advantages with them, even in general photographic enlargements. Nevertheless, standardized lens testing doesn't support such enormous differences.

Using Enlarging Lenses. After working for years in the photographic arts at many levels, from filmmaking to still photography, I find over and over again that the best equipment doesn't guarantee the best results. Sometimes this is because of flaws in the materials, but more often it is because of "operator error" or poor technique. Using an enlarging lens is a case in point. One frequent mistake is to take for granted certain capabilities of a piece of equipment. For example, it might surprise you that even the best enlarging optics sometimes suffer from misalignment of elements. This means that they're not centered in relation to one another along the lens' axis. The main effect of this *decentering* is that the corners don't have the same level of sharpness. The only solution is to bring the lens back to the store and exchange it. This

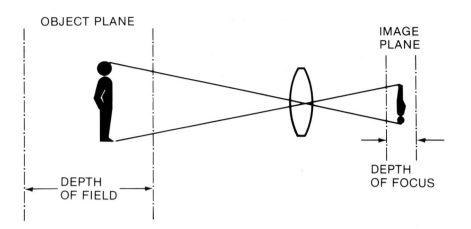

OBJECT PLANE

IMAGE PLANE

DEPTH OF FIELD

DEPTH OF FOCUS

points up the need to immediately test your lens as soon as you get home (see pages 138–139).

Another problem with enlarging lenses involves poor technique as well as equipment. The main sources of trouble are focusing methods, aperture selection, and enlarger alignment. It is important to understand just how significant these three operations are. Consider, for example, that enlarging lenses work within a distance frame of 1 to 3 feet, so focusing and maintaining the parallel relationship between the film, lens, and paper are absolutely critical. Indeed, you're often dealing with a *depth of focus* of 1 to 2mm or less. Depth of focus, incidentally, isn't technically the same as depth of field even though both refer to a specific area of sharp focus. Even the smallest of errors in focusing and alignment degrades the final image. For example many darkroom workers routinely focus using a 10X magnification, which shows the grain of the film. The usual method is to place the magnifier in the center of the print easel on a small square of the print paper. This is done at the maximum aperture in order to see the image at its brightest, just as in an SLR camera with an automatic diaphragm. Then the lens is closed down to the correct exposure aperture.

If a lens stays in focus while you change *f*-stops throughout its aperture range, it is free of focus shift. You can usually determine this by watching through a grain magnifier as you stop down the lens. At the same time, I check the corners in a similar way with each change in enlarger height. Fortunately, most high-quality lenses are free of this annoying characteristic. But as the number of elements decreases in the less-expensive lenses, the chance that focus shift will occur increases.

Aperture selection should be based as much on trying to use the sharpest *f*-stop as on exposure manipulation.

To put it another way, know your best (sharpest) openings and work out your exposure times so that you can use them whenever possible. This almost always means exposures at 1 to 2 stops below maximum aperture. This question of sharpness is a thorny issue because *visual sharpness* is made up of *resolution contrast* (lines per millimeter) and the effects of light falloff. The term "visual sharpness" is a subjective form of measurement that translates how sharp the picture looks to viewers. You can talk about resolution charts all day, but if there is no incorporation of the contrast and light falloff factors, then you're talking about only part of the issue. Consequently I think that it is worth testing each aperture for all three qualities by making prints, indicating on the back the *f*-stop used, examining the results in a blind selection after they dry, and comparing your judgement against any lens-testing results.

Finally when using enlarging lenses, you must pay careful attention to enlarger alignment; this step is the most neglected part of the process. It is absolutely critical to have your enlarger aligned properly in relation to the print easel. This requires you to work out a method of determining whether or not the negative, lens, and paper planes are parallel to each other. The most popular method is to put a *level* on the baseboard and inside the mouth of the enlarger and to make adjustments to the lens-focusing mechanism. This method helps, but it is quite crude in comparison to such calibration systems as the Zig-Align. With this approach, the goal is to adjust the easel, lens, and negative carrier so that they are all exactly parallel to each other.

You can achieve this via the Zig-Align system of mirrors, which is based on the following principle: "Imagine standing between two opposing but not parallel

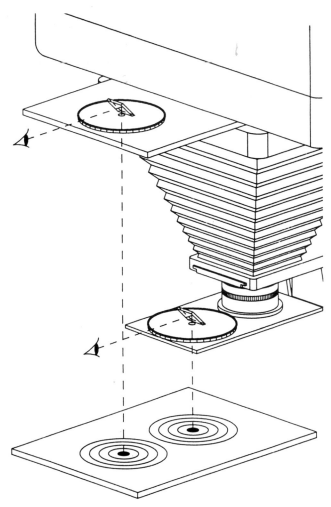

THE ZIG-ALIGN MIRROR SYSTEM
Courtesy of Zig-Align Co., Menlo Park, California.

mirrors. The mirrors reflect your image back and forth, each time diminishing it in size. When the mirrors are nearly parallel, your presence blocks these reflections. Yet to determine when the mirrors are parallel, you need to see the entire, unblocked series of images. The Zig-Align system places you outside the reflecting region of the two mirrors, allowing unobstructed repetition of images. One mirror of the system is plain and rectangular; the other is round and has a viewing hole in the center with a concentric opaque ring on it. When the mirrors oppose each other, you see repeated images of the ring through the viewing hole, resulting in the illusion of a tube. When the tube appears straight, the mirrors are parallel." Using such a precise system guarantees that you'll eliminate misalignment, which is probably the most common mechanical cause of poor images. So before you do any testing, whether it is subjective or objective, you should make every effort to align the enlarger and check the lens for focus shift.

SLIDE-PROJECTOR LENSES

Many photographers prefer to present their work in slide form and to project them on a screen. In addition a major audiovisual industry is built on producing rather impressive multiscreen slide shows, and many one-projector presentations are made in business and education every day. The lenses used in these shows are similar to camera optics in that they're based on the refraction principle and come in both fixed-focal-length and zoom styles. But this is about where the similarities end. Slide-projector lenses have no aperture settings and are designed to project light rather than receive it; furthermore, most aren't nearly as good optically as an average camera lens. Because slide-projector lenses are mounted in front of the slide, they focus the light from a bulb that comes through the transparency to the screen. As such, they're used the same way enlarging lenses are.

Focusing slide-projector lenses is usually a function of increasing and decreasing the distance between the lens and slide via a *racking mechanism* in the projector. Some lenses, however, have their own helicoid focusing mechanisms. A slide-projector lens' focal length is designated in inches or millimeters, and its single aperture setting noted, such as a 4-inch f/2.8 lens, a 102mm f/2.8 lens, or in the case of a zoom a 4-to-6-inch f/3.5 lens.

The selection of a particular lens focal length, speed, and design depends on a number of factors. The primary criteria are slide format and mounts. The majority of projectors are designed to be used with 35mm slides, though 6 x 6cm projectors are becoming increasingly popular among professionals. Medium-format projectors, of course, require lenses with more extensive covering power. Slide mounts come in two forms, glass and glassless. With glass mounts transparencies are sandwiched between two very thin sheets of glass, so they remain perfectly flat. This also means that you don't have to refocus from slide to slide. In glassless mounts the film is mounted in an open frame made out of cardboard, plastic, or metal and is therefore slightly curved because of the film's physical configuration. This curvature and open frame mean that the film has to be carefully focused and that it is susceptible to "popping" out of focus as it warms up and bends away from the heat of the light source.

To deal with these differences, you can use either of two types of projection lenses: *flat-field* and *curved-field* designs. While it might seem logical to match flat-field lens with glass mounts and curved-field lenses with the glassless kind, this isn't usually done. Most consumer and

many audiovisual projectors are equipped with standard flat-field lenses; only recently have curved lenses become widely available on the market. Professional presentations ordinarily combine glass-mount slides and very high-quality flat-field lenses.

Selecting focal lengths and lens designs also depends on how far the projectors are from the screen and how large the image will be. Suppose that you want a projected image of roughly 2 x 3 feet. Here, the lens' focal length must increase to correspond to the increase in the *projector-to-screen* distance in order to maintain that size. In this situation, then, there really is no standard focal length because the image composition is unaffected by changes in lens sizes. Only the size, brightness, and perhaps sharpness of the final image are affected. For example if the same lens is used at different distances, the brightness will fall off as the distance increases (according to the Inverse Square Law). There will also be a loss in quality as the film's image-forming particles, or grain, is spread out more and more to cover a larger area.

So which lens/mount combinations provide optimal results? Without question the sharpest images are obtained by using glass-mounted slides in slide projectors rated for use in professionally produced shows. This is because the focus plane of the slide doesn't vary from image to image. Furthermore, these slide projectors have better *slide-gate alignment*; the gate is part of the machine that holds the slide in roughly the same way film is held in a camera. (No slide projector, however, approaches the high standards of a camera's film-plane flatness.) In practice bad alignment is apparent when the projector is parallel and level to the screen and only the center and perhaps one corner of the slide are sharp.

When you select a lens, you have to consider a few variables. *Rear-projection* screens often force you to use shorter focal lengths because the space behind the screen is limited. You should opt for a focal length that is just short enough to fulfill your needs. When you place an extremely short lens very close to the screen, *hot spots* might form in the center of the screen where there is a brighter circular area of light caused by the out-of-focus filaments of the bulb. This problem is compounded by the tendency of wider-angle lenses to experience light falloff at the edges as part of their optical design. With *front-projection* screens, however, you can use either a fixed-focal-length or zoom lens to control the distance. (Generally, rear-screen projection requires shorter focal lengths than zooms are commonly available in.) The advantage of using fixed-focal-length lenses is that they are sometimes sharper and almost always faster by 1 stop. On the other hand, zoom lenses allow you to make major changes in the projected image size. This feature can be a real boon to photographers who show slides under a variety of room conditions.

The choice of a flat-field or curved-field lens depends on the slide mount. Glassless mounts benefit more from curved-field lines, and all glassless-mount slides are helped by autofocus projectors. Selecting an exact focal length and aperture is a matter of following the projector manufacturer's standardized recommendations.

Next, you have to give some thought to lens sharpness and brightness. I am always amazed how little attention photographers pay to the optics that are involved with the final presentation of their images. They'll spend hundreds, even thousands, of dollars on high-quality lenses, use the finest-grain film, set up a steady tripod, and then pop their work into a projector that is equipped with a lens of questionable quality—and that needs a thorough cleaning. Sharp projector lenses that are well corrected should be standard equipment for photographers who want to make the best possible presentation of their pictures—especially if the projected image is going to be quite large. Most likely this means investing in a more expensive optic, though not necessarily. The problem is that there are few published reports on lens quality. Furthermore, it is difficult to test in a store because the best setup requires a completely darkened room. In the end most photographers are left to make subjective judgements by looking at some of their technically best slides with borrowed lenses, allowing for the effect of both projection screens and projector alignment.

Three types of front-projection screens are in use today, and each has its own effect on picture quality in terms of how sharp the reflected image is and how it spreads the light from the lens over an audience. *Matte* screens, the first type, can be any smooth white surface, such as a wall. These provide the sharpest image, but spread out the light so much that viewers have to be fairly close to the screen. In other words because the light reflects in all directions, it quickly loses intensity (again, a result of the Inverse Square Law). Clearly, then, these screens are reflectively inefficient. But the angle at which you can sit in relation to the screen is quite wide. I prefer this setup for small groups of 10 to 30 people and moderate enlargements 3 x 4 feet or 4 x 5 feet in size. This is the best screen to use for testing lenses.

Keeping lenses clean is essential for optimal results. The most common method is to use lens tissue and cleaning fluid. Be sure to apply the liquid to the tissue, not to the lens where it might seep into the camera's internal parts.

Beaded screens have what amounts to tiny glass balls or beads that effectively focus reflected light more toward the center of the viewing area. They are far more efficient reflectors than matte screens, so the image seems brighter but also takes on a pebbly or beaded finish when viewed up close. This is acceptable for distant viewing where it isn't noticeable, but it is a distraction up close for lens testing. The screens' angle of reflectance, which is between 20 and 25 degrees, is also much narrower than that of matte screens.

Finally, *lenticular* screens are made up of vertical strips running from top to bottom that have "Vee-shaped" or curved indentations with highly reflective surfaces over a broad area. In this regard, lenticular screens are superior to beaded screens. But for lens testing, they are also prone to break up the sharpness when viewing up close because of the vertical-line effect.

In addition to thinking about what screen surface is best for your viewing situation, you should also make every effort to set up your projector level and parallel to the screen. Failure to do this, especially at longer distances,

is asking for trouble with sharpness because of the magnified effect of changes in focus or alignment. Unfortunately, when showing slides, photographers too often settle for a low-angle position rather than one squarely in the middle of the screen. This results in keystoning. This not only causes image distortion, but also might even throw the top or bottom part of the picture out of focus.

If keystoning is an inescapable problem in a room you often show slides in, you should give some thought to equipping the projector with a PC lens. Like its camera-lens counterpart, a PC lens for a slide projector enables you to correct for keystoning by shifting the lens off-axis. These lenses are particularly useful in theaters where the problem more likely is that you must project down instead of up from a control booth at the rear of an inclined-seating arrangement.

Extraneous light interferes with the quality of the image. Naturally the brighter the projection, the less effect room light has on an image. In general, you should have the room as dark as possible. Screen textures also play a role. Matte screens are most hampered by stray light because it

bounces off their smooth surface in all directions, thereby lowering the overall contrast and brightness of the projected image. Lenticular screens are the most resistant to the degrading effect of incident light because their angle of reflectance for light coming from any direction other than straight is diverted away from the audience. Beaded screens fall somewhere in between the two.

Optical Quality. In addition to all these factors—screen texture, projector alignment, and extraneous light—the optical quality of the slide-projector lens itself is an important variable. Generally, these lenses don't match the specifications of camera lenses. This doesn't mean, however, that they are all of poor quality. On the contrary, many are quite good performers. There are a number of ways to test a projector lens for sharpness and other optical qualities, such as color correction and light transmission. When making such evaluations with a manual projector that is set up level and parallel to the middle of the screen, remember that there are two types of slide mounts (glass and glassless) and two types of lenses (flat-field and curved-field). See pages 138–139 for procedures to follow for testing alignment, color correction, light transmission, and sharpness.

Learning more about lenses and the guidelines for their use is only the first step in a process that leads to better control over your photographs. For me, knowledge has always been a stimulant that has a beginning but no end. The idea was to learn enough to know how things work, what to try, and to get an idea about what to expect. My purpose was to expand my creative energies by making images that would be more satisfying to me. This didn't mean slavishly executing what I had read, but rather experimenting with what I had learned to produce something different, to violate the guidelines at times to discover the exceptions rather than the rules. Many times I took chances or made mistakes. But the results were rewarding enough to help me believe in myself and my work beyond being able to make technically good photographs. That is what I would like to leave you with: a feeling that you've learned enough from reading this book to go out and take photographs that will lead you into new directions and with a greater sense of satisfaction with your photography.

APPENDIX 1

View Camera Movements

1. View Camera Movements

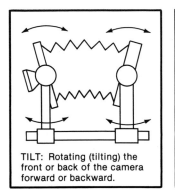

TILT: Rotating (tilting) the front or back of the camera forward or backward.

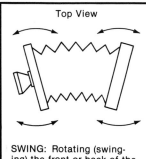

Top View

SWING: Rotating (swinging) the front or back of the camera left or right.

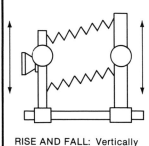

RISE AND FALL: Vertically raising or lowering the front or back of the camera.

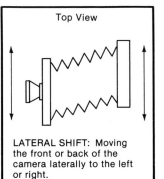

Top View

LATERAL SHIFT: Moving the front or back of the camera laterally to the left or right.

2. Vertical Perspective Control (Low Camera Angle)
Useful when photographing buildings from a low angle.

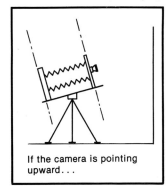

If the camera is pointing upward...

and the subject looks like this on the groundglass—converging vertical lines—**(remember, the image will be upside down),**

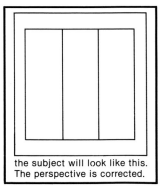

1. tilt the camera back parallel to the face of the subject to correct perspective;
2. tilt the camera front parallel to the back to correct sharpness. Refocus if necessary, and...

the subject will look like this. The perspective is corrected.

3. Vertical Perspective Control (High Camera Angle)
A definite requirement for still–life and product photography.

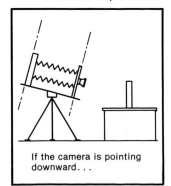

If the camera is pointing downward...

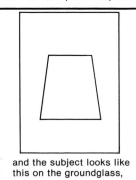

and the subject looks like this on the groundglass,

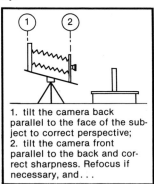

1. tilt the camera back parallel to the face of the subject to correct perspective;
2. tilt the camera front parallel to the back and correct sharpness. Refocus if necessary, and...

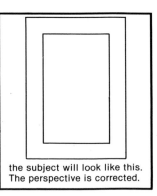

the subject will look like this. The perspective is corrected.

and How They Work

4. **Horizontal Perspective Control**
Useful in architectural, still–life, and product photography.

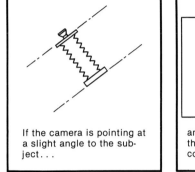

If the camera is pointing at a slight angle to the subject...

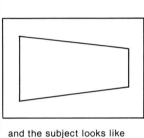

and the subject looks like this on the groundglass—converging horizontal lines—

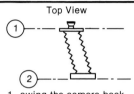

Top View

1. swing the camera back parallel to the face of the subject to correct perspective;
2. swing the camera front parallel to the back to correct sharpness. Refocus if necessary, and...

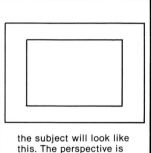

the subject will look like this. The perspective is corrected.

5. **Vertical Image Placement**
Improves composition, eliminates reflections.

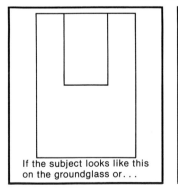

If the subject looks like this on the groundglass or...

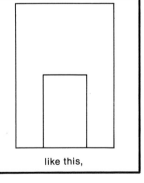

like this,

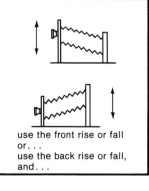

use the front rise or fall or...
use the back rise or fall, and...

the subject will look like this, properly composed.

6. **Horizontal Image Placement**
Used for the same purposes as vertical image placement.

If the subject looks like this on the groundglass or...

like this,

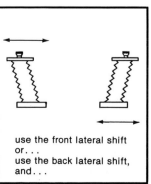

use the front lateral shift or...
use the back lateral shift, and...

the subject will look like this, properly composed.

APPENDIX 2

Lens Testing

by Bob Shell

Since the first photographic lenses were devised, optical designers and photographers have sought practical ways to test lens performance. While it is easy for anyone to look at a photograph and tell if it is acceptable, it is another matter to quantify exactly what it is about a lens that produces a good image.

The two primary characteristics of a lens that contribute to image quality are *contrast* and *resolution*. To the average person, contrast signifies the separation between light and dark, with higher contrast signifying few middle tones. However, to an optical engineer, contrast has a more technical meaning. Assume that the light and dark areas of a scene to be photographed are displayed on a graph; the bright areas are peaks, the dark areas are valleys, and the midtones are the slopes in between. Here, lens contrast refers to how accurately that waveform is transferred through the lens and onto the film. A lens with high contrast transmits the waveform with minimal distortion.

Resolution refers to the smallest detail the lens is able to render clearly on the film. Usually, optical engineers test contrast with a target consisting of very fine lines of black and white of equal width that progress from relatively large to extremely fine. When the engineers photograph this target with fine-grained film, they can examine the processed film under high magnification to determine which set of lines is the finest—which is rendered with clear separation between black and white. The sets of lines are measured in line pairs per millimeter. So, a stated resolution of 50 means that a lens is capable of clearly rendering a set of lines that has 50 line pairs per millimeter.

Until recently most photographic publications measured resolution figures for lenses, but this has fallen out of favor because of the realization that resolution is only a small part of the total picture. Various concepts that combine contrast and resolution into one set of data have emerged. For example, the commonly encountered *modulation transfer function* (MTF) basically tracks resolution against contrast. I prefer the lens-testing method devised by Leica. This evaluation uses a target that has a very bright area and a very dark area separated by a knife edge. The transition from dark to bright produces a square wave in the simplified graph discussed here. However no matter how perfect the lens, the waveform produced after it passes through the lens has some slope in its square section and a rounding of the "corners." This indicates that some light passes from the light area into the dark area and degrades the lens performance. The degree of both corner rounding and induced slope signifies the overall quality of the lens: the more rounding and the greater the slope, the poorer the performance.

In addition to the contrast/resolution duality, other lens characteristics affect image quality. These are referred to as *aberrations* and *chromatic errors* and include *spherical aberration, coma, astigmatism, field curvature,* and *distortion*. Spherical aberration, if left uncorrected, produces a sharp core image surrounded by a diffused halo image. It is intentionally introduced into the design of some soft-focus and portrait lenses for effect. Because it is easily corrected in a multi-element lens design, it is rarely a serious problem in modern, good-quality lenses. Coma is the tendency of a lens to make off-axis image points appear comet-shaped.

Another type of aberration, astigmatism, can best be visualized. Suppose the subject to be photographed is a spoked wheel. In a lens with no astigmatism, both the *tangential* (wheel rim) and *sagittal* (wheel spokes) aspects of the image are sharply rendered. In a lens

with astigmatism, one or the other is unsharp. Because improper assembly—one of the elements is tilted off-axis—is the primary cause of astigmatism in modern lenses, it is rare in high-quality lenses.

Field curvature is simply the formation of a sharply focused image on a curved rather than a flat plane. The flatness of the film results in an inability to get both the center and the corners of the image in focus at the same time. Many lenses exhibit some field curvature when used wide open, but this aberration tends to become less important at smaller *f*-stops because the depth of focus becomes greater.

The last type of aberration is distortion. This is the formation of a curved image from a subject with straight lines. In most lenses, this is well corrected; if it exists, it is only apparent near the edges of the image field. The fisheye lens is an example of a lens in which distortion is intentionally left uncorrected. There are two types of distortion: *pincushion distortion* occurs when the lines tend to bow inward toward the image center, and *barrel distortion* occurs when the lines tend to bow outward.

Chromatic errors are either longitudinal or transverse chromatic aberrations. They occur because all glass bends light of different wavelengths to different degrees. For example, glass prisms separate sunlight into the colors of the spectrum. This property of glass, called *dispersion*, causes light of different wavelengths to be focused at different image planes. The result is a sharply focused image of one color surrounded by a fringe of color, which is produced by the other color images that aren't in focus. Dispersion can be minimized by using different types of optical glass in a multi-element lens design. Recently new types of optical glass, called *low-dispersion glass*, that minimize this

effect have been developed, and along with crystal fluorite, which also exhibits very low dispersion, are used in some of the best modern lens designs.

The term *apochromatic*, or *APO*, refers to a lens in which chromatic errors have been eliminated because its design brings all colors of visible light to a plane of common focus. Obviously, for critical color photography a true APO lens is superior. However, the term has been used very loosely lately; in fact, many advertised APO lenses aren't truly apochromatic, and some suffer from other optical problems as well.

For working photographers, laboratory testing of lenses is both impractical and unnecessary. From the photographers' point of view, a lens that produces an image of the quality they (or their client) want is a good lens. I've taken—and sold—many images with lenses that didn't do particularly well on the formal test bench. Photographers who want to do some informal but valid lens testing don't need a great deal of complex equipment. One of the easiest tests to perform requires nothing more than a tripod and a clear, calm day. For this test, you mount the camera and lens on a sturdy tripod and then shoot fine tree branches against a blue sky. Usually I use Ektar 25 film for this type of test because it has exceptionally fine grain; I also test lenses wide open because most aberrations decrease and contrast and resolution increase as the lens is stopped down. If a lens performs very well wide open, it will ordinarily perform better at its midrange stops (before the image begins to degrade at the very small stops, a result of a separate optical phenomenon known as *diffraction*).

You can analyze the lens either by viewing the processed negatives under a magnifier or by having prints made up to the size you usually produce. A very good

lens renders the smallest twigs sharply defined against the sky, while lenses of lesser quality produce images in which the twigs tend to blur or have fringes of color around them. This simple test actually checks for all of the aberrations except distortion.

You can easily check distortion by photographing a carefully drawn rectangle with approximate proportions of 1:1.5; the rectangle should be just inside the image area. To eliminate possible distortion in the printing system, check the negative by placing a machinist's straightedge on it and seeing to what degree the lines bow. Slight bowing is common, particularly on zoom lenses used at the extremes of their zoom range. If more than slight bowing occurs, the lens has problematic levels of distortion. Photographers who never shoot pictures of architecture or other subjects in which straight lines are important might not be bothered by distortion levels that are unacceptable to other photographers.

You can do simple tests for coma and astigmatism with a little more effort. To make a coma target, punch a small hole in a piece of aluminum foil and illuminate it from behind. Make the hole carefully, so that it is quite round and has no burrs. Examine the hole under a magnifier. (Very critical testers can buy laser-cut pinholes from scientific supply houses for this purpose.)

Then in a darkened room, photograph this target at various locations in the outer field, and examine under magnification the image on the film. The closer the image is to a round, sharp dot, the less coma the lens exhibits. To test for astigmatism, draw a spoked wheel in black ink on a white board and photograph it centered in the image area. Examining the test film will readily show astigmatism as lack of sharpness of the rim or the spokes, or portions of either.

An old-fashioned test of contrast and resolution consists of tacking sheets of newspaper to a wall, placing the camera a moderate distance from the wall, and photographing the newspaper with a fine-grained film. Carefully measure to ensure that the camera is parallel to the wall on all axes. If the print is sharply rendered all the way to the four corners of the negative, the lens is very good in terms of contrast and resolution. Although most lenses show some image degradation toward the corners of the negative, this isn't a problem if the degradation is equal in all four corners. When the lens is stopped down to $f/5.6–8$, type should be sharp all the way to the corners. If it isn't, the lens has relatively poor resolution. If one (or more) corner differs markedly from the others, the lens probably has a tilted element. Clearly, testing lenses for quality and aberrations is essential to producing effective images.

Index

Aberrations, 16, 65, 67, 85, 127, 138–39, 140
Action shots, 54–55, 56, 81, 92
Aerial photography, 78
Angle, dynamic, 53, 54
Angle of coverage, 22
Angle of view, 15, 20–21, 44, 46, 50, 54
Aperture
 automatic, 24–25
 settings, 22–25, 65, 79, 122
 -shutter relationship, 28–29
 of soft-focus lens, 125–27
Apochromatic (APO) lens, 86, 132, 139
Architectural photography, 109
Aspect ratio, 60, 61
Astigmatism, 16, 138–39, 140
Atmospheric interference, 95–97
Autofocus, 57
Automation, 8, 10

Background, 42–43
Balance, 49–50
Barrel distortion, 67, 139
Bayonet-type locking mount, 33
Beaded screen, 136
Bellows, 35, 118, 121
Between-the-lens (leaf) shutter, 32–33
Bird's-eye view, 46, 111
Blur shot, 52, 53, 54, 76
Bowing, 140
Brain, perception and, 59, 64
Bubble level, 109

Camera(s)
 autofocus, 57
 designs of, 33–37
 panoramic, 100–101, 102, 112
 rangefinder, 25, 36, 56, 86
 single-lens-reflex (SLR), 24, 25, 37, 56, 64, 86, 94, 122
 twin-lens-reflex (TLR), 24, 37, 56, 86
 view, 34, 36–37, 141
Camera rise (shift), 107
Camera shake, 76–77, 78, 92, 94
Camera viewpoint and perspective, 43, 44, 102, 104
 angle and, 51
 balance and, 49–50
 depth of field and, 51
 distortion and, 46–47
 horizon line and, 47–48
 negative space and, 48–49
 rule of thirds and, 48
 shutter speed and, 51–53
 size perception and, 50–51
Center of interest, 42, 48, 98
Chest pod, 92, 94
Chromatic aberrations, 16, 67, 85, 139
Click stop, 23

Closeup lens, 68, 114–24
Closeup photography, 67, 68, 77, 114, 117
Coincident-image focusing, 37
Color fringes, 16
Coma, 16, 140
Composition, 38–61
 of action shots, 54–55, 56
 film format and, 60–61
 focus and, 56–57
 foreground/background in, 42–43
 framing in, 43–44
 human vision and, 58–59
 mind's eye and, 59–60
 subject in, 42
 visual aids to, 60
 with wide-angle lens, 98
 See also Camera viewpoint and perspective
Compression, 41
Contrast, 138, 140
Convergence, 46
Cropping, 79

Depth of field, 23, 25–27, 41, 42, 46, 51, 57, 77, 91, 92
Depth of focus, 133
Depth perception, 74
Diaphragm shutter, 32
Diffraction, 16, 124, 139
Diffusion filter, 127, 129–31
Diopter, 118–19
Dispersion, 139
Distortion, 16, 33, 67, 139, 140
 apparent, 46, 65, 69, 107

Electronic flash, 33, 68, 76, 90, 106
Enlarging lens, 131–34
Exposure
 aperture setting and, 24–25, 122
 metering, 122, 124
 shutter speed and, 28–29, 32–33
Extended-coverage lens, 22
Extension tube, 68, 118, 122

Fast-blade phenomenon, 33
Field camera, 35, 37
Field curvature, 16, 139
Film format, 20, 22, 27, 60–61, 68
Filters, 60, 79, 86, 97, 107, 126, 127, 129–31
Fisheye lens, 100, 102, 107, 110–12, 139
Fixed-focal-length lens, 19, 24
Flare, 79, 81, 86, 107
Focal length, 18–20, 58, 65, 122
Focal-plane shutter, 32, 33
Focus, 37, 38, 56–57, 65, 76, 89, 118, 122, 133, 134
Focus-lock button, 57

Focus shift, 57, 133
Focus throw, 89–90
Fog filter, 130
Follow-focus, 76
Foreground, 42–43
Foreground dominance, 41, 43
Framing, 43–44
Framing card, 60
f-stop, 22–23, 24, 25–26, 28, 92, 122, 125

Glass
 lens coatings, 86
 low-dispersion, 139
Graduated-color filter, 79, 97
Group shots, 49, 67–68, 73, 82, 106
Gunstock mount, 92, 94
Gyrostabilizer, 78

Halving/doubling principle, 28
Handholding, 72, 76–77, 87, 102
High-modulation lens, 22
Horizon line, 47–48, 104
Human vision, 58–59, 64
Hyperfocal distance, 26

Image circle, 21, 22
Image quality, 16, 68, 119, 138
Implied action, 52
Incident-light meter, 124
Infinity, 18, 26
Infrared correction line, 33
Interior shots, 106
Inverse Square Law, 68, 76, 135

Keystoning, 107, 136

Landscape photography, 66, 74, 75, 82, 89, 109, 125, 127
Leaf shutter, 32–33
Lens(es)
 aberrations, 16, 65, 85, 127, 138–39, 140
 apochromatic (APO), 86, 132, 139
 camera design and, 33–37
 cleaning, 136
 closeup, 68, 114–24
 composition and. See Composition
 covering power of, 21–22
 design of, 15–16
 effects of, 40–41
 enlarging, 131–34
 fisheye, 100, 102, 107, 110–12, 139
 moderate-angle, 71–81
 perspective-control, 107–109, 136
 pinhole principle and, 12, 14, 15
 properties of, 18–33
 selection, 38, 40, 46, 61
 slide-projector, 134–37

soft-focus, 124–29
standard, 19, 41, 47, 62–71, 79, 119
testing, 124, 139–40
See also Telephoto lens; Wide-angle
 lens; Zoom lens
Lens barrel, 79
Lensboard, 33, 36
Lens coatings, 86
Lens elements, 15, 16
Lens hood, 81, 107
Lenticular screen, 136

Macro lens, 68, 119
Magnification, 18, 41, 50, 51, 54, 87,
 90–91, 114, 117–19
Matte screen, 135
Metering, 122, 124
Microprism focusing, 89
Mind's eye, 59–60
Mirror telephoto lens, 85–86
Moderate-angle lens, 71–81
Modulation transfer function (MTF), 138
Monopod, 92, 94
Motion, sense of, 51–53, 54, 109
Mounting rings, 94

Nature photography, 91, 109
Negative space, 48–49
Neutral-density (ND) filter, 86, 126
Nodal points, 18

One-to-two rule, 27
Opening up, 24, 29

Panoramic camera, 100–101, 102, 112
Pan shot, 52, 54, 76
Perspective. *See* Camera viewpoint and
 perspective
Perspective-control (PC) lens, 107–109,
 136
Pincushion distortion, 67, 139
Pinhole principle, 12, 14, 15
Polarizing filter, 79, 97
Portrait photography, 68–69, 73, 78, 89,
 127, 130

Press camera, 37
Preview button, 25, 56, 57

Rangefinder camera, 25, 36, 56, 86
Rear-element filter, 107
Reflected-light meter, 124
Refraction, 15
Resolution, 138, 140
Reversing ring, 119
Rug (runway) effect, 102
Rule of thirds, 48

Shutter design, 32–33
Shutter-release button, 37
Shutter speed, 24, 92
 -aperture relationship, 28–29
 electronic flash, 33
 moving subject and, 51–53, 54, 77
Single-lens-reflex (SLR) camera, 24, 25,
 37, 56, 64, 86, 94, 122
Size perception, 50
Skylight filter, 97
Slide-projector lens, 134–37
Slit-scan shutter, 101, 112
Soft-focus filter, 127, 129–31
Soft-focus lens, 124–29
Speed streaks, 109
Spherical aberrations, 16, 138
Split-image focusing, 37, 89
Split-screen focusing, 89
Sports photography, 55, 86, 91
Spot focus, 56
Standard lens, 19, 41, 47, 62–71, 79, 119
Stop-action shots, 52, 53
Stopping down, 24, 25–26
Subjects
 in composition, 42
 isolating, 43, 54, 89, 91, 105–106
 moving, 51–53, 54
Synchronization (sync), 33

Tabletop photography, 67
Teleconverters (tele-extenders), 69–70,
 85
Telephoto lens, 18, 21, 27, 66
 effects of, 41, 46, 47, 50, 51, 54

longer, 54, 55, 82–92, 95–97
moderate, 74–78, 119
Through-the-lens (TTL) meter, 122
T-mount adapter, 125
Tripod, 55, 87, 92–94
True-zoom lens, 19
Twin-lens-reflex (TLR) camera, 24, 37,
 56, 86

Ultraviolet (UV) filter, 97, 107

Variable-zoom lens, 19, 79
View camera, 34, 36–37, 140
Viewfinder, 25, 89, 90
 optical, 60
Viewpoint. *See* Camera viewpoint and
 perspective
View-screen blackout, 89
Vignetting, 16, 21, 107
Visual aids, 60

Wedding photography, 73
Wide-angle lens, 15, 18, 21, 27, 66, 68
 in action shot, 54
 composition and, 98
 effects of, 41, 43, 46, 47, 50, 51, 53,
 101–102
 medium-wide *vs.* ultrawide, 100–107
 moderate, 72–74
 perspective control and, 107–13
Worm's-eye view, 44, 46, 110

X setting, 33

Zig-Align mirror system, 133–34
Zone focusing, 56
Zoom creep, 79
Zoom lens, 24, 41, 77
 in action shot, 55, 81
 distortion, 140
 focal length of, 19–20
 focus and, 57
 macro, 119
 moderate, 79, 81
Zoom streaks, 55